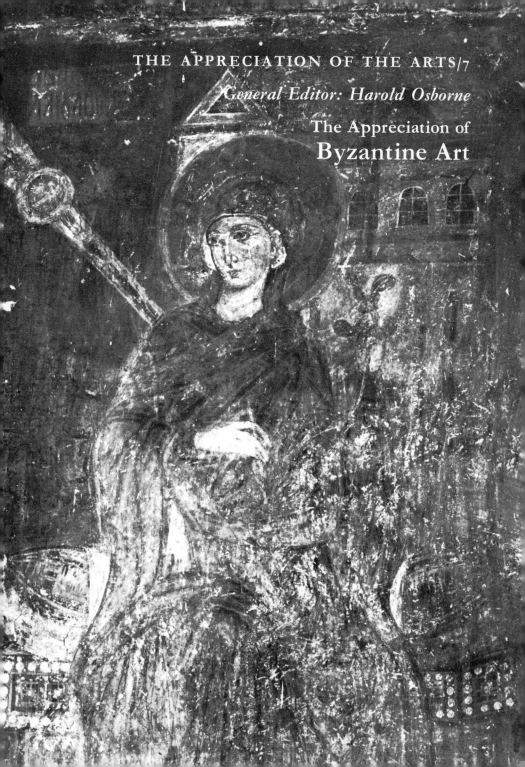

THE APPRECIATION OF THE ARTS/7

General Editor: Harold Osborne

The Appreciation of
Byzantine Art

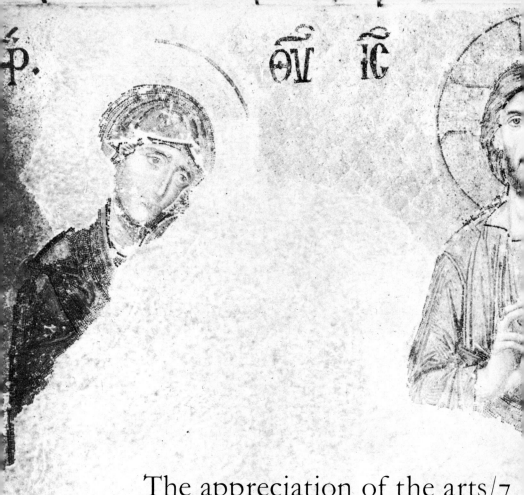

ӨΫ ĨC

The appreciation of the arts/7

The Appreciation of

London. *Oxford University Press*

BYZANTINE ART

David Talbot Rice

Oxford University Press, Ely House, London W1

GLASGOW NEW YORK TORONTO MELBOURNE WELLINGTON
CAPE TOWN IBADAN NAIROBI DAR ES SALAAM LUSAKA ADDIS ABABA
DELHI BOMBAY CALCUTTA MADRAS KARACHI LAHORE DACCA
KUALA LUMPUR SINGAPORE HONG KONG TOKYO

Clothbound edition ISBN 0 19 211922 2
Paperbound edition ISBN 0 19 211923 0

© Oxford University Press 1972

Set by Keyspools Ltd and printed in Great Britain
at the University Press, Oxford, by Vivian Ridler, Printer to the University.

Contents

Illustrations

Numbers in the right hand margin of the text give page numbers of the illustrations referred to

Acknowledgements

We should like to acknowledge Paul Elek Ltd. for permission to reproduce the illustration on p. 29, which originally appeared in David Talbot Rice, *Constantinople.* The photograph was taken by Wim Swaan. We should also like to thank Professor Victor Lazarev for the photographs that appear on pp. 172 and 175.

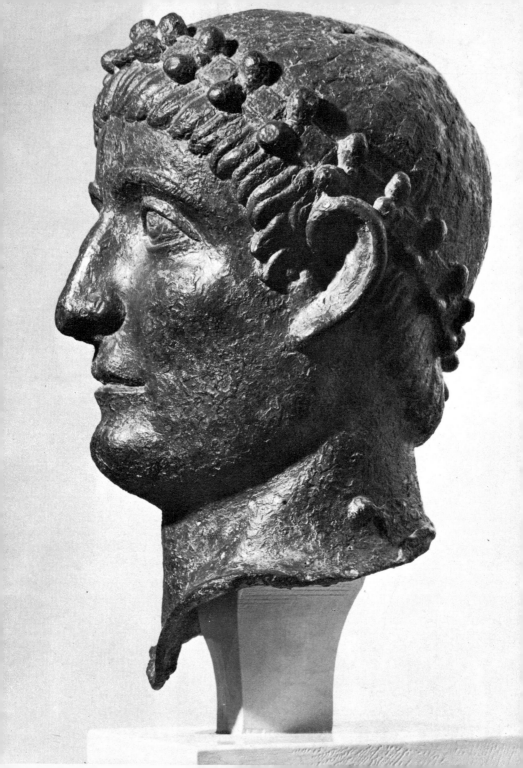

A Definition

One must first begin with a definition—what do we mean by Byzantine art? The short answer, of course, is the art of Byzantium, the city which was renamed Constantinople after the emperor who transferred thither the capital of the old Roman empire in the year 330. But was the art that was produced there under the patronage of Constantine and his immediate successors already a truly Byzantine art? The artisans he employed there were drawn from all over the empire, but more especially from Rome; the layout of the city was to a great extent based on Roman ideas; the cathedral that he built to solemnize his adoption of Christianity was a basilica, a longitudinal building with timber roof, following in plan and elevation a type that had long been in use in Rome for judicial purposes; the sculptures that adorned the city were in no way different from those of pagan Rome and they included large portrait statues of the emperor like those that had been set up by ruler after ruler throughout the centuries. There were streets, fora, and columns similar to those of Rome; and the paintings, so far as we can judge of them from descriptions and a few scanty vestiges, were of a straightforward narrative character, Christian in theme if they were in churches but otherwise essentially Roman in appearance.

Though in recent times we have seen changes that affect the very basis of art taking place during a period of no more than a few years and though in Italy in the fifteenth century art developed in an unprecedented manner and with remarkable speed, in the fourth century developments were far less rapid and changes much less spectacular. If eventually they were to prove little less fundamental, the process of development was much more gradual and delayed and some two centuries were to elapse before their effect became fully apparent on the surface of art. Yet change was taking place in the minds of thinking people; efforts to define the new faith were occupying the thoughts of clergy and emperor alike, as we can see from the findings of the great Councils of the Church held at Nicaea in 325, at Constantinople in 381, at Ephesus in 431, and at Chalcedon in 451, and by about 500 the effects of a changing outlook had begun to be apparent in art.

Bronze head of Constantine. Early fourth century. In the National Museum, Belgrade.
Hirmer Fotoarchiv München

The development of a new style in art was, however, far from

1

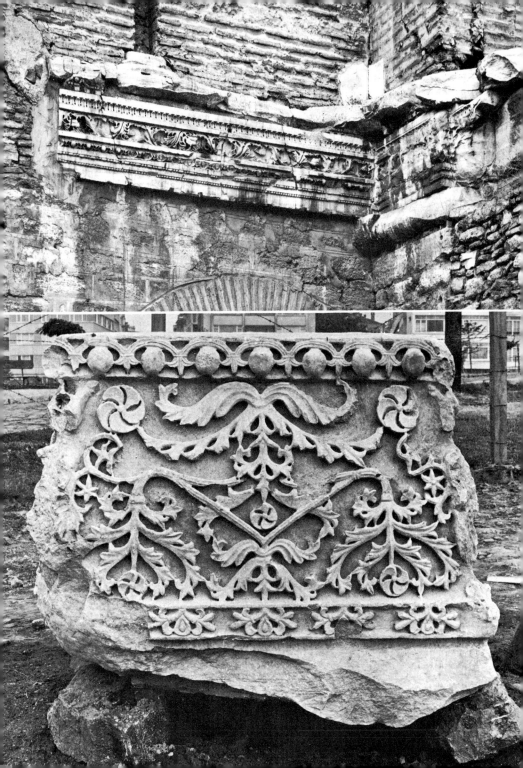

uniform. In one area works which were still essentially classical continued to be produced till as late as the eighth century, while in another a new outlook began to dominate art quite rapidly. The change was naturally least apparent in Italy, where the old pagan outlook continued to persist, whereas in the cities of the East, where the new faith was more readily accepted, a new approach to art soon developed alongside it. And it was in the city of Constantinople, where the population was Greek and where contacts with Asia Minor, Syria, and even Persia and Mesopotamia exercised an important influence, that the change was most rapid.

It is probably in the sphere of architectural sculpture that it is to be most clearly observed. Happily a number of carved marbles which can be firmly dated are available for study and the nature of the change can be appreciated if we look at them closely. The first hints of a new approach, a new conception, are to be seen in the low relief friezes on the cornices that topped the columns of the aisles and adorned the west end of the church of St. John of Studios, which date from 463; those at the west end are best preserved, for those in the interior of the church have been severely damaged by fire. The idea of a horizontal cornice, as opposed to an arcade, was in itself conservative, recalling a classical model, as does the columned west front of the building; but the frieze itself, consisting of acanthus leaves and an egg-and-dart moulding, has already moved away from the naturalistic conception of classical art towards a greater degree of stylization and depends for its effect more on the contrast of light and shade than on true modelling, laying stress on a two-dimensional pattern rather than on three-dimensional naturalism. Even though the result was restricted to black and white, the treatment can best be described as colouristic.

This tendency was carried further at the end of the same century in an important series of sculptures recently unearthed on the site of the church of St. Polyeuktos, set up for Juliana Anicia close to the aqueduct of Valens around the year 500.[1] True, the floral motifs of the ornament are still recognizably naturalistic; but the whole impact is new and distinctive, for the ornament relies wholly for its effect on the rhythmic repetition and the formal balance of the pattern rather than on representational exactitude or realism.

Sculptured cornice from the church of St. John of Studios, Constantinople. 463. *Hirmer Fotoarchiv München*

Sculptured cornice, from the church of St. Polyeuktos, Constantinople. *c.* 500. *Dumbarton Oaks and Elizabeth Harrison*

[1] Its remains have recently been unearthed by a mission sponsored jointly by the Byzantine Research Centre at Dumbarton Oaks in Washington and the Museum of Antiquities at Istanbul.

3

The acme of this new style was reached less than fifty years later in the cornices and capitals of Justinian's buildings, San Vitale at Ravenna, SS. Sergius and Bacchus, and, more especially, the great cathedral of Hagia Sophia at Constantinople, begun in 533 and completed less than six years later. These capitals, as well as many similar ones at Constantinople, Ravenna, and elsewhere, were probably carved by Greek workmen trained in the marble quarries of the Marmara Islands not far from Constantinople itself. They represent the full development of the Byzantine ornamental style and they set the pattern for stylistic development during the next six or seven centuries. The new style was to exercise an influence that extended to Italy and even further to the west on the one hand and to Armenia on the other, as well as to Egypt and beyond in the south.

It was not only in the quarries of the Marmara Islands that this new, ornamental conception was developing, however. At an even earlier date the same stress on black and white pattern was coming into vogue in Asia Minor, notably at Sidamarra, not far from Ephesus, where a famous group of sarcophagi was produced which were adorned with ornamental work in a very similar style, made up of columns, cornices, and pediments in low relief. These formed the framework

Sarcophagus of the
Sidamarra group. Fifth
century. In the Berlin
Museum

for the main decoration which consisted of free-standing figures in three dimensions which were conceived in a very different style, for even when the figures depict Christian personalities such as Christ or the apostles, they still recall pagan representations of philosophers and are recognizable as Christian only because of attributes such as haloes. The end of a renowned sarcophagus now at Berlin may serve as an example. In the architectural details the drill was used so extensively that the leaves have virtually ceased to bear any recognizable relationship to their naturalistic models, though the figures are realistic and cling to old established forms.

If the figures on these sarcophagi are still conservative, it would seem that elsewhere a change was taking place, even in figural art, though it was more marked in two-dimensional than in three-dimensional work. Thus some of the mosaics of the fifth century are beginning to show a change of outlook which is clearly to be seen if we compare the figures in the lowest register on the walls of S. 6 Apollinare Nuovo at Ravenna, set up when the building was restored to Orthodoxy under Justinian's inspiration in 561, with those of the uppermost level, done under the patronage of Theodoric, who was of the Arian heresy, some thirty years earlier. Here the figures,

Capital in the church of Hagia Sophia, Constantinople. c. 535

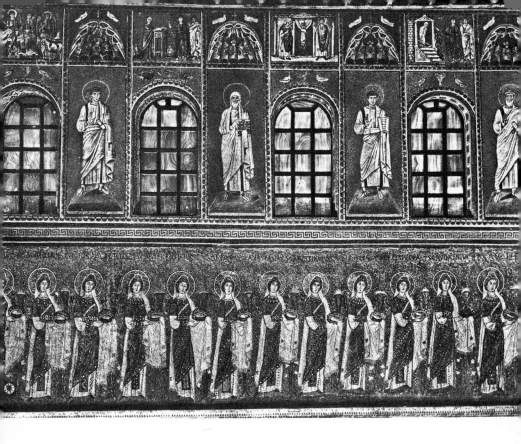

Mosaic. Procession of the Martyrs. S. Apollinare Nuovo, Ravenna. Sixth century. *Mansell Collection*

though dumpy with over-large heads, are vivid and expressive and are still conceived naturalistically, while in the later work on the lower register, which depicts rows of males on one side and females on the other, they are severe and formal and depend for their appeal on the rhythmic character of the composition. Indeed, this rhythmical approach has been carried even further here than in the ornamental sculptures of the capitals in Hagia Sophia. There is no attempt to indicate depth, the composition is two-dimensional, and the aesthetic conception behind it is closer to that of a work of pure abstraction than to a narrative picture, which in this case tells the story of two groups of martyrs, one male and one female, progressing towards the east end of the church to be received there respectively by Christ and the Virgin.

A similar absence of any attempt to create an illusion of three-dimensional space, combined with a severely frontal rendering,

6

characterizes the two famous portrait groups in San Vitale at Ravenna which depict Justinian and Theodora. Though great attention has clearly been devoted to drawing the character of many of the principal figures, especially Justinian, Maximian, and the general behind the former, who is probably Belisarius, all elements pertaining to a picturesque or naturalistic appeal have been to a great extent eliminated. The mosaic dates from around 540 and both Justinian and Theodora bear offerings in token of the recapture of Ravenna by Belisarius. Placed as the compositions are in the sanctuary of the church, they have a religious rather than a purely pictorial character. They assert the fundamental significance of the faith to which the imperial figures bear witness, and the very absence of three-dimensional realism supports the esoteric, votary character of the panels. The glorious, glowing colours, made possible by the very nature of the mosaic medium that the Byzantines preferred above any other, play the same role as the vestments and solemnities of the mass; they glorify God and attest not only the value of the emperor's offering, but also the very essence of the Christian faith.

Though the costumes of the martyrs in the processions in S. Apollinare Nuovo or the uniforms and equipment of Justinian's body-guard in the San Vitale panel attest a debt to classical models, there are other features in these mosaics which must have been derived from the East. The ethereal conception of the martyrs, who seem to float over the earth rather than stand upon it, seems to derive from such a work as the famous painting of 85 A.D. from the Temple of the Palmyrene Gods at Dura in Syria, which Breasted, who published it, describes as an Oriental forerunner of Byzantine art, rather than from the classical world, while the colourful grandeur of Theodora's robes and those of her courtiers again belong to the East rather than to the West; Theodora's crown even follows a type that was first used in Sasanian Persia, and came to the Byzantine world from there.

Another factor that distinguishes these mosaics is the way that the colours are used. In earlier work there was a certain degree of colour symbolism; for example in the scene of the separation of the sheep and goats in the upper row of the mosaics of S. Apollinare Nuovo, set up under the patronage of Theodoric about 500, the angel who protects the sheep is coloured red, that behind the goats blue. The colours are those of night and day respectively, going back to an age-old association between light and goodness, dark and evil. In general,

however, in these and earlier mosaics colour contrasts were gentle, for the artists sought through them to achieve the aims of an illusionist art. In Byzantine art the aim was different. An illusion of space or depth was no longer sought, so that the colour contrasts could become harsher and more strident, each shade telling by its own quality, its own brilliance. This is especially true of such a composition as the Theodora panel in San Vitale, where the effect of the composition is very much dependent on the colour; it is not just an outline design, a drawing to which colour has been added simply to brighten it up; as in many of the more experimental paintings of the later nineteenth century in the West, we have a work conceived in colour, and for that reason it loses more in monochrome reproduction than many other compositions, and it therefore tends to look flat and over rigid. This use of colour as the handmaid of form was another Byzantine development which became extremely important in later years (see pp. 162ff. and 202). It was to be inherited by El Greco in the sixteenth century, and developed to a degree hardly equalled again till the twentieth century.

There is in addition another significant feature about this mosaic which heralds developments that were to become important in later Byzantine art, namely the treatment of light (see pp. 165 and 169). The figure of Christ in SS. Cosmo and Damian at Rome floats in space before a background of pink dawn clouds which seem to symbolize not only the heavenly associations of the figure but also the fact that Christianity represents the dawn of a new age. In the ancient faiths of the East dawn represented not only the conquest of darkness by light but also the defeat of evil by good, and throughout Byzantine art, indeed throughout much of Christian art, light is imbued with a similar significance. St. Bernard of Clairvaux (1090–1153) compared the light shining through a stained glass window to the word of God, the light of the Father, while in later Byzantine times stress was laid on what was termed the inner light, which in a picture emanated not from any natural source but from the divine figure that was therein portrayed. The conception is most obvious in renderings of the scene of the Transfiguration, whether it is depicted symbolically, as in S. Apollinare in Classe, or more directly as in numerous mosaics and paintings from the sixth century onwards. The conception is a mystic one, derived no doubt from the East, but surviving as a natural development of Byzantine esoteric thought. It was to reach its ultimate extreme in the fourteenth century under the influence of

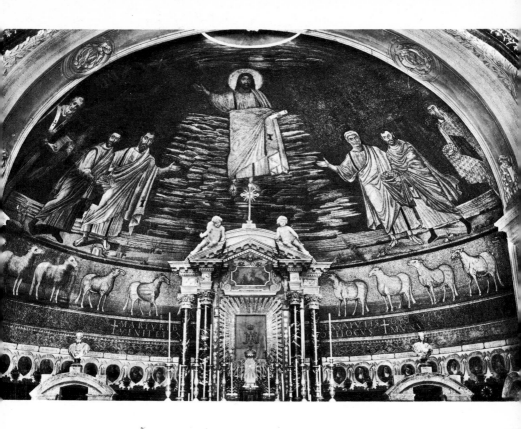

osaic. The apse of SS.
osmo and Damian,
ome. 526–30

a sect known as the Hesychasts, who favoured contemplation of an almost Buddhist character.

Another aspect of the new style, in default of examples from Constantinople where virtually nothing survives, may be illustrated by two mosaics at Rome. The first is in the apse of Sta. Pudenziana, and dates from between 384 and 389, and the second is in SS. Cosmo and Damian, and was set up about a century and a half later (526–30). In both, Christ is portrayed as an impressive, even awesome figure with heavy beard. At first glance one might think it was wholly inspired by the philosopher portraits of classical sculpture, but closer attention suggests that the figures reflect a more transcendental outlook which was wholly foreign both to Greece and to Rome; it is to be associated rather with the eastern Mediterranean and with the mystic faiths like Mithraism and Gnosticism which had begun to penetrate the Roman world at much the same time as Christianity.

9

This aspect is especially prominent in the figure of Christ in SS. Cosmo and Damian; he has all the awesomeness of the Semitic Yahweh, and the nature of the conception is brought out clearly if we contrast this mosaic with the rendering in the apse of San Vitale at Ravenna, where the Christ is beardless, a lovely, youthful figure, modelled, one would think, on that of an Apollo. He is seated firmly on the orb of the world which takes on almost the character of a throne. In SS. Cosmo and Damian the figure of Christ seems to belong not to this world but to the realm of the imagination and the spirit. It is a symbol of the faith rather than a depiction of the living Christ, and the mosaicist, one feels, is seeking not only to depict the divine power that made man in its own image, but also to interpret the ideas that lay behind the new teaching. It is this aim of interpretation, this stress on the spiritual, that distinguishes these works as Byzantine; they may be contrasted with the series of Old Testament and New Testament scenes in Sta. Maria Maggiore at Rome, dating from between 432 and 440, which are more clearly concerned with recounting in a straightforward manner the actual narratives as recorded in Genesis, the New Testament, and the Apocrypha.

As time went on certain conventions of representation were developed to support this approach, more especially in the treatment of perspective. Already at quite an early date the system known as vertical perspective had been developed, according to which figures in the background were depicted above those in the foreground, though there is otherwise no effort to suggest depth or three-dimensionalism. It was frequently adopted in low relief ivory carvings of the sixth century. The figures in the background are usually on a larger scale than those in the foreground, and as time went on this led to the development of a distinct system, known as inverted perspective, which was applied to the depiction of buildings, thrones, and similar inanimate objects. Here the part of the structure furthest removed from the spectator is larger than that closest to him; the exact opposite of Western perspective, in fact, with the vanishing point in front of the picture instead of behind it. Though the idea developed naturally enough out of the system of vertical perspective, it is possible that later painters made use of it intentionally, with the object of bringing the spectator into closer association with the picture, to make him as it were a part of it, so that he experienced the event from inside and was not merely a spectator from without. But in some instances, where the efforts at indicating perspective are

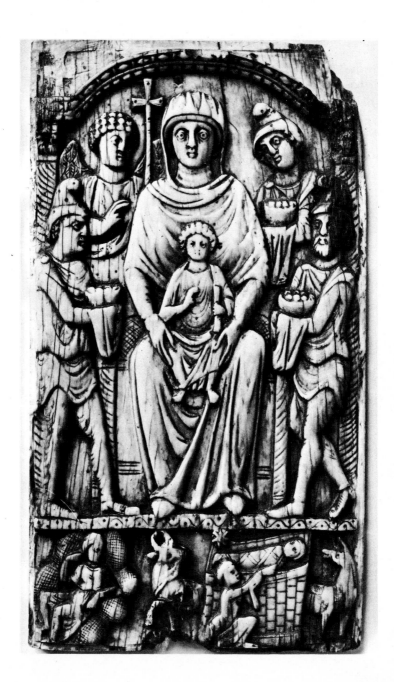

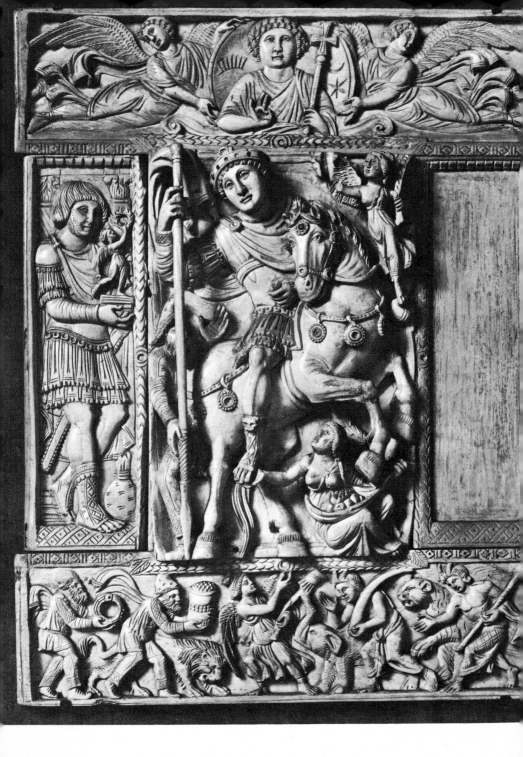

virtually grotesque, no other explanation than the complete ineptitude of the artist is acceptable. Neither of the two intentional systems should, however, be confused with yet another which was in constant practice, that of enlarging the principal figures to indicate their greater importance. This was an old Oriental custom which had permeated a great deal of the art of the Mediterranean world early in the Christian era. It is often known as 'psychological' perspective.

Another convention that may be noted at this stage refers to the proportions of the figures and more especially to those of the faces. Panofsky suggests that the Byzantines took over from the Romans a system that was first outlined by Vitruvius, even if its application was not universal till a later date. According to this system the length of the nose was applied as a norm, and a circle described with its base as centre would equally determine the height of the forehead. If a second circle was drawn with the additional length of the same norm it would serve to indicate the correct outline for the head and hair, and a further addition would delimit the halo. By continuing to add the same norm the correct positions of the various parts of the body could be determined, the body itself being regarded as seven heads, or twenty-eight norms, in height. Not every Byzantine figure was made to conform to these proportions by any means, but the system lived on, to be revived at a later date, when set rules came to be substituted for individual originality. Those rules are set out in the book we know as *The Painter's Guide* (see pp. 199f.).

If certain elements proper to classical art lived on, others quite rapidly disappeared, and of these the most striking was the decline of three-dimensional sculpture, the pre-eminent art of the classical age. No doubt the deep seated Oriental suspicion of the graven image, so often reiterated in the Old Testament, produced an effect in this direction, but changes of taste in architecture may also have exercised an influence, for the developed Byzantine interior was ill adapted to the display of statues; a two-dimensional, colourful decoration was far more satisfactory and such decorations became the vogue quite early in the Byzantine era. In carving, stylized ornament in low relief was preferred, while on the walls mosaics very soon became almost universal; they represented a more spectacular decoration than the wall paintings which had been so popular among the early Christians both in Rome and in the East. Only on a small scale did three-dimensional work remain in favour, and even there the relief was kept comparatively low, while the spirit of the work reflected ideas

13

quite distinct from those that dominated in classical sculpture. A fine ivory of about 500, which at first glance seems to have a very classical character, may be cited to illustrate the change of outlook. It is one side of an imperial diptych, now in the Louvre, and is usually known as the Barberini ivory. It has sometimes been identified as representing Justinian (527–65), but a more probable association would seem to be with Anastasius, who reigned between 491 and 518, for he is known to have received an embassy from India in 496, and he was also involved in struggles against the Goths; groups of Indians and Goths bearing gifts and tribute are shown at the bottom of the ivory. The massive figure of the emperor on his charger is still imbued with all the dignity of a great Roman conqueror, and the earth, in the form of an allegorical figure, as well as the subject nations, pay him homage. But above, dominating all, is the figure of Christ, to whom the Byzantine emperor, together with the whole Byzantine state, in turn owed their allegiance. The emperor was Christ's earthly vice-regent, and he was entitled to mundane but not to spiritual glory. It is this clear portrayal of his allegiance to Christ that establishes the ivory as Byzantine, though in many ways the style still reflects much of the character of Roman art.

In contrast to the rendering of Christ in the apse of SS. Cosmo and Damian, where he is depicted as a wholly spiritual figure, the divine aspect here is a good deal less marked. One feels that artist and patron alike were not able to dissociate themselves completely from the affairs of this world in the same way that the mosaicist had done. On the ivory the reverence paid to Christ is really little more than lip service and the spirit of imperial Rome is still clearly to the fore. But in another very important ivory, carved perhaps a quarter of a century later, the spiritual element is again dominant. The panel depicts the Archangel Michael standing in a niche, his feet poised above a flight of steps though they do not rest on them. Even if the ornament of the niche, the costume, and certain other details hark back to some Roman model, the unworldly pose is already essentially Byzantine; once more the mystic approach of the Dura wall painting is to be discerned; once more we seem to be on the threshold of a new age, rather than at the end of the old classical tradition.

In the sphere of architecture the transition to a new, wholly Byzantine, style was rather more clearly defined than in the other arts and it can be discussed in more concrete terms. The governing factor was the use of vault and dome for the roof, on a universal scale. The

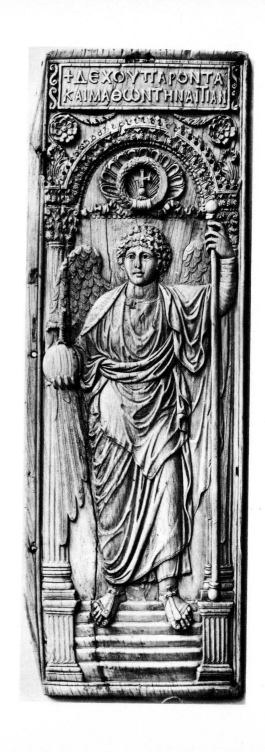

ceilings of coffered concrete or simple timber that were usual in Roman architecture tended to disappear completely, and with this change in the nature of the roof there were corresponding developments in the elevations and the ground plan. True, the Romans had used vaults on a vast scale, as in the baths of Caracalla and Diocletian, and the dome, as in the Pantheon; but the dome of the Pantheon topped a circle not a square, while the Byzantine vaulted and domed structures differ fundamentally from their Roman predecessors both in construction and in conception, for they depend not so much on strength and mass as on the balance of thrust and counter thrust and are treated not as static, but as dynamic organic entities. The longitudinal basilicas with timber roofs which had been the most popular building form in early Christian times had passed completely out of favour by the beginning of the sixth century. Once more Justinian was the great innovator, and it was thanks to his patronage that so many important buildings were set up in which the new style reached perfection with amazing rapidity.

The destruction of the original cathedral of Hagia Sophia, which had been begun by Constantine, in the Nika riots of 532 gave Justinian his opportunity, though his ideas in church building had no doubt crystallized before that, and the setting up of domed churches at Ravenna, Ephesus, Jerusalem, and probably elsewhere in the twenties and thirties of the sixth century indicates how far his architects had already developed their ideas. Indeed, as the new church of Hagia Sophia was begun only a few months after its predecessor had been destroyed it is even possible that the idea of replacing the old building with a new one more suited to the underlying spirit of Christianity had already been conceived. In most of the new buildings certain elements proper to classical structures continued to survive: the centralized buildings, such as San Vitale at Ravenna or SS. Sergius and Bacchus at Constantinople, follow the conception of the old martyrium; the great churches, such as St. Irene or Hagia Sophia at Constantinople, or Justinian's church at Ephesus, had three aisles like an early Christian basilica. But there was a new stress on breadth as opposed to length, arcades replaced the horizontal entablatures of classical architecture, and at a higher level still vaults and domes were not only used instead of the simple timber roofs, but they were also used in a new way so that thrusts were compensated not by mere mass and weight or strength of material, as in the Pantheon or the Basilica of Maxentius at Rome, but by their

own carefully calculated proportions. There is a story that during the building of Hagia Sophia the masonry of one of the great arches began to crack and the masons rushed to Justinian to tell him the news; his reply was simply that they should go on building, for when the two extremities met they would serve to support each other. It is no doubt little more than a legend, but it shows that the idea of organic architecture, based on thrust and counter thrust, which we find at its culmination in the great Gothic cathedrals of the Île de France, had already been conceived.

It is this new outlook that distinguishes the style, and alongside it we find the same stress on the transcendental as opposed to the material that we found in the visual arts. That it was something intentional, something conscious and not merely due to chance, is clearly shown if we turn to contemporary accounts of the great cathedral of Hagia Sophia. In a long poem describing the beauties of the structure, a court official, Paul the Silentiary, writes of the dome that: 'It rises like a beauteous helmet, and it seems that the eye, as it wanders around, gazes on the circling heavens.' Of the vault he says: 'Measureless curved arches spring up like the many coloured bow of Iris. Every arch has its foot at either end fixed unshaken and joined to the neighbouring curves. As each rises slowly in the air in bending line, it separates from the other to which first it was joined.' The dome he further describes as like the vault of heaven, sprinkled with stars, and the coloured marbles below as having all the beauty of the flower-bordered streams of Thessaly. When the multitude entered the building at its opening it seemed to all as if the mighty arches were set in heaven, so glorious was the effect that they produced. 'By divine counsel, while angels watched, the cathedral had been built again.' Once more the essence of all that Byzantine art stood for is stressed; divine counsel, not man's ingenuity, was responsible for the glory of the new structure.

Hagia Sophia in many ways stands alone, for nothing so ambitious, so elaborate, or so impressive, was ever again attempted. But domes and vaults from that day on became an essential feature of practically every Byzantine church; further they made an ideal setting for the best loved of all Byzantine arts, the mosaics of the type that an attempt has been made to describe above, mosaics where the mundane themes of story telling had been forsaken in exchange for the interpretation of divine truth. Once more we may quote the Silentiary: 'From the mosaic of the roof the golden stream of glittering rays

pours down and strikes the eyes of men, so that they can scarcely bear to look.' The effect that was sought, and achieved, was surely to impress, to overawe, to move to profound spiritual ecstasy, rather than merely to recount the Bible story so that those who could not read should understand it.

Justinian's contribution as a patron of art as we know it today was almost wholly in the religious sphere. We do not know him through the palaces, the fora, the streets, or the public buildings that he set up, all of which have disappeared, but from the churches. Yet in his churches one has the impression that Christ dominated the undertaking from above, just as his bust was set at the top of the Barberini ivory, and with the full development of the pure Byzantine style in the tenth century, we see his bust dominating the church itself from the centre of its dome. In Hagia Sophia this was not so, for in the central dome there was a cross. The old feelings against representation still exercised an effect; the cross that Constantine had seen in the sky before the battle of the Milvian bridge still dominated imperial Christian thinking. But the idea was the same both then and later; cross or bust of Christ, both were equally symbols of the faith, for it was the idea of Christ's sacrifice on the cross that artists and architects alike sought to express, and it was in the cathedral of Hagia Sophia at Constantinople that this idea found perhaps its most glorious expression.

So our story must really begin about the year 500, for it was then that the new style began to become universal. The Christian faith had made its impact some three or four centuries earlier, even if there were still persecutions and massacres of the faithful. It received sanction in 313 thanks to Constantine's vision, with the declaration of the so-called Peace of the Church. It was officially adopted as the faith of the Roman empire by Theodosius II early in the fifth century. And throughout the whole of this long period Christian art had been slowly developing. Many works were produced towards the end of this period in which elements that can be termed Byzantine were present, even if we have been able to call attention to only a few of them here. Nevertheless, taken as a whole, this age was still 'Early Christian' rather than 'Byzantine', and it is best to distinguish it as such. It left its heritage in East and West alike, but for several centuries to come the Eastern heritage was the more progressive, the more significant. Byzantine art, in spite of numerous classical survivals, was something new, something distinct. It may have in-

fluenced—indeed it did from time to time influence—developments in the West, but it was not a fundamental factor in the western European heritage to the same degree as was Early Christian art. Byzantine art was developed to suit and serve an eastern Christian mentality, a thought-world distinct from that of Italy and the West, and to that thought-world it was admirably adapted. That it was at a later date taken over lock, stock, and barrel, by the Slavs was perhaps fortuitous, the result of geographical and historical causes. But both art and thought were equally well suited to the Slav outlook, and both were adopted throughout Russia and the Balkan lands. Finally, when the Byzantine Greeks were conquered by the invading Muslims it was the Slavs of Russia who assured the survival not only of the Orthodox faith but also of the art that served it. Moscow was indeed the third Rome and it retained this role till the anti-Christian attitude of the Communists and the events following upon the wars of the first quarter of the twentieth century threw the ball, seriously diminished in size, back once more into the Greek court.

Inevitably any survey of the attitude adopted towards Byzantium in the West, and more especially in Britain, must begin with the publication between 1776 and 1787 of Gibbon's great survey, *The Decline and Fall of the Roman Empire,* in no less than six large volumes; subsequent editions have often filled double that number. It followed to some extent the line of approach set half a century earlier by Montesquieu, with the publication in 1734 of his *Causes de la grandeur des romains et leur décadence,* though Gibbon's work was a great deal fuller and paid much closer attention to the history of the post-Roman period. Indeed, there is hardly an aspect of Byzantine history, purely speaking, which he does not deal with.

Apart from its importance as a classic of the English language, Gibbon's book is particularly interesting from the point of view of the study that is being attempted here, for it is typical of the dichotomy of attitude towards things Byzantine which has persisted in Britain, if not in the whole of western Europe, until well into the present century. On the one hand by the very fact of its publication it attests that serious interest in this phase of civilization existed even if the book was written on the assumption that after the 'Grandeur that was Rome' there was nothing more than a long decline till the final stage of decadence was reached in 1453 when the city of Constantinople fell before the sword and cannon of the Turk. But on the other hand stress was laid on the progressive character of the decline rather than on the fact that the civilization survived in face of great odds for no less than one thousand, one hundred, and twenty three years, no mean achievement when we look at the history of contemporary or subsequent ages in Europe or even at that of Rome itself. Yet it was this aspect of Gibbon's approach that laid the foundations for unreasoning opposition to all things Byzantine which characterized the outlook of so many nineteenth-century historians and which was epitomized by W. H. Lecky in his *History of European Morals,* published in 1869, when he wrote:

Of that Byzantine Empire the universal verdict of history is that it constitutes, without a single exception, the most thoroughly base and despicable form that civilization has yet assumed. There is no other enduring civilization so

absolutely destitute of all forms and elements of greatness, and none to which the epithet *mean* may be so emphatically applied. Its vices were the vices of men who had ceased to be brave without learning to be virtuous.... The history of the empire is a monotonous story of intrigue of priests, eunuchs and women, of poisonings, of conspiracies, of uniform ingratitude and perpetual patricides.

But not all the scholars of the nineteenth century would have agreed with Lecky, and at much the same time that he was writing, or a little before, historians both in Britain and on the Continent were being attracted to the study of the Byzantine empire for other reasons than a prurient inquiry into immorality. One may mention the names of Fallmerayer in Germany and Finlay in England as two of the most outstanding of them. It may be that they were first drawn to the subject thanks to the romantic appeal of the wars of Greek independence; like Byron, Finlay's enthusiasm was first roused by Greece's struggle for freedom from Turkish overlordship. But as a scholar he sought to inquire, to make an effort to fill in the long gap in the story that separated the Greece of his day from the universally revered Greece of the classical age, and his object was to trace that story backwards. It was thus that in 1851 he published his *History of Greece from its Conquest by the Crusaders to its Conquest by the Turks,* and it was followed the next year by two volumes dealing with the preceding ages: *Greece under the Romans* (146 B.C. to 716 A.D.) and *The Byzantine Empire* (716–1057). Later another volume was devoted to the age of Ottoman and Venetian domination, and two final ones to *The Greek Revolution.* It was Greece itself that formed the theme of his work rather than Byzantium, but for Finlay the story was a continuous one which began in classical times and which he believed would surely not be ended with the conclusion of his final volume; the story, he thought, was the prelude to a regeneration, to a new age of greatness. His viewpoint, especially towards the continuity of Greek history, is reflected in Greece itself, where the man who is king in 1972, though in exile, bears the name of Constantine the Thirteenth, the Twelfth being the monarch who reigned intermittently between 1913 and 1924, and the Eleventh the Byzantine emperor who died at the walls of Constantinople in the last gallant defence of Byzantium in 1453. But whatever it was that first aroused Finlay's enthusiasm, he was one of the first writers in Britain to show a deep and penetrating understanding of the Byzantine world and his diaries and travel notes, now preserved in the library of the British School at

Athens, prove that his interest was of the widest; it even included a keen appreciation of Byzantine art and architecture.

It was perhaps a similar enthusiasm for Greece as the descendant of the classical age, combined with a love for the little known, that inspired the German scholar Fallmerayer as early as 1827 to write a history of the empire of Trebizond, a city whose story had also attracted Finlay, for his first volume, that on Greece under the crusaders, also included a long section on Trebizond. Thereafter the city remained unconsidered in literature for another century, till William Miller published his brief history in 1926. But Fallmerayer was not the only German scholar to be drawn to post-classical Greece. K. Hopf published a history of Greece from medieval to modern times in 1867, while G. F. Hertzberg covered much the same ground as Finlay in his *Geschichte Griechenlands seit den Absterben des antiken Lebens bis zum Gegenwart,* published between 1867 and 1879. Once again the romance of Greece's struggle for freedom and her heritage from the classical age were the primary motivating factors.

It was, however, in France that the first publications devoted to the Byzantine era alone, appeared. As early as 1840 Berger de Xivrey had read a paper on the life and works of the emperor Manuel Palaeologos to members of the Académie des Inscriptions, and in 1870 another French scholar, A. Rambaud, published his *L'Empire grec au dixième siècle,* in which he presented a sympathetic and penetrating study of this supposedly decadent phase of history. The works of both writers indicate a new approach and a sympathetic understanding well in advance of their time.

If the attention paid to the history of the Byzantine world tended to be somewhat biased, either through the conception of continuous decline or because it provided no more than a necessary interlude between the romantic present and the universally admired past, that given to Byzantine art was a good deal more restricted. Taken as a whole the art was but little known and still less appreciated. Yet a few fine books devoted to first-hand studies of monuments in the field were produced, and they are today revered as more or less standard works on the subject. Most important were two large volumes by Charles Texier and R. P. Pullan entitled *Byzantine Architecture* and *The Principal Ruins of Asia Minor,* published respectively in 1864 and 1865. The journeys on which the material published in these volumes was collected were made during the first half of the century, and the books contain valuable information on a mass of material, some of which

Mosaic panel in Hagia Sophia, Constantinople. The Emperor Leo VI at the feet of Christ. 886–912:
above From a water colour by Salzenberg, 1852
below From a recent photograph

22

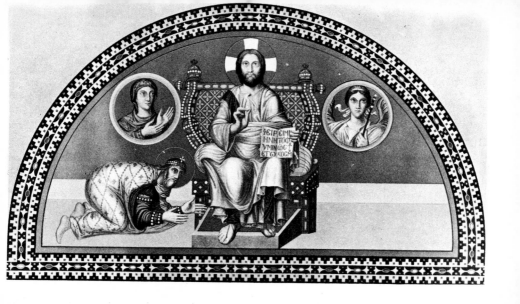

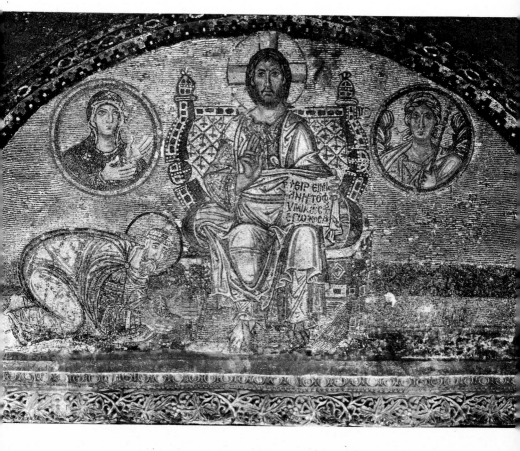

is no longer extant. In 1852 two other important books were produced, one by the Austrian scholar Salzenberg, describing with the aid of a series of plans, elevations, and drawings many of the buildings of Constantinople, and the other dealing with the restorations done at the command of Sultan Abdul Mejid in Hagia Sophia at Constantinople by two Italian architects, the Fossati brothers. During the course of the restorations in Hagia Sophia several of the original mosaics were laid bare. Surprisingly, though the Fossati brothers made careful drawings of them, these were not published; but Salzenberg, who also saw the mosaics, did reproduce some of them 23 in his book in one or two somewhat idealized colour plates.

These colour reproductions, together with others of wall paintings at Trebizond and elsewhere included in Texier and Pullan's book, provide an interesting study in themselves, especially if they are compared with the actual works or with modern photographs of them. They serve to show that the artists and art lovers of the nineteenth century looked at these things through distinctly tinted spectacles! The intentionally formalist compositions, the somewhat aloof character of the figures in the Byzantine works had been misunderstood and interpreted as woodenness, while the facial expressions were sweetened almost beyond recognition. When even the process of copying was so severely affected, it is perhaps not surprising that a true understanding of Byzantine art was but very little developed.

But even so, if the aesthetic character of the major works of Byzantium was but poorly understood, the illuminated manuscripts were more justly appreciated. Manuscripts had indeed been valued for a long time, and the famous Vienna Genesis had already been published on two occasions, in 1659 and 1776. Other manuscripts were referred to with approval in library catalogues, and the great collectors, like Cotton whose books are now in the British Museum, regarded not only the early ones, but even those of the eleventh or twelfth centuries, as fully deserving their attention. In his enchanting book, *The Monasteries of the Levant,* first published in 1848, Robert Curzon gives some delightful accounts of his efforts to procure fine examples, and he writes with great appreciation of many of the eleventh- or twelfth-century examples that he saw, though he was not always able to obtain them. But he was no great admirer of the later wall paintings in the Byzantine style which he encountered in the monasteries of Mount Athos and the Meteora. 'I never saw a picture of a well-looking Greek Saint anywhere,' he wrote, 'and yet the earlier

24

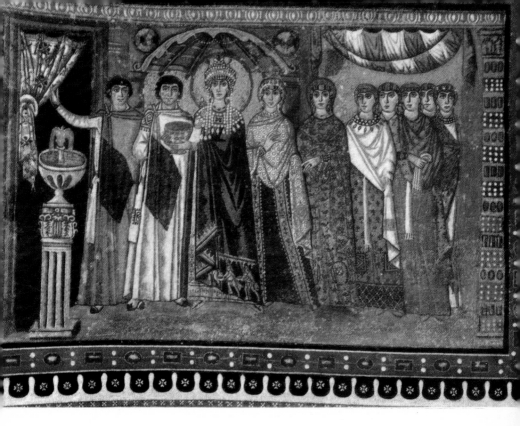

Greek artists in their conceptions of the personages of Holy Writ sometimes approached the sublime; and in the miniatures of some of the manuscripts written previous to the twelfth century, which I collected in the Levant, there are figures of surprising dignity and solemnity.' The manuscripts which he collected were much admired on his return; they eventually passed, along with the rest of his collection, to the British Museum.

Curzon, however, was a pioneer, and for a long time the manuscripts were not appreciated by more than a few men who, like him, were enthusiasts. Even the great mosaics in Rome and Ravenna, which were there for all to see, awoke but little interest. But one writer, Lord Lindsay, adopted a new outlook, for he put forward a surprisingly penetrating appreciation. The section devoted to Byzantine art, which is separate from that concerned with the Early Christian art of Rome, opens with the following paragraph:[1]

[1] Lord Lindsay, *The History of Christian Art*, Edinburgh, 2nd ed., 1885, vol. i, p. 239.

We are apt to think of the Byzantines as a race of dastards, effete and worn out in body and mind, bondsmen to tradition and circumstance, little, if at all, superior to the slaves of an oriental despotism—and that too from the very first hour of Constantine's migration to the Bosphorus. Yet even were such indiscriminate dispraise restricted to the latter ages of their decline, the heroic death of the last Constantine might warn us that men still survived, even in that hour of ruin, to speak the language and wield the sword of Greece, while throughout the whole period of their early history, the unbroken line of Christian Fathers, men of undoubted genius and of learning, to which the contemporary West presents but a feeble parallel, amply vindicate their intellectual character.

Lord Lindsay's book, the first critical study to be devoted to Byzantine art in Great Britain, was much admired by Ruskin. In writing of Byzantine architecture in *The Seven Lamps* (1880, iii, section 15) he notes this fact and adds that up to then Lord Lindsay was probably the only man to discern this excellence. For Ruskin, however, the most inspiring work was to be found in the ornamental sculpture and he praises the capitals of St. Mark's as 'barbaric in contrast to the Greek, perhaps, but possessed of an all-embracing power', and he goes on to describe their imagery as 'taken from the shadows of storms and hills and having fellowship with the night and day of the earth itself'.

Thirteen years earlier, in *The Stones of Venice,* he had referred to the quality of the low relief sculpture with equal enthusiasm. 'Those capitals,' he wrote, 'called barbarous by our architects, are without exception the most subtle pieces of composition in broad colour which I have met with in architecture.' The reference to colour is especially significant, for Ruskin is not referring to polychromy, but to the effect produced by a black and white design in low relief as opposed to sculpturesque modelling. His conclusions were of course reached on the evidence of work that he had seen in Italy and more especially in St. Mark's at Venice, but they are applicable to all Byzantine sculpture from Justinian's day onwards, and even Paul the Silentiary would not have described them in more glowing terms. St. Mark's, happily, contains a very full and representative series.

With regard to Byzantine architecture Ruskin's views were somewhat variable, as they were, indeed, on many branches of art, sometimes blowing hot and sometimes cold. In *The Seven Lamps* he concludes that the Byzantines built 'altogether from feeling, and that it was because they did so, that there is this marvellous life, changeful-

ness, and subtlety running through every arrangement' (v, section 16). In *The Stones of Venice* on the other hand (ii, p. 74) he says: 'We have to estimate the relation in which St. Mark's stands to those northern cathedrals that still retain so much of the power over the human heart which the Byzantine domes appear to have lost forever.' Admittedly Ruskin's first-hand knowledge of Byzantine architecture was limited to what he could have seen in Italy, and he describes as Byzantine a number of secular buildings in Venice which, if they are indeed to be counted as Byzantine at all, reflect only a very late phase of the style. One cannot avoid the comment that the dome was certainly Byzantium's greatest contribution to architecture, and the best of her domed buildings, of which St. Mark's may surely be counted as one, are possessed of an atmosphere of unworldly sublimity which is perhaps even more spiritually profound than that engendered by Gothic cathedrals, and is certainly in closer accord with the liturgy, for the enactment of which the buildings were conceived.

The mosaics of Venice, in St. Mark's and at Torcello, seem to have impressed Ruskin rather less than the sculptures. He praises them as a form of decoration admirably suited to curved vaults and domes, and cites in particular the semi-dome at the east end of the church at Torcello; the Byzantine architecture of Venice was surely conceived as a frame for a decoration of this character. But the mosaics seem, for Ruskin, to have had little more than a decorative significance and he does not have very much to say of them as works of art in their own right. Yet his understanding of Byzantine art was far from superficial and he went so far as to distinguish between the phases and styles of mid-Byzantine art—something that no other writer had contemplated—and he was the first to recognize that there was something of a revival under the Comnenes in the twelfth century; even more he attributed this to the genius and initiative of Constantinople itself, rather than to the influence of the West. In this respect he was a prophet well ahead of his time, for as late as the second quarter of the twentieth century such scholars as were prepared to accept that there was such a revival at all were prone to regard it as coming about almost wholly as the result of Italian inspiration.

But even with Ruskin to lead the van, appreciation of things Byzantine in Britain was well behind that in France. There Didron, as early as 1839, had spent week after week looking at later paintings and mosaics all over Greece, ending his journey on Mount Athos,

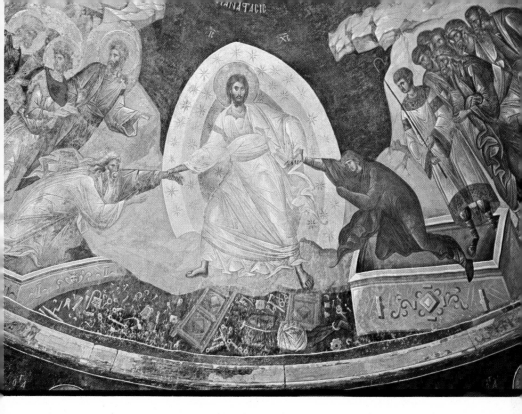

where he watched a monastic painter at work, recognizing that his
method can have differed but little from that practised in Byzantine
times. He also succeeded in obtaining a copy of a manuscript giving
instructions as to how paintings should be executed. He published it
in 1845, together with a sympathetic account of his study of the
paintings. He was one of the first to describe them as beautiful as well
as to point out that medieval work in the West owed a clear debt to
what had been done at an earlier stage in the Byzantine world.

It was, however, no doubt to a great extent as a result of Ruskin's
teaching that in England William Morris began to take an interest in
Byzantine art; and in due course he developed a very keen enthusiasm
for it, though it must be admitted that his ideas in this direction were
extremely muddled. That he admired the dexterity of the craftsman-
ship of the ivory carver or the textile weaver is not surprising, for
Morris was at heart above all a craftsman. And he was, in addition,
a convinced admirer of what he believed to be a universal medieval
conception, that of the craftsman working to produce the perfect

result to the greater glory of God. Byzantium was for him part of the medieval world, and when he said that 'Byzantine art was Gothic art re-born' he no doubt referred to this medievalism in both. Again he thought that Byzantine art, like the art of the Pre-Raphaelites, was firmly in the camp against the academic and the classical (*Collected Works*, xxii, p. 158); it was the early art of the fifteenth and fourteenth centuries in Italy that the Pre-Raphaelites admired, an art that was itself in many ways more closely akin to the Byzantine than to the later trends that developed after the Renaissance. But in spite of this Morris can hardly be claimed as an artist who was directly inspired by the Byzantine idiom, as his contemporary John Francis Bentley was when he built Westminster cathedral.

Though once more there is little evidence of an affection for Byzantine art in his work, the painter Burne-Jones was another great admirer of the Byzantine, especially as regards the mosaics, and he turned to mosaic, an essentially Byzantine technique, when he was asked to decorate the Anglican church in Rome. But Morris admired them too, seeing in them the crowning beauty of the most solemn buildings. 'Nothing more beautiful than the best Byzantine art,' he stated, 'has ever been produced by man.' For him the acme of that art was Hagia Sophia, 'the crown of all the great buildings of the world'. It is sad that he never actually saw it, but Fossati's plans and drawings had been available since 1852 and he possessed Salzenberg's book on Byzantine architecture.[1] The admirable study, *The Church of Sancta Sophia,* made by his friend W. R. Lethaby, in collaboration with Harold Swainson, was to be published in 1894, two years before Morris's death, but Lethaby must surely have discussed it with Morris at an earlier stage.

Morris, in any case during his earlier years, was an exception, for the ninth edition of the *Encyclopedia Britannica,* published in 1876, contained no entry on Byzantine art. There is a short section dealing with Byzantine historians, that is to say the Byzantine writers themselves, and there is a very brief entry on the early, but not the later, history of Byzantium. Constantinople itself, on the other hand, is dealt with fairly fully; there are reasonably complete accounts of the walls, of the layout of the city, of the site of the Great Palace and of the Hippodrome, and quite a penetrating, if unenthusiastic, description of Hagia Sophia. Other churches are accorded a summary mention; but surprisingly the mosaics of Kariye Camii (the church of

[1] I am lucky enough to own his copy.

the Chora) receive a warm, if brief, eulogy; the church is described as 'a gem of beauty, still even in its decay, rich with mosaics of the fourteenth century, of a style purer and more refined than that which is more often seen and admired at Ravenna and Palermo'. Under the heading 'Mosaics' there is a fuller entry, with a list of the monuments then known. Though at the outset it is stated that owing to the intense conservatism of Byzantine art no regular stages of progress can be traced, some attempt is made to distinguish the differences between the styles of the fifth, the ninth, and the fourteenth centuries; the work of the middle period is condemned as lacking in naturalistic feeling, whereas the best work is said to be that produced as a result of Italian influence in the fourteenth century. Though the reason given for this excellence can hardly be accepted today, the praise accorded to this last phase of Byzantine art indicates great perception on the part of the writer, for even the greatest experts were still condemning this late work as recently as the early twenties of the present century.

But the writer of this article, Henry Middleton, sometime Slade Professor at Cambridge, was an exception, as was W. R. Lethaby, the author of the first independent entry on 'Byzantine Art', which appeared only with the eleventh edition, published in 1910. Though comparatively short, this article was characterized by true appreciation and understanding and dealt with the subject as a whole, from architecture to the minor arts, even if, unlike Middleton, the author did not pay much attention to the paintings and mosaics of the last phase. More typical of the period was the attitude of W. Lübke, the author of an extensive general history of art published in 1869, who devoted only nine very uninformative pages to Byzantine art. He referred to its prevailing characteristics as dullness and stiffness, growing ever more pronounced as time went on. Writers on aesthetics supported the same outlook. C. L. Michelet thus stated that Byzantine art 'exhibits only the forms of the dogmas of the church, without infusing into them inwardness of soul.' He goes on to affirm that the art stiffens into lifelessness and aridity while the divine representations remain little better than shadows. The progress made in the spiritualization of the subjects in Italian painting is contrasted, a view which would surely be disputed by analysts today, even if Italian art is preferred from the artistic point of view. Hegel's accounts have adopted the same outlook and even so perceptive an authority as the great Burckhardt, in his *Age of Constantine the Great* (1852), had

pp. 32–3
Wall painting in the church of the Pantanassa, Mistra. The Raising of Lazarus. 1438. *Josephine Powell, Rome*

31

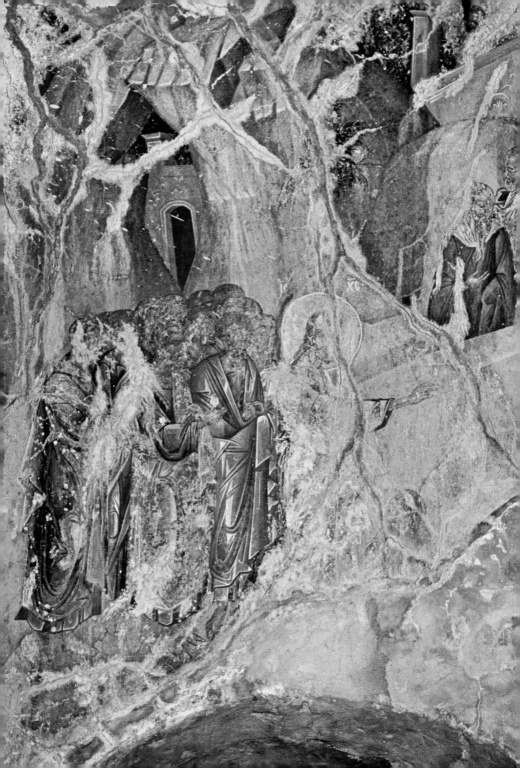

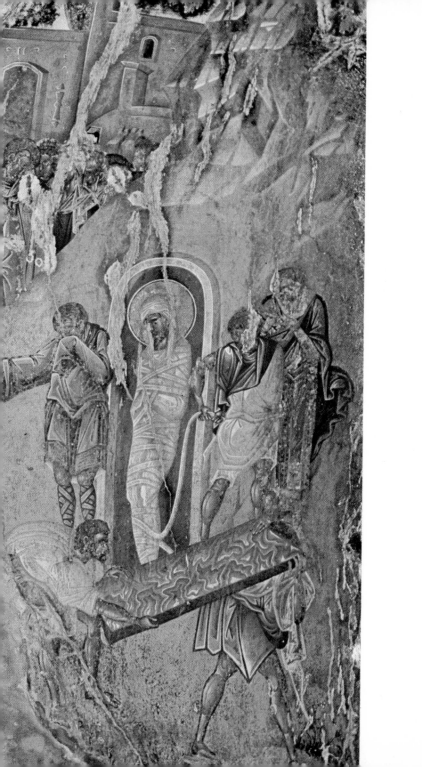

no more to say of the art than that in the religious sphere there was an incredible stubbornness in the constant repetition of obsolete motifs.

It was perhaps thanks to some extent to his friendship with Morris, rather than to the perusal of the works of such supposedly learned writers, that W. R. Lethaby was drawn to Byzantium. He too was a convinced medievalist and like Morris he combined his enthusiasm for the Byzantine with that for the Gothic world. In the preface to his *Medieval Art* he enunciated this quite clearly: 'In briefest summary there are two chief styles of medieval art to be dealt with in these pages, the eastward culmination, or the Byzantine school and the western, or Gothic.' Unlike Morris he was a scholar and sought to substantiate his ideas and theories by a thorough investigation of the monuments themselves, and he visited many of the buildings about which he wrote. Indeed, after Texier and Pullan and Finlay he was one of the first to pay attention to Asia Minor and Syria, and he was certainly the first person in this country to appreciate the importance of the role of the Near East. He looked upon Romanesque and Gothic as the final expressions of a vital trend which was conceived in the Near East in the early days of Christianity.

Lethaby, though a writer of some genius, was really primarily an architect and his outlook represents that of a few men trained in the same profession at the turn of the century. They were men in a minority who, so far as their understanding of things Byzantine was concerned, were in advance of their age. Before speaking of them, however, we must note how the very name of Byzantium had begun to appeal to a number of figures in the literary field for very different reasons.[1] Oscar Wilde and John Addington Symonds were both enthusiastic about Ravenna, and the latter spoke in glowing terms of Hagia Sophia. A generation later W. B. Yeats made Byzantium the theme of two of his most lovely poems. The conception of decadence and double dealing, of bloodshed and dishonesty, so much to the fore in people's minds at the middle of the century, had been to a great extent obliterated; the emperor of Byzantium had become a benign character, delighting in the products of his goldsmiths. For Yeats at least it was the glory of the arts on a small scale and the skill of the craftsmen who fashioned them that assumed a primary place. 'The

[1] I would here express my indebtedness to an article by Mr. J. McAlindon entitled 'The Idea of Byzantium in William Morris and W. B. Yeats', in *Modern Philology*, May 1967, p. 307.

image maker, who first put Christ upon the Cross', the goldsmiths who could make 'the Lords and Ladies of Byzantium think on what was past, or passing, or to come' were in his view to be numbered amongst those who had left the most glorious legacy from the past.

The year 1900 really marks a turning point, and in the field of scholarship a whole series of persons who may truly be termed Byzantinists appear on the scene. By that time several Byzantine historians had produced books of real significance, characterized by balanced historical scholarship rather than by preconceived ideas. It must suffice to mention the names of J. B. Bury in Britain and Charles Diehl in France, both of whom set out with the object of re-estimating the evidence and inquiring whether the Byzantine age was in reality one of sterility or continuous decline. Both these men, and others of their generation too, were to devote themselves with a lifelong enthusiasm to the study of the Byzantine world and, in Diehl's case, to that of its art also. But even so it was really not till late in the first quarter of the twentieth century that Byzantine history came to be studied at all widely. In the preface to his *History of the Eastern Roman Empire,* published in 1912, Bury stated that it was still quite impossible to contemplate writing a history of Byzantine civilization as a whole; it was essential to wait until each successive period had been exhaustively studied in and for itself. And as late as 1929 in his book *The Byzantine Achievement* Robert Byron was inveighing against the outlook of 'triumphant reason' that had hampered his studies at Oxford and which still pertained well nigh universally and prevented a true understanding of the Byzantine mind. In spite of the work of the pioneers it was not till the second half of the twentieth century that the study of Byzantine history began to find a place in the curriculum of British universities.

The study of Byzantine literature—though it must be admitted that as a subject it is less fruitful than Byzantine history or Byzantine art— ran as a very poor competitor. In Britain the writings of the early historians had of course served the scholars, but the literature itself received little attention except among theologians. On the Continent more progress had been made, notably in the publication of K. Krumbacher's great *Geschichte der byzantinischen Litteratur* in 1897. We have had to wait till after the middle of the twentieth century for English translations of the books of the more literary writers like Anna Comnena, who produced a vivid account of the life of her father, Alexios Comnenos. As Mr. Sewter wrote in the preface to his

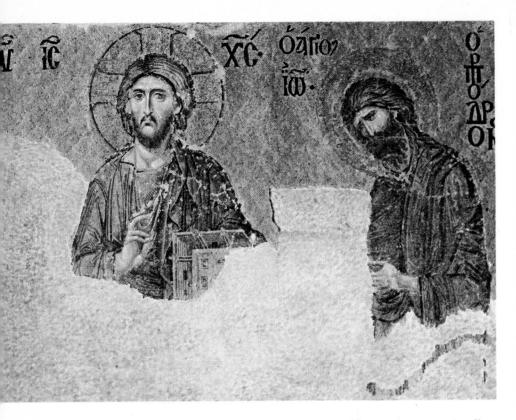

Detail from
mosaic panel in the
church of Hagia Sophia,
Constantinople. The
Deesis. Probably *c.* 1130.
Hirmer Fotoarchiv Munchen

translation of Psellus (London, 1966): 'Fifty years ago any schoolboy who professed admiration for things Byzantine would almost certainly have been seriously reprimanded.' And without some understanding of both literature and art, in addition to a detailed knowledge of history, how could a study of the civilization by undertaken?

Nevertheless a leading Russian scholar, Theodore Uspenskij, set out on such a task, and the first volume of his epic undertaking appeared in 1912. The Russian Revolution was to delay the completion of its publication until 1948. Here was a first attempt to write the story of the civilization as a whole, and it was fitting that this attempt was first made in Russia, for was not Moscow the successor of Byzantium, the third Rome, and had not Russia become virtually the direct heir of Byzantine culture? The universal character of his approach was paralleled in France with regard to a rather more limited period by Gustave Schlumberger.

Two other excellent general histories by scholars of Russian

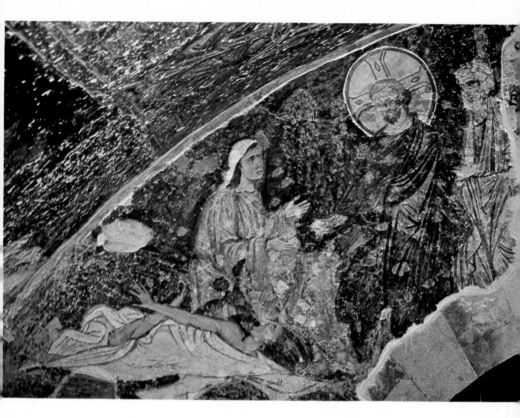

origin were to follow, though they wrote in exile, namely A. A.
Vasiliev, with his *History of the Byzantine Empire*, first published in
1928, and George Ostrogorsky, with his *History of the Byzantine State*,
first published in German in 1940, but subsequently reissued both in
German and English on several occasions. But it was probably the
English scholar Norman Baynes who, in a short lecture delivered in
1945, succeeded in penetrating most deeply into the heart of what he
called the Byzantine thought-world. This brilliant little essay was
made more widely available with the publication of Baynes's collected
works under the title *Byzantine Studies and Other Essays* in 1955.

If the Russian scholar Uspenskij was to lead the van in the sphere
of general history, another Russian, N. P. Kondakov, was the first to
attempt a general work on Byzantine art. His *Histoire de l'art byzantin
considéré principalement dans les miniatures* was published in 1891, and
even before then he had been responsible for several important essays
published in Russian. He was to remain the doyen in the study of

Byzantine art and archaeology till his death in 1925, and to inspire scholars in the study of the subject the world over.

In Britain the first aspect of Byzantine art to be seriously studied was architecture. Lethaby and Swainson had published their book on Hagia Sophia in 1894 and several scholars had begun to seek out Byzantine buildings and sites in Asia Minor and Greece at much the same time. In 1908 these men, under the leadership of Edwin Freshfield, banded themselves together to institute the Byzantine Research Fund, the object of which was to facilitate the first-hand study of Byzantine monuments in the field. At much the same date similar efforts were being made in France and Germany, and in the four or five years before the beginning of the First World War a great deal of important work was put in hand, even if its publication sometimes took place very belatedly. In England the Byzantine Research Fund was responsible for issuing four fine volumes, the last of which appeared in 1920. But the war had made finance difficult, and the Fund was never revived after its close.

By the second decade of the century learned articles on various aspects of Byzantine art had begun to appear in art periodicals, but the first serious general work to be attempted in England was Dalton's *Byzantine Art and Archaeology,* issued in 1911. It remains a standard work, essential for any serious research in virtually the whole field of study. In France Diehl's *Manuel de l'art byzantin* appeared in 1910, while in Germany Wulff's *Altchristliche und Byzantinische Kunst* followed in 1914. One might almost have asserted that the day had been won and that full acknowledgement of the qualities and importance of Byzantine art had been recognized. But still in 1928 the Professor of Classical Art at Oxford, P. Gardiner, who produced a book on *The Principles of Christian Art,* was writing critically and coldly of the early mosaics. He even took Professor Baldwin Brown to task for speaking with enthusiasm about those of Sta. Pudenziana, while of the later manifestations he said:

I need not further dwell on the art of Byzantium and Ravenna, remarkable as it is from some points of view, and greatly as it is admired by some critics. It is essentially a petrified art, reaching a high standard in its own way, but destitute of all Christian life. It belongs to a different world from ours. The art of the Eastern Church, held down by Turkish domination and Czarist despotism, has been unable to grow. In saying this I do not call in question the genuine piety of the peasantry and the self-devotion of the priests of Eastern Europe, but only point out that their religion has not found characteristic expression in art.

And later still, in 1935, D. M. Robb, in his book *Art in the Western World,* a volume of 1,000 tightly packed pages, devoted no more than three of them to the Byzantine style.

But nevertheless an appreciation of Byzantine art, not only of architecture and craftsmanship, was gradually increasing. As early as 1902 Sir Martin Conway referred to dignity and refinement as the main characteristics of the Byzantine style and stated that 'there is no stiffness in a Byzantine figure of the good period; the stiffness in works of the Byzantine style is a quality applied by western workmen attempting to imitate the grave formality of the East' (*Early Tuscan Art,* p. 13). Other critics supported his view, while artists themselves found in Byzantine art of the middle period inspiration for their own works; one need only mention Rouault in France and Mestrović in Yugoslavia. Like their own art, that of Byzantium had sought to interpret inner thought, to penetrate to the spiritual essence of things; as Roger Fry put it, 'It had great power in penetrating to the inner recesses of thought' (*Transformations,* 1926, p. 78).

So much for the art of the Second Golden Age (843–1204). But what of that of the last phase, the age between the crusading conquest in 1204 and the Turkish conquest in 1453? Peirce and Tyler, ardent devotees of early and mid-Byzantine art though they were, were still writing in their little book, *Byzantine Art,* published in 1926, that 'the manner grows dry and hard before the twelfth century is half over, and although a few new ideas are seen stirring in the thirteenth and fourteenth centuries, the story of Byzantine art really ends with the sack of Constantinople by the Franks in 1204.' No description could be less applicable to the mosaics of Kariye Camii, admired already half a century earlier by Professor Middleton in his article on Constantinople in the ninth edition of the *Encyclopedia Britannica.* But even while Peirce and Tyler were writing the outlook towards the later phases was changing. Paul Muratov in his *La Peinture byzantine* (1928) had recognized this and had stressed the importance of what later came to be known as the Twelfth-Century Renaissance, and appreciation developed apace thanks to the discovery of a number of important paintings which had till then lain hidden beneath coats of whitewash or plaster, most of it added when churches in Greece and the Balkans had been converted to the worship of Islam after the Turkish conquest of the mid-fifteenth century. If the works of these later phases usually took the form of paintings rather than the more sumptuous mosaics or treasures of the middle period it was rapidly

Wall painting at
Sopoćani, Serbia. The
Nativity. *c.* 1260.
Josephine Powell, Rome

coming to be realized that their artistic merits were not necessarily any less considerable.

Truly serious inquiry into the nature of the art of this last phase had been set on foot by the French scholar Gabriel Millet, who since the tail end of the nineteenth century had undertaken a number of journeys in Greece and the Balkans. It has continued ever since, with increasing vigour as the young nations of eastern Europe have gradually become conscious of the artistic heritage in their own lands. Today not only are the mosaics of Kariye Camii at Constantinople enjoyed by increasing numbers of visitors, but also an admirable series of wall paintings of the same date have been laid bare beside them, while the paintings of Mistra in the Peloponnese, first noticed by Millet, now draw almost as many visitors as do the classical monuments. In Greece, Yugoslavia, Bulgaria, Romania, and the U.S.S.R. works in the Byzantine style, some of them actually by

40

painters of Constantinopolitan origin or coming from one of the other main centres of Byzantine culture, form a nucleus for the attraction of tourists and the subject-matter for the letterpress and the plates of numerous state-sponsored publications.

The attraction that is exercised today by the paintings of this last period is perhaps to some extent to be attributed to the fact that it is something new and unfamiliar, that it is unusual, and that it is mostly to be met with in places which are immensely attractive in themselves. But it lies too, in the fact that this late Byzantine art, like the art of today, attempted through formalism, symbolism, and colour, to substitute true insight for mere surface representation.

To understand this art, as indeed nearly all Byzantine art, to the full, however, it is necessary to attempt to penetrate more deeply into the nature of the Byzantine thought-world. The stress on 'triumphant reason' which governed the outlook of the nineteenth century was inimical to any such attempt. Reason as such counted for little in the Byzantine world. Its place was taken by faith—faith in the workings of a divine power which could aid Justinian to rebuild Hagia Sophia in the astonishingly short period of five years, eleven months, and ten days, that could bring a pestilence that would free the city from the menace of an Arab attack in the eighth century, or that could provoke a storm that would wreck the fleet of a Russian attacker in the tenth. It is impossible to penetrate the nature of the Byzantine outlook unless their belief in the miraculous is regarded with sympathetic understanding, and it is equally impossible to understand the art if insistence is laid on material exactitude or pure representation for its own sake. The fact that the critics and writers of the nineteenth century first gave credit to the architecture is not surprising; many of its merits were of a concrete nature and it could be appreciated for its functional qualities. Had more works of the secular art survived, appreciation there would doubtless also have come more quickly, for taken as a whole secular art was more straightforward and followed more clearly the classical norms and it was also not difficult to appreciate the technical excellence of the minor arts, the exquisite delicacy of the ivory carvings, the superb ingenuity of the textile weavings, or the glories of the metal work. But to accept the stylization, the absence of any search for illusionism, the formal lines and the near abstractions of the mosaics and the paintings was something that called for a more profound, more penetrating approach.

Only when the art of the day began to change, when new criteria of vision had been developed thanks to the experiments of a Rouault in the interpretation of the stress laid on inner significance, of a Cézanne in the beauty of formal pattern, or of a Gauguin in the expression of form and meaning through colour, was man in the West ready to look at Byzantine art through appropriately adjusted spectacles. Yet even so, something was still lacking—the eye of faith. Today many believe, or at least hope, that some answer to the riddle of life may be provided by scientific discovery. The Byzantines placed their trust in Christ, believing that only in faith was an ultimate answer to be found, and they firmly believed that art was a vehicle towards this realization. Nineteenth-century rationalism could not accept such a view or even attempt to meet it half way. Today our outlook may be more materialistic, yet we have learnt to accept, even at times to approve, the outlook of others and at least we now know how to perceive in a new and distinct idiom.

'Byzantine Art—a European Art'. This was the title of the great exhibition of Byzantine art held at Athens in 1964. Was this a clear and just description of the art? A cursory glance at the map suggests that a large question mark should be added at the end of the statement, for in early times the empire extended far into Asia, to the confines of Persia and Mesopotamia in the east, into Africa, to the fringe of the Sahara in the south, while in Europe it embraced the much smaller area of the Balkans, Italy, Spain, and southern Gaul. Thus, so far as geography is concerned, a good deal less than half the empire lay actually within Europe and quite early in the day barbarian tribes began to advance into the more westerly areas and the western Balkans and northern Italy fell away very quickly. Even Justinian's expansionist policy was unsuccessful in reclaiming more than a part of this territory, and with his death much of it again passed to barbarian control. Thereafter North Africa, Egypt, and Syria were to remain important sections of the empire for another century, till they were surrendered to Islam just before the middle of the seventh century. The great cities of Egypt and Syria, notably Alexandria and Antioch, had in fact been more influential in building up Byzantine culture than any in the west except Rome, while the role of the great towns of Asia Minor, such as Ephesus, was fundamental in the development of Christian teaching. The upland area of Asia Minor, which remained in Byzantine hands till conquered by the Seljuk Turks in 1071, was indeed the real heart of the empire and during the centuries that elapsed between 500 and 1071 it was not only more stable than the Balkans, but was also a more important source of agricultural and mineral wealth as well as of manpower. Even after the conquests of 1071 parts of the coastal fringe still remained Byzantine till the collapse of 1204 and it was at Trebizond in the north and Nicaea in the west of Asia Minor that were situated the most effective centres of resistance during the time that Constantinople was in the hands of the crusaders, that is to say from 1204 until 1261.

In sheer surface area the territories outside Europe thus exceeded those within, and in many ways they were more significant and more important. It is of course true to say that except for Alexandria the role of Africa was not a creative one, but this was not the case with

regard to hither Asia.

If geography alone could determine the answer to the question whether Byzantine art was a European art, it would thus surely be in the negative. But it must be remembered that practically the whole of this area had long been subject to the influence of classical culture. The coastlands of Asia Minor were wholly Greek while the uplands and Syrian-Palestine had for several centuries been a part of the great Roman empire; Alexandria and Antioch were dominated by a Hellenistic make-up, and the coastlands of Asia Minor had been almost as influential in the formation of Greek culture as had been the city-states of Greece itself. If European art as we know it is to be classed as the child of classical art—and this is what the term 'Renaissance' implies even if the barbarian invasions did interrupt the progress of development between classical times and the fourteenth century—Byzantine art was surely born of the same parentage. But just as the arts of Europe in the Northumbrian, in the Carolingian, and in the Ottonian phases, or those of France and Italy before about 1000, were subjected to a number of diverse influences which made each of them a distinctive art in its own right even after the Renaissance, so also was Byzantine art affected by elements other than the purely classical: as Diehl once wrote, Byzantine art was the outcome of a triple fusion, in the making of which the classical heritage, the outlook of the East, and the Christian faith all played a part. In this chapter it will be our aim to analyse the respective contributions of the first two of these elements by the application of what may be called the clinical method; the contribution of Christianity will be considered both here and sporadically throughout the book. Our survey will begin with a study of the classical contribution.

The city of Constantinople, founded by Constantine in 330, was thus conceived as the successor of Rome; it was built on the model of the old capital, under the direction of craftsmen who had mostly been trained in Rome, and almost till the end it continued to be referred to as Rum (Rome). This word indeed came to be universally adopted as the name by which not only the city but also the central portion of the Byzantine world was known. In Islamic times it was even adopted all over the Near East as a general designation for Christians of the Orthodox faith as apposed to the 'Franks' from the west. The language of the new city was Latin, and Latin remained the official tongue for at least three centuries till it was finally replaced by Greek, the language of the indigenous population. Such influences

44

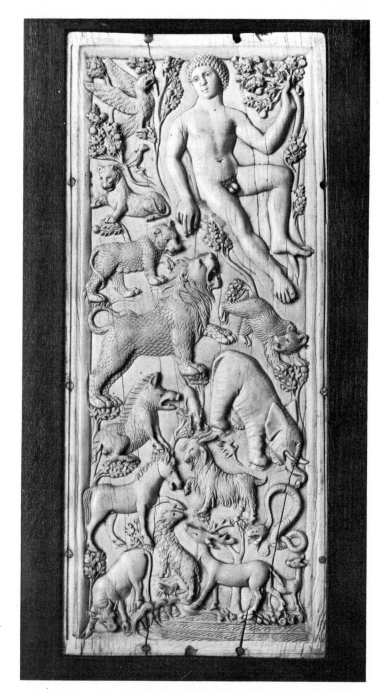

Ivory. Adam in Paradise.
Sixth century. In the
Museo Nazionale,
Florence. *Hirmer
Fotoarchiv München*

as were brought to bear on the development of the city's culture by the locality were Greek, for the old Byzantium which Constantinople replaced had been a Greek city, founded many centuries earlier by colonists from Megara. Today the Greeks of Greece look upon themselves as the direct heirs of the Byzantines, and through them of the Greeks of the classical age.

The mere fact of the acceptance of Christianity by Constantine in 313 and its adoption as the official faith about a century later at first exercised no very great influence on art. New and wholly Christian themes in art had already been developed during Roman paganism from the second century onwards, and classical motifs were simply given a fresh look in the service of the new religion. Adam in Paradise, as we see him on an ivory of the fifth century now in the Museo 45 Nazionale at Florence, was clearly modelled on the classical theme of Orpheus; Christ, beardless and youthful, took on the physiognomy of Apollo; the figure of Samson or David struggling with a lion recalled the most usual depiction of Heracles; the apostles as we see them on Roman sarcophagi have the appearance of the philosophers so usual in Roman sculpture. Even if new and wholly Christian sub-

Silk textile. Sampson and the lion. Late eighth century. *Victoria and Albert Museum, London: Crown Copyright*

46

jects were in due course introduced, artistic styles proper to late
classical art lived on. Thus a considerable group of sculptures exe-
cuted for Christian patrons in Constantinople in the fifth century has
aptly been described as Neo-Attic—a lovely child's sarcophagus
bearing angels on its side from the Sariguzel region of the city affords
a good example of the clear-cut, precise manner of this style—while
manuscript illustrations done as late as the tenth century frequently
followed classical models.

Stemming again from a classical source is the theme of the pic-
turesque landscape as we see it in some of the earlier mosaics in St. 48
Demetrius at Salonica; while what may most satisfactorily be termed
the 'architecturescapes' that were so popular as the background for
other scenes, for example in the apse of Sta. Pudenziana in Rome,
were derived from the same source. These 'architecturescapes' appear
again in numerous fully-fledged Byzantine manuscripts, as well as in
the mosaic decorations of the Baptistery of the Orthodox at Ravenna 49
and, on a larger scale, in that of the so-called church of St. George 50
at Salonica. Here there are figures with arms raised in prayer before
the buildings, but in the mosaics of the courtyard of the Great Mosque
at Damascus, erected for the Islamic caliph al Walid in 715 with the
aid of Byzantine craftsmen, picturesque landscapes, and 'architec-
turescapes' are blended to form an outstandingly effective non-figural
decoration. They might well be described as the very acme of Icono-
clast art.

If classical figures and classical themes were important in the early
religious art of Byzantium, they were even more to the fore in secular
art. It would indeed be true to say that until the seventh century
Byzantine secular art was virtually wholly classical both in theme and
in style, and in this sphere the classical themes continued to dominate

47

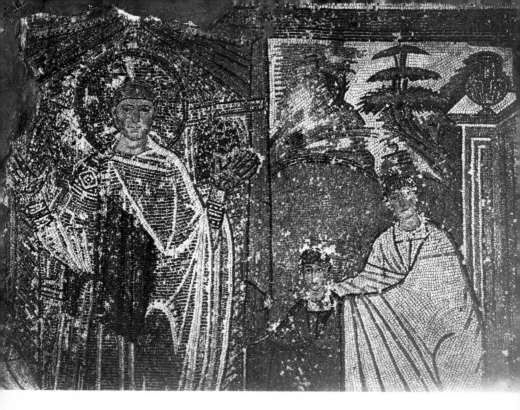

above
Mosaic. On the west wall
of the church of St.
Demetrius, Salonica.
Sixth century. *Photo
Lykides*
right
Mosaics in the Baptistery
of the Orthodox,
Ravenna. *c.* 450. *Mansell
Collection*

for many centuries to come. One has only to glance at the array of
silver plates produced in the imperial workshops of the capital, at the
secular ivories, carved perhaps in Alexandria, or at the mosaic floors
like that of the Great Palace at Constantinople. When the collection
of silver dishes in the Hermitage at Leningrad was first published by 52
Matzulewitsch in 1929 the term 'Byzantinische-antike' (the Byzan-
tine antique) was coined to describe them, and it is equally applicable
to many of the mosaic floors laid between about 400 and 700, as well 53
as to the secular ivories. And in passing one may note that imperial
portrait sculpture of a wholly classical type was still popular till
Justinian's day, while such forms as the triumphal arch or the column
with reliefs set spirally up its surface, as on Trajan's column at Rome,
were used in Constantinople on more than one occasion. Nor is it
really necessary to call attention to the survival of the scroll, the egg-
and-dart pattern, the acanthus leaf, and other classical motifs as
subjects for architectural ornament throughout the whole of the
Byzantine era.

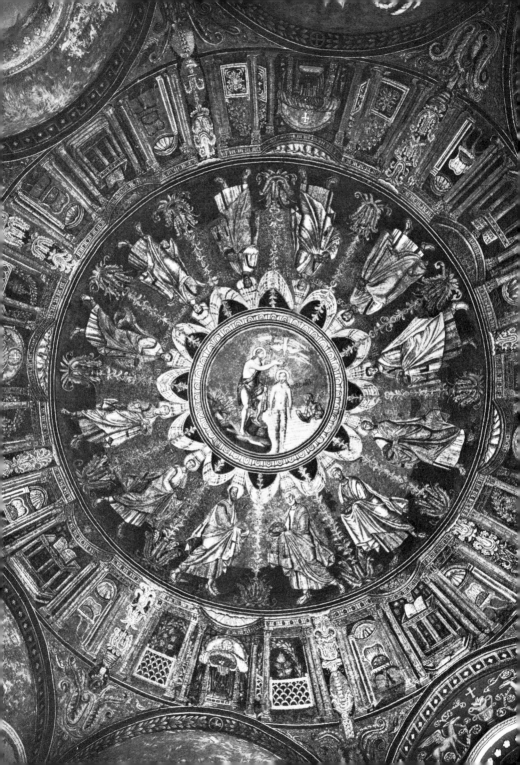

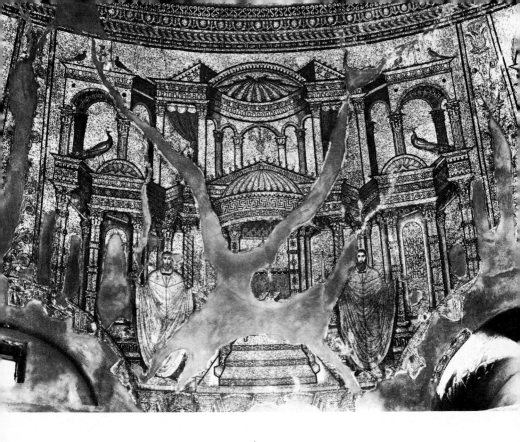

Classical themes continued to be of the greatest importance in
secular art even after Iconoclasm (726–843). A volume of Nicandor's
book on the medicinal properties of plants, now in the Bibliothèque
Nationale in Paris, may be cited because of its wholly classical illus-
trations, and those in other medical works or books on the chase, like
the Pseudo-Oppian in St. Mark's library at Venice, are similar in
style. Again a series of ivory caskets, intended presumably as jewel
caskets, were adorned with classical themes; there is a good example
with a battle scene in the Cluny Museum in Paris, though the Veroli
casket in the Victoria and Albert Museum in London is perhaps 54
better known. It bears such classical scenes as a Bacchic procession
and Europa on her bull, though strangely this has strayed into the
scene of the stoning of Achan from the Book of Joshua! Further, we
know from literary sources that classical texts formed the principal

50

subject for study in the universities and that they were also generally familiar to a wide circle of readers; how else could the import of the quotation of a few words from the *Iliad* (iii, 156) have been universally understood when they were spoken by one of the crowd as the emperor Constantine IX rode home through the streets with his beautiful Caucasian bride? 'It were no shame,' the man shouted, and at once Homer's words served to conjure up the picture of the war that raged at Troy because of the beauty of Helen.

Motifs of a classical origin in any case continued in use right to the end; they were an essential element in what little secular art we know from later times and were also important in religious art, notably in costumes and in the employment of allegorical figures of classical character to symbolize natural features. Thus the river Jordan in the Baptism scene almost invariably includes a depiction of a river god, 49 while night is symbolized by a tall woman with a shawl over her head, holding an extinguished torch, and dawn by a cherub bearing a burning torch. Attention may be drawn to the figure of an old man pouring water out of a large pot in the Baptism scene in the Baptistery of the Orthodox at Ravenna in early times and to similar ones in many of the wall paintings and icons painted as late as the seventeenth 55 century. The costumes worn by Christ and his followers continued to follow classical models even after 1453, the draperies often being rendered with all the elegance of an Attic statue; often they suggest an almost conscious copying of earlier models—how else could one account for the marked similarity between the Angel of the Resur- 56 rection in the wall paintings of 1235 at Mileševa in Yugoslavia and that in Sta. Maria Antiqua at Rome, painted in the seventh century, 57 in all probability by an artist from Alexandria where art of a very classical character survived with exceptional purity till a later date than elsewhere? The same classical style is to be found indeed in works even later than the paintings at Mileševa, for example in sculptures in the church of the Saviour in Chora (Kariye Camii) at Constanti- 58 nople, executed in the early fourteenth century. We see there something of a return to the fully modelled naturalism of late Roman or Hellenistic art.

The great importance of the classical heritage throughout the whole of Byzantine art is thus not to be disputed. But, as we attempted to show in the first chapter, Byzantine art was not just late classical art revived; it was something new and distinctive in its own right, and other elements had a very vital part to play in addition to that of

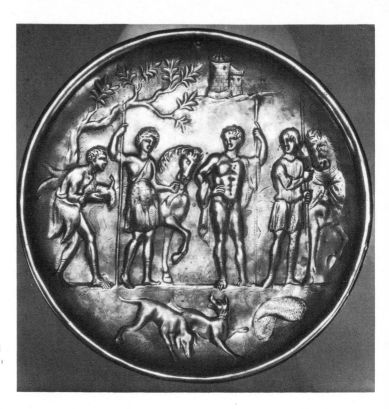

Silver plate. Meleager and Atalante. 610–29. *The Hermitage Museum, Leningrad*

Mosaic floor, from the Great Palace of the Byzantine Emperors, Constantinople. Sixth century

classicism. At the outset of this chapter we grouped them under the general heading of 'the East', but here we must be rather more specific and attempt to differentiate between various aspects of this eastern stream. We may begin our survey with a consideration of the role played by Asia Minor, that is to say the geographical area that today constitutes modern Turkey in Asia.

Important developments in architecture had been taking place there in the early centuries of the Christian era which were distinct from and in some ways in advance of those that took place in Rome. Attention was drawn to the region by the Austrian scholar Strzygowski in an epoch-making work, *Orient oder Rom,* published in 1900. He insisted that it was in Asia Minor that progressive developments with regard to domical architecture were first enacted, for he believed that it was in that area or in Syria that the problem of setting a dome above a square base was first solved. It is in any case to that region that we must look for the development of the most efficient means

of transition between the square substructure and the circular base
of the dome, namely the spherical triangular pendentive. Though
Justinian's great buildings no doubt owe something to Roman
prototypes, it was, Strzygowski maintained, in Asia Minor and
northern Syria that the idea of roofing anything other than a circular
building with a dome was first conceived, and it was from there that
the idea came to Byzantium. We must not forget that the architects
of Hagia Sophia, Anthemius of Tralles and Isidore of Miletus, both
came from the region of Ephesus in Asia Minor, and it was probably
there that their first buildings were set up.

So far as the development of pictorial art was concerned, however,
it would seem that Syria played a more important role than Asia
Minor, even if the influence she exercised was, in early times, of an
indirect rather than of a direct or concrete character. In fact the phase
of indirect influence actually began well before the recognition of
Christianity by Constantine. During the early centuries of the

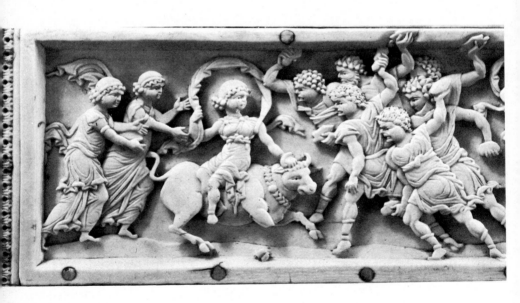

Christian era certain rather esoteric ideas in art had been reaching the West which were clearly opposed to those of the classical outlook. They were introduced along with the Eastern religions like Mithraism and Gnosticism, and, indeed, Christianity itself. They were flavoured by something different from, even opposed to, the tenets of idealism and surface beauty that characterized later classical art. They sought for a more intense expression of inward thought and laid stress on a more mystic outlook, and they made use of formal poses, stylized figures, and even severely exaggerated forms in order to achieve these objectives. The effects that these ideas were exercising had already begun to influence the art of pagan Rome by the second century; they constituted an important element in Mithraic art and in the budding art of the Christian minority population.

The story of the development of this mystic style may be begun with a monument set up by the Arsacid ruler Antiochus I of Commagene (60–34 B.C.) at a place called Nimrud Dagh, on the slopes of the southern Taurus mountains. It consists of a rock relief in which the king is depicted taking the hand of Mithra. The heads of the various

Sculptured tomb niche,
Kariye Camii,
Constantinople.
Fourteenth century

figures are shown in profile, the bodies in three-quarter view; they are all clothed in stiff, formal costumes, and the whole relief is imbued with an atmosphere of ritualistic mysticism which is entirely foreign to the spirit of Hellenistic art, with its love of naturalism, or of Roman art, with its interest in exact observation and prosaic narrative. Rather the art seeks to convey the immaterial element of divine power and the intensive fervour of the earthly worshipper. Certain conventions, certain idioms, have been developed to this end, notably a linear, rather two-dimensional style and a hieratic arrangement of the figures. Soon, in later Parthian times, was to be added the convention of frontality, intended to ensure a direct contact between the divine image and the worshipper and to intensify the other-worldly character of the theme. Later again the low relief, silhouette character of ornamental sculpture became associated with these other stylistic factors, to produce an essentially formal, semi-abstract, and very expressive, if crude, style. It was an art of this type that became dominant in Syria and northern Mesopotamia around the third century and which even remained important after the Islamic conquest of the area; it also affected developments in places very far afield, from Rome in the west to Afghanistan in the east and from Egypt in the south to Russia in the north. In the Syrian area the style was first defined by Rostovtzev as the 'Parthian', on the evidence of material discovered during the American excavations conducted between the two world wars at Dura on the middle Euphrates, but the term is not wholly satisfactory for in the art of the Parthian era frontality was not universal. It would be perhaps better to term it the 'Syrian style'.

Antiochus had sought to bring cohesion to the diverse faiths which existed in his realm and to blend as far as was possible the extrovert paganism of the classical world with the more searching, introspective faiths of Syria, Mesopotamia, and Iran. The attempt did not lead to greater clarity, but rather to the growth of the mystic conception in religion and an increase in the popularity of Mithraism and Gnosticism throughout the Roman empire. These beliefs even penetrated as far to the west as Britain. At the same time the style in art associated with the relief at Nimrud Dagh began to affect most of the monuments set up in Syria, notably the sculptures of Palmyra. By 264 A.D. practically the whole of Syria was under the control of Odenathus II of Palmyra and his famous queen, Zenobia, and this did much to propagate the popularity of the Palmyrene style. When the

Silver paten from
Lampsacus. Sixth century.
In the Museum of
Antiquities, Istanbul.
Hirmer Fotoarchiv München

Palmyrene empire fell to Rome, its art continued in being and its style even affected the art of the more developed and sophisticated cities of the region, of which Antioch was the most important.

We can picture both the way of life and the various influences that were exercised on artistic developments at Antioch thanks to the results of excavations carried out there by a joint Franco-American expedition in the years between the two wars, for a remarkable series of mosaic floors was unearthed, dating from the second to the sixth century. In the earlier period the style seen in the floors of the more important villas was predominantly Roman; in those of a rather later date the stylization proper to the Syrian manner was very much more marked. Thus in the hunting scenes, which formed the most popular

theme from the fifth century onwards, frontal poses were adopted for most of the figures, and the expressions were given a far-away look, while in the emblema—that is to say the panel that occupies the centres of the more formal floors—the figures were rigid and severe. In some floors of the third century at Edessa, further to the north, the Syrian style was expressed to an even more marked degree. The work there is on the whole rather clumsier than that at Antioch, but the figures are strangely compelling in their intensity, and the effect is almost hypnotic, aiming to achieve a mystic union of the dead with the divine.

More important from our point of view are the wall paintings which have been unearthed at Dura. First must be mentioned those from the Temple of the Palmyrene Gods, dating from 85 A.D., where a ritual scene is depicted with rigid formalism. Breasted, who was the first to publish these paintings fully, entitled his book *Oriental Forerunners of Byzantine Painting,* and no more apposite description could have been found. All the features that characterize these paintings— the rigid poses, the formal attitudes, and the intensely spiritual conception—are factors which reappear time and again in Byzantine art, from the famous panels of Justinian and Theodora in San Vitale at 25 Ravenna to the long arrays of saints who occupy the lower registers of the walls in numerous mid-Byzantine churches. Though they are rather less formal, the paintings on the walls of a synagogue and a Christian church, dating from around 245 A.D., which were also unearthed at Dura, are also important from our point of view. The figures are rather dumpy in contrast to those in the Temple of the Palmyrene Gods, but they are expressive and have the same basically spiritual character.

It is in many ways surprising to find a synagogue decorated with a series of representational narrative scenes depicting Old Testament subjects, when both at an earlier date and later Jewish art was normally aniconic, and the close similarity that these paintings bear to those in the church suggests that both were inspired by similar models. Perhaps they were drawn from some early manuscript of the Pentateuch, which was common to both faiths and was copied even before the Christian era. The illustrations of the famous Ashburnham Pentateuch are similar, and probably represent a Western variant derived from the same basic model.

As in all the work of the Syrian style, classical elements are present in these wall paintings, and in his study of the synagogue paintings

Kraeling calls attention to the presence of figures of the Greek 'philosopher' type, as well as to the inclusion of mythological figures such as Nike and Persephone. The fact that cast shadows are included also belongs to the Hellenistic tradition, for in the East they were avoided along with anything else that might help to increase a three-dimensional illusion. Some of the weapons are also of Greek type. But these elements are on the whole subordinate to the Syrian ones to be seen in the two-dimensional conception, the linear style, an absence of interest in naturalism, and in a well-nigh universal adoption of the frontal pose.

The stress on inner significance that characterizes the Syrian style was also dominant in the teaching of the religious schools of Nisibis and Edessa. Here it was the importance of the inner life that was stressed in opposition to the pagan love of the material world, and from the fourth century onwards until the time of Iconoclasm there was a virtual tug-of-war between the two outlooks. Its vehemence is attested both in the literature and in the art of the times; one need only cite in illustration of this such works as the mosaic in the apse of SS. Cosmo and Damian at Rome (526–30), where the rendering of Christ is imbued with all the mysticism of a Semitic Jahweh, or two silver dishes, one from Riha on the Orontes in Syria, now at Dumbarton Oaks, and the other from the Struma, now in the Museum of 60 Antiquities at Istanbul; on both, the figures are forceful and expressive rather than elegant and picturesque. The dishes were apparently made at Constantinople, for both bear on the back a control stamp in the name of Justin II which was added in the imperial mint, but the style is so Syrian that it would seem that an artisan from that area must have been involved in the production of the decoration. Another important work where Syrian elements are also to the fore is represented by the wooden doors of the church of Sta. Sabina in Rome, set up in 432. The poses are mainly frontal, there is a preference for vertical perspective, and the artist has clearly aimed at expressing inward belief rather than mere narrative; furthermore the iconography is of a type proper to Syria rather than to the West. The arrangement of the scenes is interesting, for those from the Old Testament are set beside those from the New to form parallels, a system which was later to be widely adopted more particularly in Carolingian and Ottonian art.

Though the surviving monuments are few and far between, there is enough material to indicate that the Syrian style continued to

exercise an influence over a very long period. Attention may be called to such works as the famous Monza ampullae of the sixth century, small metal flasks bearing a decoration in relief, which were intended to hold holy oil or perhaps Jordan water which was taken home from the holy cities of Palestine by pilgrims. The figures are frontally posed, the scenes expressive even if crude. The paintings on the lid of a small wooden box now in the Vatican belong to the same category. They depict the Resurrection, the Ascension, the Crucifixion, the Nativity, and the Baptism. It has been suggested that the order was chosen to recall to the pilgrim that in which he visited the various sanctuaries; it may alternatively be proposed that the list should be read in the opposite direction in the manner of the Syrian script, which moves from right to left rather than left to right. Similar again are a number of ivories of the early centuries preserved in various collections in the West; one in the British Museum with the Virgin and Child above and the Nativity below, and another in the John Rylands Library at Manchester may be mentioned. They too were no doubt produced in Palestine or Syria, for the use of pilgrims about to return home. On all of these frontality, a linear approach, and the use of vertical perspective are prominent.

In addition to these stylistic features, the French Byzantinist Gabriel Millet showed that a number of iconographical peculiarities which were later to appear in sophisticated Byzantine works of all types and in every area are also indicative of descent from the Syrian stream of art. One of the most obvious is to be seen in the depiction of Christ in the Crucifixion scene, where he wears a long robe, the collobium, in place of the classical loin cloth normally found in works produced by the court schools of Constantinople. Another characteristic is the movement of scenes from right to left rather than left to right. This is especially striking in the rendering of the Annunciation, where the position of the figures of the Virgin and the angel is exactly reversed in Syrian works. Such features as these penetrated the system of Biblical illustration, and in later times became almost inextricably confused with those proper to the classical heritage or to the Byzantine world in the narrower sense of the term. Here it is necessary to do no more than call attention to their existence.

In quite another sphere attention must be drawn to a rather different element that must be regarded as a Syrian contribution, and which exercised an important effect on the Byzantine world, namely the Eastern conception of monasticism. This favoured the solitary life,

and the numerous anchorites of whom we read throughout Byzantine history lived their strange existence in order to bear witness once more to the importance of the inward life; only by dissociating themselves completely from the affairs of the everyday world could the full realization of spirituality be achieved. The idea was first conceived in the Thebaid in Egypt, but it soon spread to Syria, and it was there that the most famous of all the anchorites, St. Simeon Stylites, stood for many years in isolation on the top of a column. From there the fashion moved to Asia Minor, and though there were monastic communities there, notably in Cappadocia, the solitaries, living alone in caves, represented the most typical aspect of local monasticism. In Byzantium itself life in a monastic community was more usual, especially in the cities, where such monasteries as that of St. John of Studios at Constantinople had an important role to play. But on Mount Athos, the principal centre of monastic life from mid-Byzantine times onwards, the solitaries were almost as numerous as the monks who congregated together in the larger religious houses.

In addition to the blending of the Syrian approach with classical motifs, some of the Antioch floors bear witness to the interplay of yet another style, that proper to Sasanian Persia. The streamers that fly out from behind the neck of a lion in a mosaic from the so-called 'House of the Beribboned Lion', or from the rams' heads that form the border to another fine floor now in the Louvre, as well as the double wing motif there and on other floors, are thus wholly Sasanian; Sasanian motifs appear again in the mosaics of the Dome of the Rock at Jerusalem (c. 690). They indicate that contacts with Sasanian Persia must have been very important. They were even extended to Byzantium itself especially around the year 500. Sculpture of this date recently unearthed in the excavation of the church of St. Polyeuktos in the Saraçhane region in Constantinople are thus markedly Sasanian in character. As we have already noted, Sasanian elements are also to be found in the mosaic decoration in the apse of SS. Cosmo and Damian at Rome. The massive figure of Christ is set before a pattern of dawn clouds, which must surely be derived from the Persian conception of the Hvarenah, the mystic landscape associated with the sun cult. The theme of animals or birds confronted on either side of a plant motif—the Tree of Life—which was so frequently adopted on textiles at a later date, is also of Sasanian origin.

When Syria fell to the Muslims in the first half of the seventh century it rapidly became the centre from which influences of another

type were exercised, namely those brought about by trading and diplomatic contacts. From the ninth century onwards, if not before, a very fruitful exchange in ideas and in actual art products was set on foot. Its effects are to be seen in the adoption of techniques and motifs in the Byzantine world which originated in the Islamic area. A number of techniques of Byzantine pottery making thus followed those which were first fully developed in Persia and Mesopotamia, while a whole repertory of motifs which ultimately sprang from Mesopotamia or Persia and which travelled to the west by way of Syria were taken over by Byzantine craftsmen, potters, sculptors, and textile workers alike. The theme of a man standing, attempting to strangle a lion on either side of him, which served for Daniel in the lion's den, was thus derived from the old Mesopotamian representation of the god Gilgamesh, while the disposition of two birds or animals confronted, with a formal tree between them, though of Sasanian origin, was also so much used in Islamic art that it too must be mentioned in this connection. The motif travelled westwards along one of the westerly extensions of the silk road, probably that which passed through northern Mesopotamia and Syria. The use of Kufic script as a motif of decoration in manuscripts, on textiles, and even on stone carvings in the Byzantine world was also due to Islamic influence, Syria perhaps serving as the primary source of inspiration. This form of intercommunication continued even after 1071, when the Byzantine army was defeated by the Seljuk Turks at the Battle of Manzikert so that the whole upland area of Asia Minor fell under Seljuk control. But by then the basic debt owed by Byzantium had already been incurred, and any subsequent contributions were of a secondary, mainly superficial character.

One other aspect of Eastern influence must be mentioned briefly; it is that exercised by art of a wholly abstract, non-representational character. This influence was obviously most important in Iconoclast times, when figural art in the religious sphere was prohibited (this will be referred to more fully in a later chapter). But a move in this direction had already been made in early times. Justinian and his immediate successors avoided portraits of Christ on their coins, favouring rather the abstract theme of the cross, while the decoration of the capitals of Hagia Sophia and other buildings, though basically representational, has been so formalized that the arrangement of the leaves is more geometric than naturalistic. Stone closure slabs of the same period were also popular, on which formal, even purely

geometric, ornament alone appeared. Strzygowski was the first to stress the importance of this trend in medieval art, and he attributed its development to the influence of the art of the nomadic peoples of Central Asia. Whether or not he was correct in this is now somewhat debatable; but the basically Eastern conception behind the affection for non-representational art is hardly to be disputed, for it was to become a dominating factor in the development of Islamic art. So it too must be counted as one of the important non-classical elements in the composition of the fully-fledged Byzantine style.

This survey of the arts in Syria and the Eastern world has led us far afield, but it throws an important light on the initial theme of this chapter—was Byzantine art a wholly European art? In spite of the basic importance of the classical heritage, it has become clear that a considerable degree of Eastern influence was also exercised. Though the classical elements may be accepted as truly European, these other elements are distinct; and even if many of them were to be adopted at a later date in various branches of European art, they can hardly be counted as part of the true European heritage. It thus becomes clear that the art which was defined in the first chapter as Byzantine art was not, by its very definition, a wholly European art. Whether or not it became more, or less, of a European art as time went on will form one of the main undercurrents of this inquiry.

This is not purely an academic question but is very germane to the attitude of mind with which we must approach Byzantine art in order to grasp its nature fully. We must, in fact, accept that we have to learn a new language if we are to appreciate it completely, and that language is not a wholly European one in the narrower sense of the term. Even today the Greeks, Byzantine's most direct heirs, speak of 'going to Europe' when they visit London, Paris, Berlin, or even Vienna. This extraneous element is thus perceived by them, even if they would be the last to admit it overtly.

Ivory diptych of Consul
Areobindus. 506. *Photo
Musée National Suisse,
Zurich*

In the previous chapters we have endeavoured to outline the nature and the basic character of Byzantine art; in those that follow our object will be to discuss from their artistic point of view a number of the more outstanding products of that art, including the architecture, in the sequence of the various periods into which the Byzantine age can, for purposes of study, most conveniently be divided; and, further, we shall try to analyse the characteristics that distinguish these phases one from the other, for each phase was distinctive, in spite of the assumptions that for long prevailed in the West that the art changed but little and was characterized above all by its monotony.

The earliest of these periods, usually known as the First Golden Age, extended broadly from around 500 till the beginnings of Iconoclasm in 726; but it may conveniently be subdivided into three phases so far as the history of art is concerned: that of formation, around 500; that of realization under Justinian (527–65); and that of decline that followed during the politically regressive reigns of his successors. In dealing with the first of these it will be our aim to attempt to define the factors that began to stand out at the commencement of the sixth century and which serve to distinguish Byzantine art from that which may, more justly, be termed Early Christian.

Happily our task is facilitated by the fact that there are several important works of art of various types that are fairly firmly dated either by inscriptions upon them or by external evidence, to round about the year 500. Attention may first be drawn to a group of ivories known as the consular diptychs. These were made for the consuls when they assumed office and were given by them as presents to friends or officials to celebrate the occasion. Though there are a few earlier ones that are clearly Roman, the majority of those that survive belong to the years just after 500, notably six made for consul Areobindus (506), one for Clementinus (513), one for Anthemius (513), and three for Anastasius (517). On the majority of them the consul is shown seated in his official chair in a formal, rigid attitude, with some appropriate scene below, which either depicts the games in the Hippodrome or boys pouring out coins from sacks, an indication of the consul's intended liberality. On either side of the consul figures of classical character, the personifications of Rome and

Constantinople, usually appear, and in the case of Anthemius busts of the emperor and empress are also present in medallions at the top. Occasionally, instead of this full composition only the consul's bust is shown, in a medallion framed with a floral pattern. But always the consul holds a sceptre in one hand and the *mappa* or kerchief which he dropped as a sign for the start of the Hippodrome games, in the other; his assumption of office was marked by official games in the Hippodrome. Exceptionally, on one of the leaves made for Areobindus, there is no more than an inscription and a monogram and a formal pattern of crossed cornucopiae, with below a basket of fruit. Both this motif and the figures are treated in a very formal manner; the figures are posed strictly frontally, the heads are large and inelegant, the eyes staring and rather lifeless. The personifications, the official chair, and the costumes all belong to Roman art and are found often enough at an earlier date. To the Roman tradition too belong the inscriptions, which are almost invariably in Latin. But the large heads, the severely frontal poses, and the general formalism savour more of the Syrian style. It is true that Syrian elements of this nature had begun to affect Roman art before the Byzantine era dawned, but on the diptychs the Eastern formalism has been carried quite a long way and if one compares these ivories, all made for consuls at Constantinople, with one like that made for Probus, consul at Rome in 406, the differences at once become apparent. There the frontality is less severe and the attempt at portraiture more convincing; it is a work of Roman art, easily distinguishable as such, whereas the diptychs done around 500 already savour of the Byzantine.

Another important example of the budding Byzantine style is afforded by the architectural sculptures from Saraçhane which have already been referred to. They belonged to a church which was dedicated to St. Polyeuktos, set up under the patronage of Juliana Anicia, wife of Areobindus, soon after the year 500. The church has long since been destroyed, but fragments of cornices and capitals 2 survive and they serve to give a good idea of what the decoration was like. On some of the cornices there were vine scrolls carefully modelled in a comparatively naturalistic style. On others the ornament is much more formal, and the carving harder and more metallic; it is of a distinctly orientalizing character, and attests the influence of Sasanian art. Carvings at Taq i Bostan and elsewhere in Persia as well as the decorations on silver plates in the Hermitage may be

compared. On some of the fragments there are monograms and on others inscriptions finely cut in relief; the letters are Greek. In addition to the cornices some square capitals for engaged piers were found, and on these the decoration was even more formal than on the most stylized of the cornices. On one of them, a date palm, conceived almost as a piece of geometric ornament, covered one face, while on the others there were stylized acanthus leaves forming a formal repeat pattern.

A particularly interesting feature about some of the sculptures from St. Polyeuktos is the similarity that their decoration bears to that of the two large piers which stand between St. Mark's at Venice and the sea. At one time it was believed that these had been brought from Acre in Palestine, but their similarity to the carvings in St. Polyeuktos suggests rather that their home was in Constantinople and this is borne out by the fact that one fragment found there must have belonged to a pier absolutely identical with those at Venice; one must therefore conclude that the Venetian examples were taken there as part of the loot from Constantinople after the Fourth Crusade. The decoration of the Venetian examples has always been cited as an example of an orientalizing style in art, stemming from either Persia or Syria. Whether it should be attributed to a direct influence of Sasanian art at Constantinople or whether both represent the off-spring of an orientalizing style which was first developed elsewhere it is hard to say. But in either case these sculptures are of special interest, for in the naturalistic vine scrolls they show the heritage of classical art and the Roman tradition; the stylized ornament is in an orientalizing tradition, while the fact that inscriptions on them are in Greek bears witness to the growing role exercised in Constantinople by Greek as opposed to Roman culture. In fact, many of the various elements that were to coalesce to form Byzantine art have already begun to blend here, to produce work which is already in a new idiom.

The name of Juliana Anicia is associated with another interesting work, a copy of Dioscorides' treatise on the medicinal uses of plants, dated by an inscription at around 513. Most of its illustrations are practical representations of the various plants, a type of thing that showed little variation throughout the ages. But three pages bear more elaborate illustrations: two follow the old classical tradition of including a portrait of the author; on the other Juliana Anicia is depicted seated between the personifications of Megalopsychia (Magnanimity) and Phronesis (Prudence), with two other allegorical

figures paying reverence at her feet; they represent Love of the Arts and Love of the Patron. The figures are enclosed within an octagon formed of two intersecting squares, all enclosed within a circle, and in the corner spaces so formed there are putti against a blue ground. The personifications and the putti are wholly classical, but the surround appears at a later date in Mesopotamian manuscripts and probably repeats an old Mesopotamian motif. Once more we see a diversity of influences, though the fusion is here a good deal less complete than in the case of the St. Polyeuktos sculptures.

To much the same date belong the mosaics of the Arian Baptistery at Ravenna, set up under the patronage of Theodoric the Goth. They differ in style from the others executed under his patronage, namely the thirteen scenes from Christ's life and the thirteen from the Passion that occupy the space above the windows of S. Apollinare Nuovo. These are essentially Early Christian works, narrative in content, conservative in style, whereas those in the Arian Baptistery are more experimental, more forceful. The figures of the apostles are thus formal and rigid and are silhouetted against an almost plain background, in contrast to those in the earlier Baptistery of the Orthodox, where there are elaborate plant forms and draperies in the spaces between and where there is also a clear attempt to indicate depth. The rendering of the actual baptism is also more formal, more stylized in the Arian building. The most distinctive feature is the colouring; in the Baptistery of the Orthodox the shades are pale, the transitions gentle; in that of the Arians they are brilliant and the transitions are violent. There is no attempt at illusionism, as in the earlier work, either in the colouring or in the technique of setting and juxtaposing the cubes; rather the artist seems to have sought his effects through violent contrasts; it is the technique of a Gauguin as opposed to that of a Corot, brilliant yellows are set beside brash greens, reds beside green or blue. They might scream, but do not do so thanks to the artist's skill. There is something of the brilliance of Eastern colouring here, but more striking is the superb mastery of discord that distinguishes the Byzantine work, in opposition to the search for gentle harmony that is to the fore in the less daring illusionist style.

Three other important works of art which can be firmly dated in this period and which serve to illustrate our theme may be noted; a multiple diptych in the Louvre, known as the Barberini ivory— already referred to briefly in the first chapter (see p. 14); two central leaves and other portions of a similar diptych, depicting the empress

Ariadne; and a silver dish in the Hermitage bearing the name of Bishop Paternus, dating from about 518. The high relief and the inclusion of personifications mark the ivories as works of late classical art, but the presence of the bust of Christ above that of Anastasius indicates its Christian character. Not only does Christ dominate the actual scene; the presence of his bust also illustrates the unifying influence exercised by the faith at this time.

The Ariadne panels, one of which is at Vienna and one at Venice, are closely related to the Barberini ivory, though the figures are shown in more severely frontal poses and they have the large heads characteristic of the Syrian style. There were originally rectangular plaques above and below, similar to those of the Barberini ivory. All of them were no doubt carved in the same workshop. It is hard to state in concrete terms what exactly it is that distinguishes all of these as Byzantine. It is not only the presence of Christ's bust at the top; there is in addition some subtle factor in the make-up of the works as a whole which differentiates them from late Roman products in spite of the very Roman character of many of the details.

Our next example, the dish of Paternus, is more frankly and clearly Christian. At the centre is a large Chi Rho cross, lightly incised, with the letters **A Ω** on either side of it. It is surrounded by an inscription giving the bishop's name; it is in Latin, but some of the letters follow Greek forms. Around the rim is a scroll with birds and animals in its lobes; it is interrupted by four crosses, one at each side and one at top and bottom; only the two latter survive and all of them were later additions. In general the style here is closer to Rome than it is in the other works we have noted, for the Chi Rho cross was a common motif there in early Christian times and scrolls of the same type were usual in Roman art. But the use of Greek letters in the inscription represents a Byzantine trait and in this at least it is to be classed as Byzantine rather than as Early Christian.

Though it is not firmly dated like these objects, another silver plate, now in the Museum of Antiquities at Istanbul, may also be noted here. At the centre is an allegorical figure in relief, the personification 74 of India. She sits on a curious throne made of elephant tusks; her face is shown in full frontality, but the body adopts a more naturalistic pose. At shoulder level there is a turkey to the figure's left and a hawk to her right, while at ground level there is a cheetah on either side. The ground is indicated by a horizontal line, but otherwise all the figures are as it were poised in space, with no background detail. In

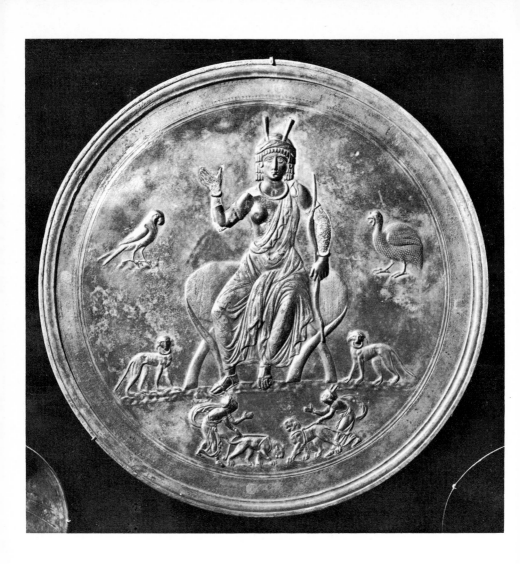

Silver dish. The
Personification of India.
Sixth century. In the
Museum of Antiquities,
Istanbul. *Hirmer
Fotoarchiv München*

the foreground, on a smaller scale, are two men holding lions on a
leash; they have the same curious head-dresses with projecting horns
as the Indian tribute bearers on the Barberini ivory. The placing of
the principal figure above the scene in the foreground (vertical
perspective), the smaller size of the figures nearest to the spectator
(inverted perspective), and the absence of background detail are all
features far removed from classical art and savour of Eastern con-
ventions, while the precise, clear-cut style of the relief is suggestive

of the manner we have termed Neo-Attic. There is little that is Roman about the dish, for only the costume could be termed classical. In fact the fusion of elements has gone further here than in any of the other works we have cited, and this is the most truly Byzantine product of all of them. This is interesting, for it is a work of purely secular art. In general the changes that mark the development of the Byzantine style were most marked in the religious sphere, as mosaics like those in SS. Cosmo and Damian at Rome or in the Baptistery of the Arians at Ravenna serve to prove. Imperial art was moving in the same direction, but the change was slower and on such secular works as the silver plates of the sixth and seventh centuries scenes of a purely classical character were still being depicted (see p. 92f.). In the case of the plate with the personification of India, we have before us a wholly secular object which can truly be described as Byzantine and nothing else, made probably quite early in the sixth century. Perhaps the most significant thing about it is its outstanding beauty, for it is a work of very high artistic quality. It is indeed one of the finest early Byzantine works that have come down to us.

There can be little dispute as to what was the most outstanding work of this age not only from the architectural, but also from the artistic point of view. It was the great cathedral of Hagia Sophia. Whatever have been the views held concerning the merits and quality of Byzantine art as a whole, admiration for this building has always been well-nigh universal, even when other styles such as the High Gothic or the trabeated classical type have been preferred. Indeed during many centuries the building has been regarded as one of the undisputed wonders of the world, even if by the time it was built the conception that there were no more than seven of them had been discarded.

The adulation of the building begins with the descriptions of several contemporary writers, notably the historian Procopius and a court official, Paul the Silentiary, who wrote a long and at times somewhat flowery treatise extolling it. 'Whoever raises his eyes to the beauteous firmament of the roof,' he wrote, 'scarce dares to gaze on the rounded expanse, sprinkled with the stars of heaven, but turns to the fresh green marble below, seeming as it were to see the flower-bordered streams of Thessaly, and budding corn, and woods thick with trees. Whoever puts foot within the sacred fane would live there for ever, and his eyes well with tears of joy. Thus by Divine counsel, while angels watched, was the temple built again.'

Procopius, in a more straightforward style, confirms the impression:

The church presents a most glorious spectacle, extraordinary to those who behold it, and altogether incredible to those who are told of it. In height it rises to the very heavens, and overtops the neighbouring buildings like a ship anchored among them, appearing above the rest of the city which it adorns and forms part of it. One of its beauties is that being a part of and growing out of the city, it rises so high that the whole city can be seen, as from a watch-tower. The length and breadth are so judiciously arranged that it appears to be both long and wide without being disproportioned. It is distinguishable by indescribable beauty, excelling both in its size and in the harmony of its measurements, none being excessive, none deficient; being more magnificent than ordinary buildings and much more elegant than those which are not of so just a proportion. The church is singularly full of light and sunshine; you would declare that the place is not lighted by the sun from

without, but that the rays are produced from within itself, such an abundance of light is poured into the church.

The old basilica which Justinian's church replaced had been destroyed in the Nika riots when the populace got out of hand; they resulted in a terrible fire which caused a great deal of destruction. The riot took place on 15 January 532. By 23 February 533, work on the new building had begun, and within six years Justinian's great cathedral was complete—something of a lesson to the architects and contractors of today! It was opened on 26 December 537. The Silentiary describes the opening:

At last the holy morn had come and the great door of the new building groaned on its hinges, inviting the emperor and people to enter; and when the inner part was seen sorrow fled from the hearts of all, as the sun lit the glories of the temple. It was for the emperor to lead the way for his people, and on the morrow to celebrate the birth of Christ. And when the first gleam of light of rosy-armed dawn, driving away shadows, lept from arch to arch, then all the princes and people with one voice hymned their songs of prayer and praise; and as they came to the sacred courts, it seemed to them as if the mighty arches were set in heaven.

The basic plan of Hagia Sophia combines two fundamental ideas, that of the longitudinal, three-aisled basilica and that of the centralized, domed martyrium. On plan, or in any view which concentrates on the lower levels, the basilical idea is predominant, even if the columns are limited in number and their rows are terminated at either end by massive piers. But if one looks upwards at the roof, the sphere of the great dome dominates much as it does in the greatest of all martyria, the Pantheon at Rome. The genius of the structure of Hagia Sophia is the manner of transition from the square below to the circle above, which has made possible the combination of the two ideas in a single building. It is possible that the church of St. Polyeuktos built some thirty years earlier, as well as structures in Asia Minor which we now know mainly from records, may have represented tentative experiments in the development of the system, and St. Irene nearby shows it in a more developed form, but no other building has the same imaginative originality as Hagia Sophia, nowhere else is the same glorious effect achieved. Lethaby and Swainson conclude the preface to their admirable book on the church with the quotation, 'L'art, c'est d'être absolument soi-même.' Hagia Sophia conforms to

this definition. No other Byzantine building set up subsequently is like it, nor on the same enormous scale, and no attempt was made to copy it by Byzantine architects, though ironically it served as the model for many of the larger mosques set up by the Ottoman Turks during the sixteenth century for the service of Islam both in Constantinople and elsewhere.

Briefly the problem that confronted Justinian's architects was how to place a circular dome above a rectangular base. They achieved it by setting a great square at the centre of the rectangle, limited by a massive built pier terminating the aisle arcades at each of their four corners. On the north and south sides these piers were linked below by rows of columns which served to support a gallery; the columns separated the central from the side aisles, and at the same time served to obscure the massiveness of the main piers. Arches linked the piers to the outer walls, so giving them greater strength to resist the thrust of the dome from above. At its east end the square was prolonged by exedrae; at the west there was a great semi-dome above. At the upper level the roofs of the side aisles and the exedrae were set up at gradually increasing heights, so that they also served to prop and support the main dome and carry its weight by degrees to the ground. At their summits the four main piers were linked one to the other by huge arches, and in the corners of the square which these formed were contrived vaults of triangular shape, but with curved sides; the curves of the two vertical sides corresponded to the curves of the arches, while the upper sides, similarly curved, served to convert the square into a circle. This circle provided a springing point for the dome, though in Hagia Sophia, as in all later examples, a drum was set between it and the actual dome, and windows were inserted in the drum.

Initially the dome itself was astonishingly low at its centre, and it exercised so severe a thrust that when an earthquake occurred twenty-one years later the dome fell. It was rebuilt twenty feet higher at the centre, and though a section of this new dome fell when another earthquake occurred in 975, it virtually remains today as set up in 558, in spite of the fact that it has had to resist at least twenty-two other earthquakes, one of which, in 1033, is reported to have lasted intermittently for 140 days; no mean attribute to the skill of the architects and masons who built the cathedral.

It is, however, not only the skill and originality of the structure that is distinctive, but also the quality of the decoration, for every

detail in the building is in its own way equally distinctive. The columns, of the finest marbles, the revetments of the walls, also of carefully selected polychrome marbles, chosen for the beauty of their veining, the sculptured cornices, and the capitals with their silhouette carvings all survive. Recent cleaning at the west end shows how brilliant these marbles must all once have been. Though they have been to a great extent shorn of their ornament of great crosses, the bronze doors from the narthex to the church have also been restored by cleaning to something approaching their original grandeur. The rather more ornate doors of the south entry were added in 840, and bear inscriptions and monograms in the names of the Iconoclast emperors Theophilus and Michael. But nearly all the mosaics with which Justinian adorned the dome, the semi-domes, the vaults, and the upper surfaces of the walls have disappeared, to be partly replaced by later ones and partly by painted plaster. The rich accoutrements, treasures of gold and silver, the silver altar and its canopy, the silk hangings, and the finely bound gospel books which the writers describe, have, of course, all perished.

Quite a large portion of Justinian's mosaic decoration was of a non-representational character. The writers speak of a cross in the dome, while the mosaics on the arches and vaults of the lower levels were purely decorative. Here and there portions of these decorative mosaics survive, and on one of the stairs to the galleries there are fragments of a fine mosaic in the form of a massive scroll pattern; it belongs to a period of repair under Justin II (565–78). Nearly all the other mosaics date from post-Iconoclast times, when figural subjects were added piecemeal at different periods. It has been suggested that Justinian's decoration was destroyed during the Iconoclast period, but as so much of it was already non-representational, Iconoclasm would afford no real reason for removing the earlier work; rather would it seem that when figural compositions were reinstated in post-Iconoclast times Justinian's formal work was removed. What is interesting is that so much of Justinian's work seems to have been aniconic, whereas in other mosaics of this age, like those in San Vitale or S. Apollinare Nuovo at Ravenna, at Parenzo, or in the monastery of St. Catherine on Mount Sinai, the work was wholly figurative.

Justinian was responsible for a great many superb foundations in addition to Hagia Sophia, both in and outside Constantinople, either directly or indirectly through local bishops such as Ecclesius and Maximian at Ravenna. The churches of St. Irene, SS. Sergius and

Bacchus, and the Holy Apostles at Constantinople, that of St. John at Ephesus, and those at Bethlehem and Jerusalem, may be noted among his foundations. Various different plans were tried out, one of the most important of which was that of a cruciform church with a dome on each arm of the cross, as in the church of the Holy Apostles. At Ephesus the plan was the same, but the nave was extended westwards and was roofed by two domes in echelon so producing a six-domed edifice. SS. Sergius and Bacchus at Constantinople, like San Vitale at Ravenna, was a centralized building, having a single dome over an octagonal base. In all of them the decorations appear to have been most lavish.

Taken as a whole the exteriors of these churches were comparatively plain; and though the proportions were usually very good, there was no attempt to overawe or to impress. Apart from the architectural innovations it was in the interiors that the originality and beauty of the new architecture was most fully realized. The Christian faith as conceived by the Byzantines stressed the importance of the inner man, the glory of the soul rather than the beauty of the body, so that the basic ideas of the faith were reflected in this concentration of decoration within the building rather than outside it. God's dwelling-place was glorified within, but no attempt was made to impress through the grandeur of the outward façade. Contrast with the heathen temple was thus complete; there the exterior was made glorious with columns and sculptures and the interior was dark and unimpressive; in Byzantine churches it was the interior that was adorned, and there men could congregate in paying homage to God.

Another unique feature about Hagia Sophia is that we know the names of the architects who were responsible—practically the only such names that have been recorded throughout the thousand or so years of Byzantine history. They were Anthemius of Tralles and Isidore of Miletus, cities of the coastal area of Asia Minor. Anthemius seems to have been a man of very unusual talent. He is referred to by a contemporary writer as 'the man most learned in the mathematical sciences, not only of this age, but of all time', and he is known to have been employed on a number of important projects. He worked on fortifications at Dara in Mesopotamia, and he was in all probability the builder of several of the great underground cisterns in Constantinople like those called by the Turks the Yeri-Batan-Saray (Underground Palace) and the Bin-bir-Derek (Thousand and one Columns). This is the most distinctive of all the cisterns in the city,

for its columns are of exceptional height, each one being made up of two sections joined in the middle with a sort of socket like those used for connecting pipes. In another direction Anthemius could have gone down to history as the first man to have realized the power of steam. Apparently he got into a dispute with the man who lived in the adjacent house and in revenge Anthemius rigged up a contraption of boilers and pipes; when the water boiled it occasioned such tremendous rumblings and vibrations that the neighbour ran out into the street thinking that his house was being shaken by an earthquake.

Anthemius seems to have played the major role in preparing the plans and layout of Hagia Sophia, Isidore acting as his assistant, though it was Isidore on his own who tackled the task of rebuilding the dome when it fell in 558. Both, following the Byzantine tradition, appear to have been skilled in the practical problems of building, and there does not seem to have been any very strict limitation of tasks like those encouraged by trade unions today. Rather each man was treated as, and worked as, an individual and was responsible for the completion of the task that had been entrusted to him through all its stages. It is for this reason that Byzantine work always tends to have a rather haphazard look, so that when the independently constructed sections of the work meet they do not always correspond very exactly. These irregularities have sometimes been attributed to a decadence of technique and the carelessness of the workmanship, but the way in which they have withstood the vicissitudes of time disproves this; those who have been attracted by these irregularities because of a horror of machine-made uniformity are nearer the mark.

The fact that both the architects of Hagia Sophia came from the same region of Asia Minor is significant, for it would seem that their work reflected ideas that were current in that area rather than in Italy or the West. Great buildings in brick, where arches and vaults had a very important role to play, had, of course, long been familiar in Rome; but a certain subtlety in the use of material depending on balance and counter thrust rather than on sheer strength and mass seems to have been developed in Syria and Asia Minor during the fifth century to a degree in advance of the standard achieved in Italy, and it was this subtlety that Anthemius and Isidore brought to Constantinople. The most outstanding feature of the system was probably the pendentive, the spherical triangle used to convert the square of the support into the circle on which the dome rested, and

it was this, combined with a very skilful use of arches and vaults not only for the roofs of subsidiary areas but also as buttresses for the main area, that made their buildings so original. In fact they had invented what is today called organic architecture, and in no early instance was this organic system used so effectively as in Hagia Sophia.

Were we concerned with writing a history of the architecture of the age of Justinian, it would be necessary to consider numerous other buildings in other parts of the empire. But this is not our object. Hagia Sophia has been discussed at some length partly because of its unique character and partly because it constitutes so admirable an example of what Byzantine architects sought to accomplish under Justinian's patronage, what ideas they tried to express. Had the various works of art that the contemporary writers describe as being associated with Hagia Sophia all survived, it would have been possible to have presented a more or less complete picture of the whole gamut of the art of the age without leaving the cathedral's precincts. As it is, only the architectural sculptures and the bronze doors survive, while for the rest—wall mosaics, altar furnishings, portable icons, silk hangings, relics, and other treasures—one must try to complete the picture by citing such comparable examples as do survive elsewhere.

The bronze doors have no other decoration on them than crosses and there is reason to believe that most of the wall mosaics were also formal. That being so, figural work like the Old Testament scenes on the Presbytery walls of San Vitale at Ravenna, or the rendering of Christ in the apse, the Processions of Martyrs in S. Apollinare Nuovo, or the great mosaic of the Transfiguration in the apse of the principal church in St. Catherine's monastery on Mount Sinai, can be left aside for the moment, fine and important though they are, while instead the apse mosaic in S. Apollinare in Classe at Ravenna (c. 549) may be called in evidence. As is well known, it depicts the Transfiguration; but it does so in a symbolic manner, the transfigured Christ being represented by a great cross in a medallion and the three apostles who accompanied him to the mountain by three sheep; only the prophets, Moses and Elias, are rendered in human form. Below is a lovely landscape, partly naturalistic and partly formal.

Speaking technically and stylistically this mosaic, together with those in San Vitale and on the lower registers in S. Apollinare Nuovo, belong without doubt to a Constantinopolitan group; there is

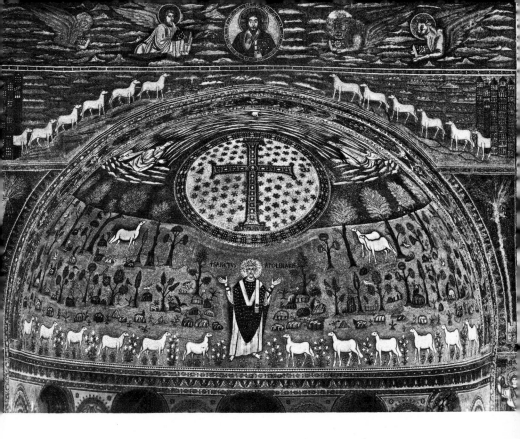

Mosaic in the apse of the church of S. Apollinare in Classe, Ravenna. 535–49. *Mansell Collection*

nothing provincial about them and they are all quite distinct from those set up rather earlier at Ravenna under the patronage of the empress Galla Placidia or of Theodoric. It seems likely from descriptions of the church of the Holy Apostles that similar figural work was also done in Constantinople itself. But the Silentiary's description of the decoration of Hagia Sophia clearly supports a comparison only with the more formal portions of all these mosaics. According to him the centre of the great dome of Hagia Sophia was adorned with a large cross: 'At the highest part, at the crown, was depicted the cross, the protector of the city.' It must have been very similar to that in the centre of the apse of S. Apollinare in Classe. Again, the nature of the background of this mosaic or of that in the apse of San Vitale, with its sprigs of flowers and trees, tallies closely with what the Silentiary says about the walls and vaults of Hagia Sophia: 'intertwining curves laden with copious fruit and baskets and flowers and birds sitting on

83

twigs'. One thinks too of the much earlier decoration of Sta. Constanza at Rome. There the somewhat prosaic outlook of Roman art was to the fore, whereas the backgrounds of the S. Apollinare mosaics are far more imaginative, more poetic; in spite of their formalism they are more clearly imbued with a true feeling for the beauties of nature.

It is, however, not only the poetry of Greece that distinguishes these mosaics from Roman examples. There is also a great depth of spiritual feeling, and this atmosphere was also uppermost in Hagia Sophia. 'Whoever enters the Church to worship,' wrote Procopius, 'perceives at once that it was not by any human strength or skill, but by the favour of God, that the construction was accomplished; the mind rises sublime to commune with God, feeling that He cannot be far away, but must dwell in the place which He has chosen.'

If the mosaics at the upper levels in Hagia Sophia were of the type described by Procopius and the Silentiary, those on the vaults of the side aisles at ground level were of a less poetic nature, for they are made up of formal patterns on a geometric basis. Today it is not very easy to see where the actual mosaics end and the painted decoration done on behalf of the Fossati brothers when the building was restored in 1848 begins. The rather dull, monotonous appearance of this decoration is to a great extent to be attributed to the fact that the bright tesserae themselves have in many cases been covered with paint which has lost its lustre.

The Silentiary writes at some length and in very glowing terms of the wonders of the lighting at night time:

No words can describe the light at night-time; one might say in truth that some midnight sun illumined the glories of the temple. For the wise forethought of our emperor has stretched from the projecting rim of stone, on whose back is planted the temple's airborne dome, long twisted chains of beaten brass, linked in alternating curves with many windings. And these chains, bending down from every part in a long course, come together as they fall towards the ground. But before they reach the pavement, their path from above is checked, and they finish in unison on a circle. And beneath each chain he has caused to be fitted silver discs, hanging circlewise in the air, round the space in the centre of the church. Thus these discs, pendant from their lofty courses, form a coronet above the heads of men. They have been pierced too by the tool of the skilful workman, in order that they may receive shafts of fire-wrought glass, and hold light on high for men at night.

The light provided by this enormous polycandelion was supple-

mented from numerous other sources, single lamps near the columns and on the beams, under the gallery at the base of the dome, and on the iconostasis, and there were even lamps arranged in the form of a cross at the east end. The Silentiary goes on to describe the brilliance that the lamps produced: 'The night seems to flout the light of day and to be itself as rosy as the dawn . . . through the spaces of the great church come the rays of light, expelling clouds of care and filling the mind with joy.' The common Western conception of the Byzantine interior as obscure and gloomy is thus clearly incorrect; on the contrary, Byzantine architects sought for brilliance and were happy if it could be realized, often in a rather dramatic way.

It is hard for us to recreate a picture of the effect produced by the lamps of Byzantine times, at first glance so primitive and seemingly so inadequate. One can visualize what the great polycandelion was like, for later examples on a smaller scale are still in use in many of the monastery churches on Mount Athos and the form seems to have changed little throughout the ages; but it is a good deal harder to visualize how a building as vast as Hagia Sophia can have seemed anything but dark at night-time even when the marbles were clean and there were mosaics on the walls above to intensify the brilliance. Once more it is necessary to readjust our conception if we are to picture the Byzantine church interior correctly.

The Silentiary's description is also very informative with regard to the nature of the iconostasis, the screen that separated the sanctuary from the body of the church. There have probably been greater changes in the course of the ages in the conception of the iconostasis than with regard to lighting, for the many-tiered structures we know in Russia or the larger churches of Greece and the Balkans represent a comparatively late development. In early times the iconostasis usually took the form of a comparatively low screen, divided into sections by pillars of marble with stone closure slabs between them; a few large icons apparently stood above. In Hagia Sophia, stone, even the finest of marbles, was not considered adequate, and instead the iconostasis was made of silver, presumably beaten silver over a wooden core. It had six pairs of columns with panels between them bearing designs in relief depicting Christ, angels, the apostles, and other figures. The mention of columns in the Silentiary's description suggests that the screen was comparatively high, for the panels with decorations representing the principal figures of the Christian story would hardly have been placed at a low level. These panels would

seem to have occupied the place that in later churches was taken up by the painted panels we know as icons (see pp. 186ff.).

The iconostasis had three doors, the central one opening so that the altar could be seen through it. This was of gold, supported on golden columns, and above it was a ciborium or domed canopy. Once more silver was used instead of the more usual marble, as for example in St. Demetrius at Salonica. The ciborium too would have been visible to the worshipper when the central doors of the iconostasis were opened. And silver was used again in the construction of the ambo or pulpit which stood in the centre of the nave, raised at the top of two flights of steps. Examples made of marble may again be compared; the most similar is probably that in the church of San Clemente at Rome. Nowhere else, so far as we know, was silver used so lavishly.

Of the few smaller things of this age that have come down to us the one that would have been most worthy of Hagia Sophia is the ivory throne of Maximian, now in the Bishop's Palace at Ravenna. It is a tall throne with curved back, almost five feet high, its supports formed by immense ivories fashioned into square columns adorned with scrolls, while the front, back, and sides are made up of a number of carved ivory plaques. These cannot all have been carved by the same hand, for their style is markedly varied. On the front are five large panels of most exquisite workmanship depicting birds and animals emerging from an elaborate and very naturalistic vine scroll. On the sides of the throne are scenes from the life of Joseph, and on both the faces of the curved back are scenes from the life of Christ.

The man who was responsible for the figures on the front was an artist of very great ability who had clearly been trained in the purest Hellenistic tradition. His figures are well proportioned and full of life and the ornamental work is more naturalistic than formal; the animals and birds are especially delightful. Here we see the classical tradition at its very best, and if judged on the basis of purely classical canons the work would be accorded a very high place at any period. The artist responsible for the scenes from Joseph's life had clearly been trained in a more formal tradition. His figures are plastically conceived and in quite high relief, but the poses are rather angular and rigid, and the carver was more interested in producing an effective pattern than in naturalistic resemblance. The man who did the scenes from Christ's life was the least inspired of the three; the relief is low, the detail summary, and the work is at times rather rough,

Ivory throne of Archbishop Maximian. In the Bishop's Palace, Ravenna. 545–56. *Mansell Collection*

86

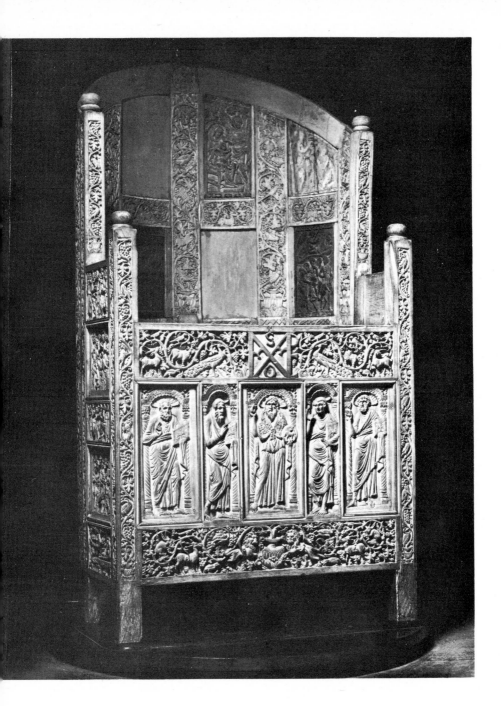

though quite expressive. He was clearly more under the influence of the Syrian style than the others. The naturalism of the full classical style and the formalism of the Syrian are represented respectively by the work on the front and sides, so that the throne serves to illustrate to some degree two of the trends that were distinguished in the third chapter.

The place of origin of this remarkable work has given rise to a good deal of discussion among the authorities, some preferring to assign it to Ravenna, some to Constantinople, and others to Alexandria, the latter primarily because of the prominence accorded to the Joseph scenes, for he was of course a personality whose life evoked special interest for Egypt. A generation or so ago it was the fashion to attribute very many more works to Alexandria than would be assigned to that city today; the fashion has died, and on stylistic grounds Alexandria now seems a good deal less likely than Constantinople. The throne is indeed so fine that one would assume that it had been produced in an imperial workshop, for only there would the largest and most impressive tusks have been available. Those that form the supports of the throne must even in their day, when elephants with very large tusks were presumably more numerous, have been exceptional.

Another ivory which might also have found a place in Hagia Sophia is one representing the Archangel Michael which is now in 15 the British Museum. We referred to it briefly in the first chapter. Here the blending of styles towards a fully-fledged Byzantine one has gone rather further. The leaf formed part of a diptych of religious rather than secular character; Greek has been substituted for Latin in the inscription at the top and the costume is carefully modelled and bears witness to the elegance of what we have termed the Neo-Attic style. But the frontal pose belongs to Syria, as does the rather large head— in the art of this trend there was a tendency to stress the size of the head, for it was looked upon as the centre of thought and was thus associated with the idea of stressing inner significance. Again the archangel's feet do not tread on the steps, but are poised above them, in what may be termed a levitating treatment, thus again testifying to the unworldly, transcendental character of this semi-divine figure, for the archangel belongs to the world of the spirit rather than to that of the flesh. Here indeed we have a work which clearly epitomizes the outlook of the new art and illustrates with outstanding brilliance the full blending of the principal elements that went to compose it.

The writers speak with enthusiasm of numerous treasures of even greater intrinsic worth than ivory in Hagia Sophia, notably crosses, patens, chalices, and reliquaries of gold and silver and illuminated Gospel books in rich mounts. Not many treasures of this kind survive from the reign of Justinian, though there are some from those of his immediate successors. One may, however, mention a silver-gilt flabellum or liturgical fan now in the Museum of Antiquities at Istanbul bearing a control stamp of Justin II (565–78), for it is decorated with a six-winged seraph very similar to those in mosaic which occupy the four pendentives below the dome. To the reign of Justin II are also to be assigned two patens, to which attention was drawn in Chapter 3 (see p. 63), one at Istanbul and one at Dumbarton Oaks, which bear in relief the scene of the Communion of the Apostles. Though control stamps indicate that they were in all probability made in the imperial workshops at Constantinople, the designs in this case savour very much of the Syrian style, for there is little hint of idealism, the poses are angular, and the faces expressive and emotional. Rather more sophisticated is a silver cross which the same emperor sent as a present to the Pope, but once again the work lacks the quality of the St. Michael ivory and seems to represent something of a decline since Justinian's day, brief though the interval was. Nor can an enamel reliquary for a fragment of the true cross which purports to be that presented by Justin to St. Radegond and which is now at Poitiers, be cited as a parallel, for it has every appearance of being of later date.

One may cite rather more convincing parallels to what might have been in Hagia Sophia's treasury in the sphere of manuscripts, for though they have been attributed to scriptoria in Asia Minor by some authorities, there are three sixth-century manuscripts surviving which are written on purple vellum, and there seems every reason to suppose that these purple codices were reserved for imperial usage. The manuscripts are a copy of the book of Genesis, now at Vienna, and two fragmentary copies of the Gospels, one, known as the Sinope fragment, now in the Bibliothèque Nationale, and the other, the Codex Purpureus Rossanensis, at the abbey of Rossano in southern Italy. It is especially tempting to assign the last of these to Constantinople, and it would have been wholly worthy of a place on the high altar of Hagia Sophia. The Syrian trend is to the fore in its illustrations, for they are expressive rather than elegant, but many of them herald developments that were to characterize the Byzantine

28

style many centuries later, and the iconography that was in vogue here was to see little change throughout the whole of Byzantine art.

Another feature in Hagia Sophia that the Silentiary described at some length were the curtains of the altar. They were of silk, and their decoration, which included figures of Christ and the Virgin, was woven, not embroidered. The only surviving silk of quality that may belong to this date is a fragment in the Vatican, bearing the Annunciation and the Nativity in medallions. But the very mention of these woven silks is of considerable interest, for it serves to stress the value that was set on such things. As is well known, it was the emperor Justinian who introduced the cultivation of the silkworm to the West; before his day the raw material had all come from China by way of the famous silk-road across Asia. The silkworm was not introduced to the West, according to legend, till 552, so that the altar curtains of Hagia Sophia must have been made from imported material, while the essentially Christian character of the design indicates that they must have been woven locally. One may therefore conclude that the imperial looms, which were later to become so famous, were already functioning around 535. The Vatican silk has sometimes been assigned to a Syrian workshop, and the frontal poses of the figures and their large heads and great staring eyes certainly belong to the Syrian trend. But, if we may judge by the parallel of the silver patens, it is possible that they also were made in the capital, and many works of art go to show how important the Syrian elements actually were elsewhere.

The story of art in the time of Justinian could be pursued further in many places other than Constantinople and by reference to many buildings other than Hagia Sophia. But it is not our purpose here to attempt to give a general survey, but rather, by calling attention to a few outstanding works, to define what it is that distinguishes them stylistically. So we may summarize in brief the conclusions suggested by these references to what exists or once existed in Justinian's great cathedral. Already by Justinian's time a considerable degree of fusion of elements had taken place, more especially between the classical and the Syrian ones, while Greek features were rapidly supplanting those of Roman or Latin origin. Gradually the effect of the locality and the ethnic character of the population of Constantinople and the coastal areas of Asia Minor was exercising its influence, alongside the Syrian and Roman heritage. And even the non-representational art, stemming in all probability from Asia, was exercising an influence too,

more especially in ornamental work as we see it on the capitals and cornices of Hagia Sophia where naturalism was ceding place to stylization. In Hagia Sophia the only one of the basic elements that we noted in Chapter 3 which did not have a significant role to play was that of Sasanian Persia. We noted it in the case of the decoration of St. Polyeuktos, however, and we will have cause to call attention to it again later on; at this period the only outstanding work where it is to be seen is the mosaic of Theodora in San Vitale at Ravenna, for the rich bejewelling of her ornaments savours of Persia rather than Rome, while her crown is of a form which would seem to have been derived from a Sasanian model.

While we are listing the factors that exercised their influence at this stage on the development of the Byzantine style it would be wrong not to stress once more the governing role exercised by the new faith itself. In the conception of a building like Hagia Sophia the Christian faith had a very vital role to play. Without the driving force, the initiative, of the faith, Justinian's great work as a patron could hardly have been accomplished; after all it was firmly believed that it was only thanks to divine help that the construction of Hagia Sophia was completed, and to the Byzantine mind it was a temple to the new faith, the most significant one so far conceived or erected since the Temple of Solomon had been built in Jerusalem.

It has often been stated by historians that between the close of Justinian's reign and the beginning of Iconoclasm about 726 there was something of an hiatus. It is certainly true that except for Heraclius (610–41), who defeated Byzantium's old enemy, Sasanian Persia, before he was himself defeated by Islam, none of the emperors brought great military glory to the state. Politically and economically it was a period of decline, for Justinian's lavish expenditure had left the treasury empty, and there was little desire to emulate his efforts either in the direction of imperial expansion or in that of architectural patronage. But even so the period was not quite so dim as some would suppose, and from the artistic point of view many of the works that are to be assigned to it not only have considerable intrinsic value but are also of high artistic quality, especially the silver plates.

Most of these are made of comparatively thin sheets of metal, with the design beaten out in low relief either freehand or into a mould. The backs were generally covered with a second sheet of metal so that the reverse of the design is not visible. The height of the relief varied, but tended to be lower in the later examples, while also in later work an engraved design supplemented or replaced that in relief. The vessels constitute nevertheless a distinct stylistic group, which seems to have assumed a particularly individual character in the earlier years of the seventh century. Some of these silver vessels bear decorations of a sacred character, like the important series with scenes from the life of David found in Cyprus, but the most interesting in many ways are those which were intended for secular usage and were adorned with scenes from classical literature or mythology. The majority take the form of shallow bowls and most of them are now in the Hermitage. Most are firmly dated because they bear on the bases control stamps made up of monograms of the emperor and of the court officials in charge of the treasury.

There must have been a straight continuity so far as these secular plates are concerned from Roman treasures like those of Boscoreale or Mildenhall, and it is natural enough that such things should have remained popular as part of the Roman heritage till around the year 500. But it is perhaps surprising that the classical themes showed so little change in the centuries that followed. One of the finest examples,

a silver bucket at Vienna, might thus at first glance be attributed to the fourth century were it not dated by control stamps not only to the reign of Heraclius but more exactly to between 613 and 630. It bears six mythological figures on the sides which are completely classical in appearance; only the fact that they seem to float in space, without any actual ground to stand on, distinguishes them from examples produced several centuries earlier. This kind of treatment was well suited to religious art, where the intention was to intensify the spiritual, unworldly nature of the theme, but it seems somewhat out of place in the more materialistic association to be found here. But we see the same thing also in some of the mosaic floors; it is really part of what we have termed the Syrian heritage and already heralds a medieval, as opposed to classical, outlook.

To the same date, because of their stamps, belong two dishes in the Hermitage. One of them depicts Meleager at the hunt, and here there is a greater degree of naturalism, for the ground is clearly indicated,

Silver bucket. 615–30.
Kunsthistorisches Museum,
Vienna

and the use of inverted perspective, which we noted in the case of the earlier dish bearing the personification of India, has been avoided; indeed the dogs in the foreground here are, if anything, over large in contrast to the figures behind. On the second dish Silenus is shown with a wine-skin on his shoulder, prancing after a maenad; here the ground is indicated, but in a more summary manner than in the previous dish, while a wine-cup and a bunch of grapes in the foreground are treated in a very stylized manner as if they were two-dimensional designs rather than concrete objects.

Rather later in date is a jug with a nereid riding on a sea-monster. It is also in the Hermitage and bears a stamp of Constans II (641–51). Though the theme is equally classical, the treatment is rather less realistic than in the preceding cases; but a trulla or ladle in the Hermitage, again of the same date, bears well modelled figures in quite high relief on its handle and nude aquatic figures on the outside of the ladle itself. The progress towards a medieval outlook is continued further on another dish in the Hermitage, which does not bear a stamp. On it Heracles is shown, deciding the quarrel between Ajax and Odysseus. The ground is totally omitted and the details are indicated by engraving; it may be contrasted with an earlier dish on which Venus is depicted in the tent of Anchises where the ground is firmly shown even though the modelling is rather stylized.

Silver plates decorated with religious themes were also produced in quite large numbers at this period. They fall into two groups, those with figural themes, notably the series of plates and dishes with events from the life of David, and those where purely formal decorations predominate—a small cross or a monogram within a circle at the centre of the bottom is the most usual. Here the decoration is usually in niello, that is to say it is engraved, with a black pigment rubbed into the incisions and then fixed by firing. The David plates were all dug up in Cyprus at the turn of the century and all are dated by stamps to between 613 and 629. Some of them are comparatively small (about 14 cm. in diameter), like one in the Metropolitan Museum of New York depicting David slaying the lion, which might almost be mistaken for a secular illustration depicting Heracles. Others are comparatively large (about 27 cm. in diameter), like that with the Coronation of David in the museum at Nicosia in Cyprus. These include the finest examples in so far as the quality of the designs is concerned, for they are both interesting and well composed; on all of them the ground on which the figures stand is clearly indicated,

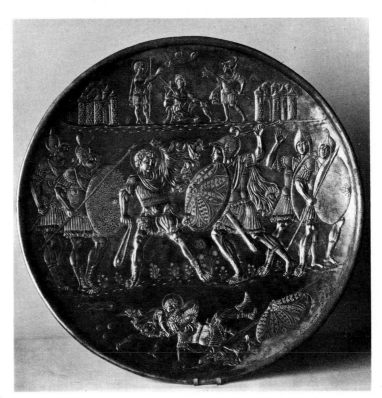

Silver plate. Scenes from
the life of David. From
Cyprus. 613–29. *The
Metropolitan Museum of
Art, New York, Gift of J.
Pierpont Morgan, 1917*

and though the conception is two-dimensional, there is nevertheless
a real feeling for space. And finally there is one dish, now in the
Metropolitan Museum at New York, which is unusually large (49 cm.
in diameter). Here the composition is in three tiers: above is the
Meeting of David and Goliath, with a firm base line separating it
from the scene in the middle, where the Combat of David and
Goliath is shown; finally, at the bottom, is the Slaying of Goliath.
The scenes at top and bottom are on a smaller scale than that in the
centre. The ground in the combat scene is marked by flowers and
plants which recall those that appear in the apse mosaics of San Vitale
or S. Apollinare in Classe at Ravenna. The composition here is per-
haps rather over-full, but there is a real feeling for movement and the
figures are well modelled.

None of the dishes of this series could ever be described as deca-
dent. Indeed they are all very impressive works of art, fit to rank with

the finest products of any period. It would nevertheless perhaps be true to say that those adorned with simple crosses represent the most truly progressive examples, for the designs are new and wholly Christian even though they are the least ambitious. Those that illustrate themes from the life of David combine interest with quality, even if they reflect more the spirit of conservatism.

A style that is akin, for in part it reflects the themes and figures of classical art, though in part the designs are new in that background detail or even the ground on which the figures stand tends to be omitted, characterizes the majority of the mosaic floors of this period, notably some of those from Antioch and, more especially, that of the Great Palace at Constantinople. The latter is still on its original site, though some of the Antioch floors are now in museums elsewhere. The date of the Constantinople floor has been much discussed. When it was first unearthed the very classical character of many of the figures suggested that it should be attributed to a date soon after 400. Subsequent excavations proved that on archaeological grounds this was impossible, and that the earliest period at which the floor could have been laid was around 550; more recently dates in the reign of Tiberius II (578–82) or even that of Justinian II (685–95 and 705–11) have been proposed. Whatever the date, the work has, stylistically speaking, reached the same stage of development as that of the silver plates of around 610; it represents a bridging stage between the true classical and the medieval phases. But neither in the silver dishes nor

Mosaic floor of the Great
Palace, Constantinople.
Sixth century

in the mosaics is the same advance towards a fully developed Byzantine style to be seen, as we find for example in the capitals and cornices of Hagia Sophia or in a number of the works on a smaller scale that have been mentioned in the first and fifth chapters.

The Constantinople floor is, however, a work of very great excellence both technically and artistically. The cubes are set with very great skill in order to produce the desired effect. All are small, and their size diminishes almost to tiny for the details, especially the faces. The colours too have been very carefully selected. Except for the blues, bright greens, and bright yellows, for which glass tesserae were used, the cubes are all of marble. The colours of these are extremely varied and the cubes were chosen with consummate mastery to produce very colourful and beautiful compositions. The motifs nearly all belong to a repertory which had been in existence for some centuries—beasts, trees, hunting scenes, circus combats, and so on—and close parallels for most of them can be found in floors of the fourth century at such places as Piazza Armerina in Sicily or in North Africa, where a profusion of floors survives. A number of floors of the earlier sixth century at Antioch may also be compared, but by this time the technical ability of the masters there had declined very considerably since the fourth and fifth centuries, and the work seen is very provincial in comparison with that of Constantinople, the cubes being large and their setting clumsy. This bears witness to the importance of the role played by imperial patronage, for Antioch was still probably the third city of the empire, and its inhabitants were rich and prosperous, but they could not command work of the same high quality as could the emperor at the capital.

Apart from its technical excellence there is another feature that distinguishes the Constantinople floor; it is that the figures, whether human, animal, or vegetable, are almost always depicted in isolation. They do not compose scenes other than those of a very elementary nature such as a hunter spearing an animal; still less do they illustrate events in the manner of the narrative art of Rome. A study of the mosaics led the excavators to conclude that several groups of technicians—workshops one might call them—were involved, so that the style is not identical throughout. Some masters were more proficient than others, some were more conservative; one, for example, set most of his figures on a clearly defined ground, though the others omitted this feature completely, silhouetting them in space as was done on the later silver plates. But, taken as a whole, the work

97

was balanced and imaginative. It clearly belongs to a medieval rather than to a classical phase of art.

To what part of the palace the floor belonged we do not know. All that can be said is that it covered all four sides of a great forecourt, like a cloister, with tall marble columns separating the sides from an open court in the middle. It served as a sort of atrium to a great apsed building overlooking the Sea of Marmara. Each side of the court was about seventy yards long and ten deep, and both the inner and the outer faces of the mosaic floor were marked by decorative borders about one yard wide. In the main area the figures were arranged in three registers, but these were not very rigorously set, nor did they have any relationship one to the other. The border was made up of a massive scroll with birds, formal plant forms based on lotus buds, and occasional human faces enclosed in its lobes; one of these faces had the appearance of a portrait from life, though others, depicting the head of Oceanus, followed a more stylized and long established iconography in the form of the god's head, with hair and beard merging into seaweed.

In addition to the Roman heritage in the iconography of many of the figures, the thought that inspired some of the scenes also savours of a Roman outlook, for example that where a mule is depicted shaking its load of sticks and its rider off its back, landing the rider a severe kick on the behind as he falls. Such boisterous humour seems far removed from the prevailing Byzantine outlook. But the scenes of bucolic life—vegetation, mares suckling their young, the lovely depiction of a water-mill, and so on—though wholly secular, do reflect the spirit of the Silentiary's poem on Hagia Sophia and accord well enough with the Byzantine outlook, while the absence of background, the two-dimensional approach, and the isolation of each figure or small group in space are features which clearly belong to the new conception of art, even if progress in this direction is less advanced than in Hagia Sophia. One is tempted to question whether this is to be attributed to the difference of outlook between religious and secular art, or whether it represents a subconscious slowing down of development brought about as a reaction against the tremendous expenditure and lavish patronage of Justinian's day. This may well have been the case, for certain other works which may in all probability be assigned to this age show similar features.

Alas, there are not many of them other than the floors and the silver. A few silks may be noted, the most important of which is probably

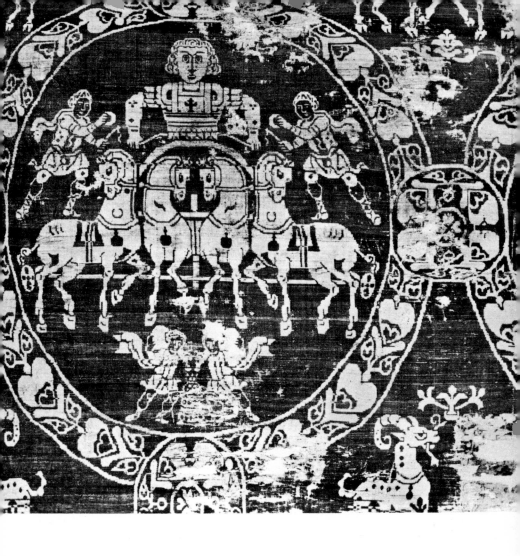

Silk textile. A quadriga.
From the tomb of
Charlemagne, Aachen.
, 800. *Musée de Cluny,
Paris*

that depicting a quadriga or four-horse chariot in a roundel found in
the tomb of Charlemagne at Aachen. One piece is now at Aachen and
one in the Cluny Museum in Paris. Below the quadriga some boys are
shown pouring coins out of sacks, and the closeness of these to
similar figures on some of the consular diptychs at one time persuaded
authorities to date the silk to the same period as the ivories, that is
soon after 500. But the borders of the medallions and the designs that
link these one to another savour rather of the early eighth century;
they may be compared with the mosaics of the Dome of the Rock at

Jerusalem (*c.* 690). It seems moreover inconceivable that an old textile could have been used for the burial of a personality of the importance of Charlemagne. Rather should we conclude that the weavers were turning back to an old motif, just as the mosaicists and the silver workers did, but were treating it in a new manner. Another silk, depicting a figure strangling a lion, of which there is a piece in the Victoria and Albert Museum, supports this conclusion. It probably represents David though Samson is a possibility, but it might equally well be interpreted as a representation of Heracles.

The disposition of the design on the former silk—a figural theme enclosed within a decorative medallion—follows an old Oriental model, for it would seem that this kind of arrangement was first developed in Sasanian Persia. It was probably introduced to the Byzantine world along with the actual material, silk. Till Justinian's day all the silk came from China by way of Persia, where it was apparently sometimes woven up before continuing its journey. In the case of the quadriga silk only the medallion is Eastern while the main motif is classical. On a textile in the Vatican which has already been mentioned (see p. 90), the Annunciation and the Nativity are similarly shown within medallions; here the main motif is Christian, but the medallion is Eastern. On another textile in the Vatican, where spearmen are arranged in pairs attacking lions on either side of a formal tree, the Sasanian influence is more considerable, for the figures wear Oriental costumes and the tree is derived from the old Mesopotamian-Persian sacred symbol, the 'hom', which was presumably of phallic origin, even if the hunters themselves are close to those depicted on the mosaic floor of the Great Palace at Constantinople. In fact we see once more in these textiles an interesting illustration of the mingling of influences, classical and Oriental elements combining under the guiding spirit of the Christian faith.

A number of works of art that were produced for Muslim patrons of the Omayyad period in Syria during the seventh and earlier eighth centuries may also be noted here, for not only did early Islamic art owe a considerable debt to Christian Syria but also, on occasions, to direct contacts with Byzantium. Justinian's patronage had played an important role in Syria before the land fell to Islam around 640, just as in other regions of the empire, and had left a sound tradition behind it. Men who had been schooled in the Byzantine idiom were employed in large numbers by Islamic patrons, but new ideas were also introduced from Mesopotamia and Persia and the influence that they

Mosaics of the Great
Mosque, Damascus. 715

100

exercised is very much to the fore in the superb mosaic decoration in the Dome of the Rock at Jerusalem (*c.* 690); that of the Great Mosque at Damascus, done for the caliph al Walid in 715, is more dependent on the classical world, for the trees and the architectural motifs are mainly of a type that originated in the wall paintings of Pompeii and Boscoreale even if examples of intermediary date exist in the church of St. George at Salonica or the Orthodox Baptistery at Ravenna, while the style is basically illusionist. The double-winged motif and the bejewelled ornaments that play an important part in the mosaics of the Dome of the Rock are essentially of an Eastern type and stem from Sasanian Persia. There are records suggesting that Constantinopolitan craftsmen were borrowed to work on the mosaics, and the formal trees are certainly very Byzantine looking, while the technique shows the same consummate skill as the floor of the Great Palace. But what is perhaps most interesting about these mosaics is the fact that at both Jerusalem and Damascus the scheme is wholly aniconic. Though human figures, even nude ones, formed an important part of the painted decorations in Omayyad secular art, in the mosques any form of representation of living persons was eschewed even at this early date in Islamic history. The mosaics of Jerusalem and Damascus may in fact be described as wholly Iconoclast decorations. Similar mosaics may well have been set up in the Byzantine world during the Iconoclast age, and in studying the origins of the provisos against figural art at that period consideration of this point should certainly be taken into account.

Though Byzantine art was in the main a figural, representative art, it underwent a phase between about 726 and 843 when figural representation of the divine or saintly form was forbidden. We know this phase as the Iconoclastic and it was instituted quite suddenly with the destruction by the emperor Leo III (717–40) of a number of much revered mosaics and other representations of Christ, notably one above the main entrance to the imperial palace. In order to understand the reasons that lay behind this ban and, indeed, many of the developments that took place when it was eventually lifted, it is necessary to examine certain ideas which had been prevalent in the Near East over a long period, ideas which are reflected in the repeated provisos against idolatry which recur as a sort of leitmotive through a great deal of the Old Testament.

Leo's attack on representation in religious art met with a good deal of opposition, and it led to a controversy which was to rage for more than a century, till in 843 the legitimacy of iconic art in the religious sphere was finally accepted. Some of Leo's successors were indeed fairly lax with regard to enforcing the ban; others were more exacting, none to a greater degree than his immediate successor Constantine V (740–75). What were the reasons that occasioned Leo's action and why was there so much support for his policy? How universal was the feeling against representation in religious art and when did it begin?

It was at one time fairly generally held that the imposition of the ban was to a great extent due to the access to power of an Eastern dynasty, whose members had been nurtured in a region where figural art was generally abjured. Jewish art, so far as it was then familiar, was cited as a parallel manifestation of this outlook, while Islamic art, where figures were often rejected even in secular work, afforded an even more satisfactory parallel to the Byzantine movement. In later times it was even asserted in Islamic writings that the artist who reproduced human forms would, at the Day of Judgement, be called upon to give them life, and when unable to do so would find himself accursed.

Recent research has, however, tended to throw rather a different light on the problem, for a number of authorities, notably Baynes and

Grabar, have cited instances of iconoclast thought in the Christian world from the time of Constantine onwards, and it would seem that a feeling against representation, in any case of the divine figure, had existed in parts of the Christian world from the very early days of the propagation of the new faith. At the Synod of Elvira, held in 305 and 306, it was decreed that no picture should be placed in a church, though it has been argued that this was not a general prohibition but referred only to the setting up or hanging of pictures of a movable, independent character as opposed to wall paintings which were fixed. It would seem that the portable picture was regarded as more dangerous than a full-scale, preconceived decoration, in that it would more readily attract an undue degree of reverence. In the fourth century an ecclesiastic called Epiphanius tore down a curtain in a church on which a figure was depicted, and in the reign of Justin II men of Samaritan origin are recorded as destroying Christian images. Baynes draws attention to a lengthy dispute in the sixth century when representation was attacked because it savoured of idolatry, but was defended on the ground that to pay reverence to a picture might be compared to kissing the seal of a royal document; in doing this, it was argued, homage was not paid to the seal, but to the emperor who issued the document. Justinian's decoration of Hagia Sophia was to some extent aniconic—in any case there was a great cross, not a depiction of Christ, in the dome, while on one face of his coins the cross was depicted and not, as in later times, a bust of Christ.

This severe attitude against representation no doubt derived from the attitude so often expressed in the Old Testament; the setting up of any graven image was indeed formally forbidden both in the Commandments (Exodus 20: 4–5) and in the Book of Leviticus (26:1). There, however, and throughout the Near East as a whole, it was primarily the three-dimensional representation that was held in disfavour; a painting, being two-dimensional, was considered less dangerous, presumably to a great extent because a two-dimensional representation did not cast a shadow. The shadow not only indicated an objective existence, but was also believed to serve as an aid to materialization; a two-dimensional work was more obviously a figment of the imaginative world, approaching less nearly towards the actual.

This attitude is reflected in many of the artistic developments that took place between the fourth and sixth centuries. A notable instance is offered by the early mosaic floors where classical models were

followed; in early times the shadows cast by the figures were indicated fully and completely, and the figures were silhouetted against plain, open backgrounds, as in the floor of the Great Palace at Constantinople. It would seem that to omit the shadow was regarded as a means of stressing the immaterial aspect of a picture, and it came to be practised even when there was no great need to stress the spiritual aspect, as for example in a secular floor. One of the principal reasons why three-dimensional sculpture virtually ceased to exist in the Byzantine world should no doubt be attributed to the same beliefs.

In this connection it is interesting to compare the attitude of Byzantine artists towards the human body in general. One of the most outstanding characteristics of Byzantine religious art is its disregard for the more material aspects of the human form. In early times a few nudes appear, like the figure of Adam on a well-known ivory of the fifth century now in the Museo Nazionale at Florence. But such figures are rare, and in later times representations of the nude were studiously avoided, and the more personal the figure the less attention was paid to its physical appearance. Thus in rendering personifications and similar figures there was some feeling for the body beneath the draperies, but when it came to the depiction of a living individual the costumes were so formal that they tended to look like dummies. In the more easterly portions of the empire the distaste for showing even a small portion of the nude form was marked, as for example in renderings of the Crucifixion, where Christ was depicted in a long robe, the collobium, and not in a loin cloth, as in the western regions, while in the scene of the Baptism Christ's body was obscured by the water in eastern renderings of the theme.

This attitude towards the human body is no doubt to be attributed to the penetration of ideas from the East which had already begun to transform the nature of Roman art in the second century. The same underlying ideas are reflected in the Eastern conception of monasticism which played so dominant a role in the Early Christian world. To mortify the flesh, to denigrate the body, was the objective that guided the anchorites of the Thebaid and Syria, for by doing so they laid stress on the importance of the inner man, the soul.

Anything that savoured too obviously of an attempt to reproduce nature at all exactly thus had its dangers according to the Eastern conception, and it was here that the greatest contrast to the classical attitude expressed itself. Classical painters had made the production

of an effect of life one of their main objectives; we read that eyelashes and life-tinting paints were added to the statues in the temples, while the painter Apelles was praised because the grapes that he depicted were so realistic that the birds came and pecked them. If the birds could be deceived in this way, so might man be deceived into thinking that a statue was imbued with life, and such thoughts no doubt struck the early Christian Fathers and helped to intensify their dread of figural sculpture, which not only cast a shadow but was also already suspect because it was the art *par excellence* of paganism. Painting, on the other hand, was more clearly illusionistic and was used by the Christians in the catacombs and elsewhere from the earliest times. Eusebius, in the fourth century, went even further when he inquired why it seemed necessary to borrow the human body in order to present the divine wisdom.

Whatever the attitude of the extremists may have been pictures were nevertheless favoured by the majority. St. Gregory of Nyssa thus stated that the painter, with his colours, could play a very useful role in the propagation of the faith, for paintings on the walls of churches constituted a visual book of Christian teaching, while St. Nilus, in the fourth century, said that scenes from the Old and New Testaments should be depicted in the body of the church so that those who could not read could follow the Bible story; but he added that in the sanctuary the cross only should be shown. He expressly stated that secular scenes, more especially the hunts so popular on the mosaic floors, should be avoided. Nor was there any universal proviso against representational paintings in early Jewish art, though opposition to them was a good deal more marked than in the Christian area. Figures thus play a prominent role in mosaic floors from a synagogue of the second century, now in the Damascus Museum, and in floors at Hamman Lif near Carthage, as well as in the paintings of Old Testament scenes in the famous synagogue at Dura. At the Quinisext Council in 691/2 a decree was promulgated which supported the same attitude. It was there enacted that the use of the symbol of the lamb to portray Christ should be avoided, for it represented only the prefiguration and the shadow of the truth, while the actual depiction expressed the whole grace and truth of his nature, 'a perpetual vision of God'. The object of art, it was further stated, should be to make the sufferings and life of Christ clear to the faithful. Thus for the great majority representation when looked on as a visual text held no dangers; even the representation of Christ, the Virgin,

and the saints was permissible in so far as it was regarded as no more than a means of approach, an aid to recognition. If this outlook had been more universal the extreme views of the Iconoclasts might never have been enforced.

But it was not universal, and the problem became serious as soon as the picture began to be reverenced in and for itself, and even more so when a belief grew up that there was a unity of identity between the picture and its prototype, or that the image itself was imbued with miraculous power. Here lay the danger, and when these beliefs became more universal, as they did between the sixth and the eighth centuries, God's displeasure at the course events had taken was seen in the disasters that beset the state at the time. Leo's action was precipitated by this belief; that of his successors, more especially Constantine V (740–75), went even further and the representation of Christ was condemned because his nature was divine and its depiction therefore impossible for man.

This view at once brought to the fore again the question of Christ's true nature, which had been so hotly debated at the various synods of the Church and had resulted in the proclamation of the Mono-physites and Nestorians as heretics, so that to the question of the legitimacy of representation was added that of the definition of the Saviour's true nature. A new council was summoned in 753 to examine the problem and another in 815 reiterated its findings. The most essential of its decisions appears to have been that, to attempt to depict Christ as the Godhead mingled with manhood savoured of the Monophysite approach, while to depict him in his human character alone was to adopt a Nestorian outlook. The two outlooks were condemned as equally heretical. So argued, any representation of Christ clearly tallied with espousing a heresy rather than true Orthodoxy; and if it was wrong to represent Christ it was argued that it was equally wrong to depict the Virgin or even the saints, who also savoured of the divine, if only to a lesser degree. So the whole essence of Christian doctrine was brought to bear on the problem of repre-sentation; and even if it can be argued that the views of all parties were not put forward at the council, it met in all seriousness and its decisions carried the day, even if they were to be refuted later when the icons were reinstated.

It has been suggested that outside the capital the ban was not always very rigorously enforced, and representational works in such places as the rock-cut churches of Cappadocia were perhaps executed

while the Iconoclast ban was still in force; monastic circles were nearly all opposed to the movement. But other work was done in Cappadocia which was truly non-representational and it would seem that even there a truly Iconoclast outlook dominated in any case in some circles. These non-representational paintings, notably those in the church called Tokali Kilisse, constitute indeed one of the most complete monuments of Iconoclast art that has come down to us. When once the ban was lifted Iconoclast works were destroyed with almost the same fervour as were the figural ones when the ban began. Figural work seems, on the other hand, to have remained in favour with little interruption in the monastery of St. Catherine on Mount Sinai and the impressive mosaic of the Transfiguration there, together with those representing St. Demetrius in the church of that name at Salonica and also some scenes in churches in Cyprus were certainly not destroyed, and it seems unlikely that they were even covered over. Nor was the ban enforced with equal severity throughout the whole of the Iconoclast period, for there were several interludes when figural art was permitted, notably one during the reign of Irene about 787.

It has thus been suggested that some of the mosaics which survived in the church of the Assumption at Nicaea until they were destroyed about 1922 during the Graeco-Turkish wars were set up at this time, notably the standing figure of the Virgin in the apse, the Hetoimasia or Preparation of the Throne on the arch before the apse, and the four archangels or 'powers' on the bema vault. They are accompanied by an inscription from Psalm 110 (109): 3 and a text which alludes to the sacred character of the figures, and it has been argued that this would have had little point if the mosaics had been executed after the ban was lifted. The style of the work would support such a date, for they are surely early rather than late, and some authorities have proposed that they should even be attributed to the sixth or seventh century. Happily good photographs were taken before the mosaics were destroyed and a careful study of these led Dr. Paul Underwood to argue that the mosaics that were visible before 1922 were actually set up during a restoration undertaken immediately after the end of Iconoclasm, and that they reproduced the original ones done around 787 well-nigh exactly. At a date soon after 787 he thinks that the figural work was taken down, though the decorative borders and the inscription were left and re-used when the mosaic was later restored. In the conch the figure of the Virgin was replaced by a cross, and

Mosaic in the apse of the church of the Assumption, Nicaea, now destroyed. c. 850

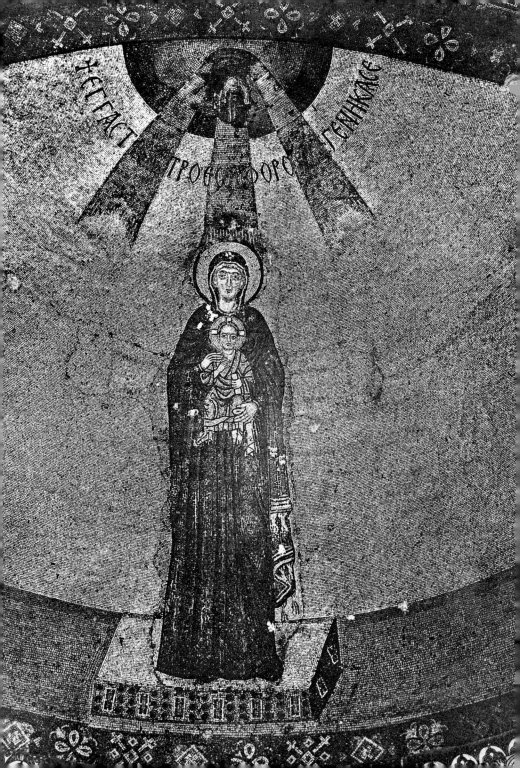

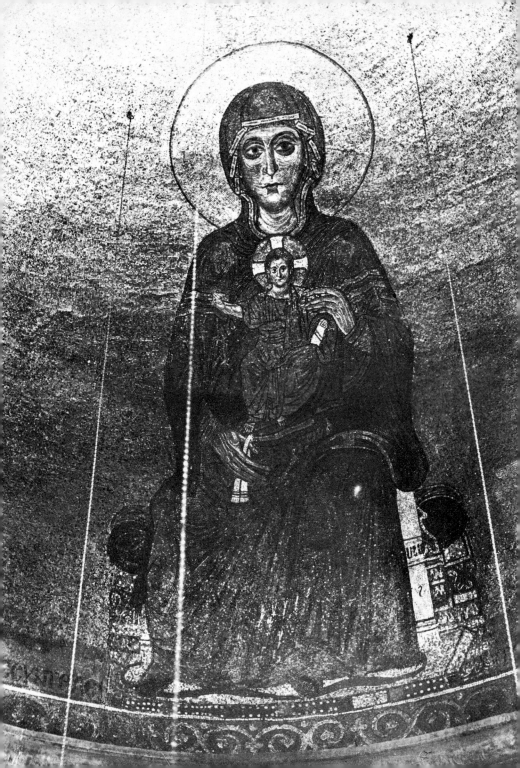

 saic in the apse of the
urch of Hagia Sophia,
lonica. Second half of
e ninth century. *Photo
kides*

ve

saic in the apse of the
urch of St. Irene,
nstantinople. Eighth
tury. *Josephine Powell,
me*

Underwood was able to distinguish its outline in the gold of the back-
ground, which had been left untouched throughout. The similarity
that the archangels show to the one that survives on the vault before
the apse in Hagia Sophia at Constantinople, which is firmly dated to
867, would support a similar or even slightly earlier date for the
restoration at Nicaea. Whether or not Underwood's ingenious

Silk textile from Mozac.
c. 950. *Musée des Tissus,
Lyon*

theory is correct, one thing is certain, namely that during Iconoclasm
there was a cross in the apse at Nicaea and that when the ban was
lifted it was replaced by the figure of the Virgin.

Exactly the same thing happened in Hagia Sophia at Salonica, and
here again the outline of the cross can be distinguished in the gold of
the background, which was left untouched when the mosaic was
refurbished. The cross had formed part of an extensive but strictly
Iconoclast decoration which was set up in the bema by Constantine
VI (780–97), and his monogram is still to be seen on the vault. When
they were complete these decorations must have been very similar to
that which still survives in the church of St. Irene at Constantinople.
It stands on a simple stepped base, an arrangement which was also
followed on the coins. Another form of cross, where stylized plants

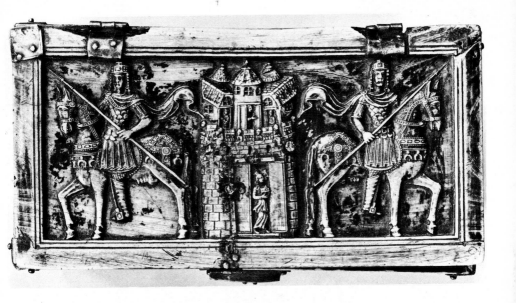

Ivory casket, Troyes
cathedral. Tenth century.
Hirmer Fotoarchiv München

spring up on either side of the stem, was also a favourite Iconoclast
motif, though it continued in use during the following centuries.
Crosses of the type adorn two of the pages of a famous manuscript,
the *Homilies* of Gregory Nazianzus, which was executed for Basil I
around 880 and is now in the Bibliothèque Nationale at Paris (Gr.

Bronze doors in the south
porch of Hagia Sophia,
Constantinople. 843.
Hirmer Fotoarchiv München

510). Such crosses also appear on sculpture and metal work of the post-Iconoclast age quite frequently, notably in repoussé on the back of a fine reliquary of the tenth century now at Limburg in Germany 129 (see p. 128). These leafed crosses represent one of the very few elements of Iconoclast art that survived without substantial change, though its formal, abstract spirit was reflected in the stylistic character of mid-Byzantine work very much more than is sometimes realized.

If there are but few works of art in the religious sphere that survived the end of Iconoclasm, there are some secular products which have been claimed for Iconoclast patrons by Grabar, notably a silk bearing the figure of an emperor driving a chariot, now in the 112 Museum of Textiles at Lyons, a fragment of a rather similar silk in the Victoria and Albert Museum, and a very interesting ivory casket at Troyes, which bears hunting scenes on the sides, two imperial 113 figures confronted on the top, and phoenixes of very Chinese appearance at the ends. The figures on the top wear costumes of Sasanian type, and they and the phoenixes at the ends were probably inspired by models imported from or by way of Persia. It is, however, far from certain that the casket is of so early a date. But we do know of one very remarkable secular work of the Iconoclast age from descriptions, namely the wonderful throne made for the emperor Theophilus, which could be raised into the air amidst a cloud of incense; beside it was a tree of gilt-bronze on which there were birds that sang and below were lions also of gilt-bronze, which roared and beat the ground with their tails. Such things were apparently popular at the Abbasid court at Baghdad, and their appearance in Byzantium attests that contacts between the two areas were close. One work in metal that is undoubtedly Iconoclast and that does survive is the south door of Hagia Sophia, set up under the emperors Theophilus and Michael in 843, just before the ban was repealed.

If Dr. Underwood's theory is correct, the figures of the four arch-
angels and of the full-length Virgin in the apse at Nicaea must have 109
been restored very soon after the end of Iconoclasm. As we have
already seen, there is little to distinguish them as belonging to this
period from a purely stylistic point of view; they might, on the basis
of style, equally well belong to a pre-Iconoclastic date. But a mosaic
depicting the Virgin in a seated position which was erected probably 110
in the sixties or seventies of the ninth century in the church of Hagia
Sophia at Salonica is, on the other hand, more definitely characteristic
of the early post-Iconoclast period and no one has ever even sug-
gested that it could be attributed to an earlier date. What is it that
distinguishes these renderings one from another, apart from the very
obvious matter of the position of the figures, one full length and the
other enthroned? The Salonica mosaic is, in the first place, somewhat
inferior artistically; it is clearly a provincial work whereas that at
Nicaea is more polished, more elegant, more proficient. Apart from
this both adopt a severely frontal attitude, but at Nicaea the face is
open, one might almost say gay, in expression, while at Salonica the
effect is one of mystical spirituality. At Nicaea the eyes are bright and
clear; at Salonica they are large and visionary. At Nicaea the setting
of the tesserae is free and seemingly casual, as in most work of the
pre-Iconoclast period. The face is outlined by two rows of green
cubes, but then—to judge from the excellent coloured facsimile given
by T. Schmidt in his work on the church—the cubes are set in groups
which at a distance produce a successful colouristic effect, like the
brush dabs of a Pointillist painting; they do not in any way follow
the contours of the face. At Salonica the cubes are arranged rhythmic-
ally in parallel curves, the oval of the eyes being reflected in a series
of curves which extend right down to the cheek-bones, while the line
of the cheek-bones is similarly reflected down to the mouth. This
linear technique is quite different from the Impressionist method of
the Nicaea mosaic, and goes hand in hand with the less naturalistic
style to produce a more spiritual, more imaginative effect, which is
wholly in keeping with the artistic taste of the post-Iconoclast period.
This linear method was to dominate in the setting of the cubes of the
mosaic decorations from this time onwards till, in the twelfth and

thirteenth centuries, the stress on curves became virtually a manner-
ism, notably in figures of St. John the Baptist—there is a typical
example of the later twelfth century at Monreale in Sicily—where the
conventionalization was used in a particularly exaggerated manner to
stress the saint's ascetic nature.

How long after the end of Iconoclasm the Salonica mosaic was set
up we do not know. It is possible that it was inspired by the similar
but more accomplished depiction in the conch of the apse of Hagia
Sophia at Constantinople, which has now been firmly dated on
technical grounds to the year 867. When this was uncovered between
1935 and 1939 from below the layer of Turkish plaster that obscured
it, a great deal of discussion arose as to its date, for though there was
a fragmentary inscription on the face of the arch in front of it, in
which the names of the emperors Michael (842–67) and Basil I (867–
86) were both mentioned, the face of the Virgin was so tender, so
intimate, that many authorities considered that it could only have
been done at a later date, when a more humanistic conception than
that which dominated in the ninth century came to be developed.
Only when a subsidiary cleaning and closer examination were under-
taken by the Byzantine Institute of America in 1964 was the fact
firmly and finally established that all the work in the apse was certainly
of the same date. The figure and face of the Virgin must thus have been
completed simultaneously, twenty-four years after the end of Icono-
clasm. The swirling, linear setting of the cubes is here a good deal
less marked than at Salonica, but the figure is none the less truly a
mid-Byzantine work, and it doubtless served as the inspiration for
many other versions of the theme, which was from that time onwards
universally adopted for the decoration on the conch of the eastern
apse just as the bust of Christ Pantocrator, the Almighty, was
adopted for the adornment of the central dome.

Though two pages of the famous *Homilies* of Gregory Nazianzus
bear decorations of Iconoclast character, the remainder of its
numerous illustrations show a great diversity of styles. Some pages
are in a conservative, monumental style in which classical elements
are to the fore, like that where Isaiah is shown standing between
Night and Dawn, both represented by figures of very classical 118
appearance. Other leaves, which are equally monumental, are
more truly mid-Byzantine in that they depict New Testament
scenes with great spiritual understanding. The majority of the illus-
trations in the manuscript, however, are of a purely narrative type.

ΝΥΣ HCAIAC ὅρθρος

Illumination from the
Homilies of Gregory
Nazianzus. *c*. 880.
*Bibliothèque Nationale,
Paris, no. 510*

Many depict Old Testament scenes or events in the lives of saints; a
leaf depicting Moses, St. Paul, Elijah, and Elisha and, below, the
Crossing of the Red Sea, may serve as an example. Each page is
divided into two or sometimes three horizontal registers and the
scenes are often depicted in succession without divisions or borders

118

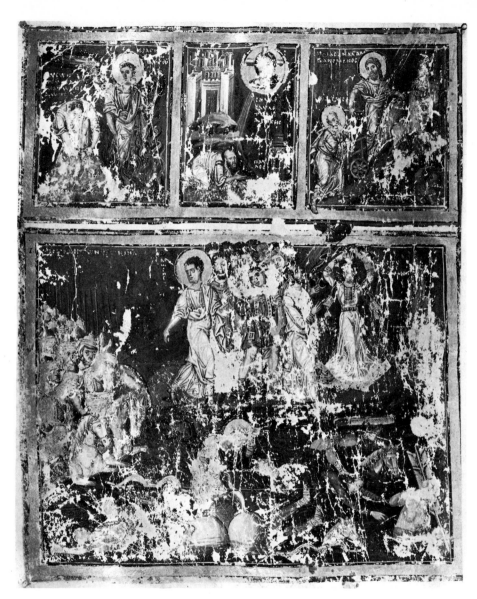

Illumination from the
Homilies of Gregory
Nazianzus, f.264v. Moses,
St. Paul, Elijah, and
Elisha; Crossing the Red
Sea. *c.* 880. *Bibliothèque
Nationale, Paris, no. 510*

between, like a continuous panorama cut up into sections and placed
one above the other. This system was normal in the wall paintings of
the majority of the rock-cut chapels of Cappadocia, where the walls
are similarly divided into several registers; there also the scenes are
depicted without divisions between them. This narrative style must

have been developed before Iconoclasm, though it was in general associated with the monastic rather than the court trend in Byzantine art. Its origin has generally been associated with Asia Minor, where monasticism flourished and where a great many ideas were first developed before being more widely adopted throughout Byzantine art.

Another important manuscript of this age is that usually known as the Paris Psalter (Bib. Nat. Gr. 139). Here the illustrations are grand and impressive, each one occupying a full page all to itself. One might even say that the narrative has at times been sacrificed in favour of presentation, for all those who should participate in a scene are not in every case included—as for example in The Penitence of David, where he bows down in repentance not before the figure of the Almighty as the narrative demands but before the margin of the picture! Taken as a whole, however, the compositions are impressive and obviously reflect the classical heritage of earlier times; so much so, in fact, that the manuscript was at one time regarded as a work of the seventh century. Several different painters must have been involved in the illustrations and they were not all equally proficient, but the two most competent of them produced pictures which are of real beauty as well as being powerful and convincing illustrations.

Though he began his life as an uneducated peasant and acquired the throne by means of murder, Basil I was a good emperor and a very active patron of sacred art, and the records attest that he was not only responsible for the decoration in mosaic of several churches in Constantinople, but that he also devised a new system for the disposal of the scenes and figures over the vaults and walls of the building. Most important of these decorations were those in the church of the Virgin of the Pharos and in another building nearby, also in the Great Palace area, called the New Church or Nea. Both decorations appear to have been striking and original. The Nea was a five-domed building, one dome being at the crossing and the others not on the arms of the cross but on the corner chapels; the form was that now usually termed the quincunx. The lost mosaics have been analysed by Professor Demus. They would seem to have followed an arrangement which was to become well-nigh universal from that time onwards. In the central dome a great bust of Christ was placed; he looked down on the church in the same way that the Almighty was believed to look down from heaven on to the world. The Virgin occupied the next most important position, in the semi-dome of the apse at the east, while the principal scenes of Christ's life were ranged

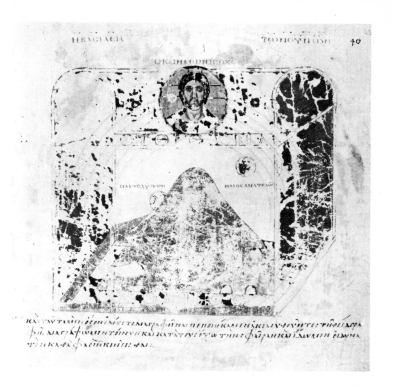

Illumination from the manuscript of Cosmas Indicopleustes. Ninth century. *Photo Vatican Library*

on the upper registers of the walls. When the dome was set on squinches—the conch-shaped niches used to transform the square below into the circle on which the dome rested—four especially important scenes were selected to occupy them; when the dome was on pendentives they were usually occupied by the four evangelists. The lower levels of the walls were either covered with marble slabs, as in the early eleventh-century church at Hosios Lukas, or were occupied by rows of saints, shown frontally and full length; it was believed that they fulfilled the role of intermediaries between the world of everyday and the spiritual world of heaven above. The church was thus looked on as a sort of microcosm of the actual world, and the idea seems to have been suggested by the text, and perhaps more particularly the illustrations, of a book which had been first produced during the days of Justinian; it was compiled by a man whom we know as Cosmas Indicopleustes, the Voyager to India. Its text was in the main devoted to a description of the universe as Cosmas saw it, and the illustrations depicted it as a sort of rectangular box

with the waters that are under the earth below and heaven, in the form of a vaulted lid, above, from which the Almighty looks down on to the world in between, formed by the body of the box. Admittedly the earliest copy of the book that has come down to us dates from the ninth century and is therefore of much the same period as Basil's churches, but its illustrations no doubt followed those of an early version fairly exactly, in any case so far as their iconography was concerned. Just as the text was intended to be a close copy of the original, so the illustrations also followed the model, even if there were changes in style due to the later date of the copy. Wherever it originated, however, this conception of the universe was certainly dominant in religious thinking in the ninth and tenth centuries, and it exerted an influence on the decoration of church interiors, engendering a system which continued in use right down to the nineteenth century.

The rows of saints that in accordance with this system of decoration occupied the lower registers of the walls have probably been more responsible for the accusations of monotony that have been levelled against mid-Byzantine art than any other single feature, in that their poses are all well-nigh identical and, since they are nearest to the spectator, they therefore constitute the most obvious part of the decoration. As the costumes of each saint are very similar and their physiognomies had to conform to set rules there was little variation from church to church. But this very monotony was an important element in the mid-Byzantine conception of art. Stress on a rhythmical effect had, as we have seen, already become characteristic of such decorations in the sixth century as, for example, in the Processions of Martyrs in S. Apollinare Nuovo at Ravenna, and the trend was enhanced by the affection for a repetitive, patterny type of decoration which was inevitably accentuated during Iconoclasm. Stress was again laid on a formal massing of figures by the oriental court ritual that had been developed at the same time, while the massing also had a spiritual significance in that it was desirable that the number of figures available to mediate with the divine power above on behalf of the congregation should seem well-nigh infinite; the greater the number, the more effective the mediation. In judging these figures as part of a church decoration it is essential to see them as far as possible through Byzantine eyes, realizing in the first place the spiritual significance of their presence and in the second accepting the fact that their very monotony was intentional and important. A

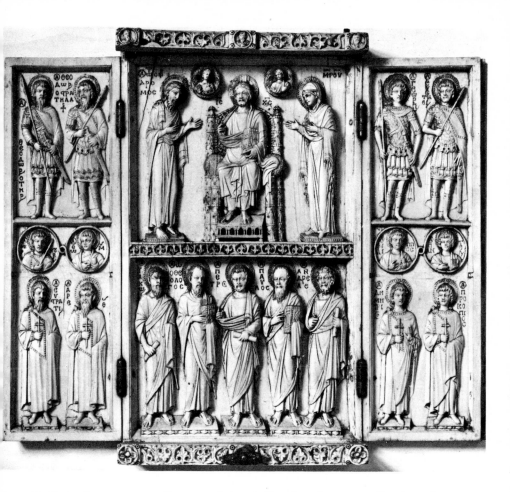

Ivory. The Harbaville
triptych. Tenth century.
In the Louvre, Paris.
Hirmer Fotoarchiv München

prayer oft repeated was believed to be more efficacious than one
offered only on a single occasion; a prayer offered up by a mass of
supplicants became part of the very mass itself. As Father Gervase
Mathew put it in his book *Byzantine Aesthetics* (p. 24): 'The sound in
a Byzantine hymn, the gestures in a liturgy, the bricks in a church,
the cubes in a mosaic, are all matter made articulate in the Divine
praise; all become articulate through being part of a rhythm.'

This conception of the correct form of decoration for the walls of
a church was reflected on a reduced scale in the adornment of many
of the small works of art of the period. A lovely ivory carved towards
the end of the tenth century which is now in the Louvre may serve
as an illustration. It is a triptych which served no doubt as a sort of

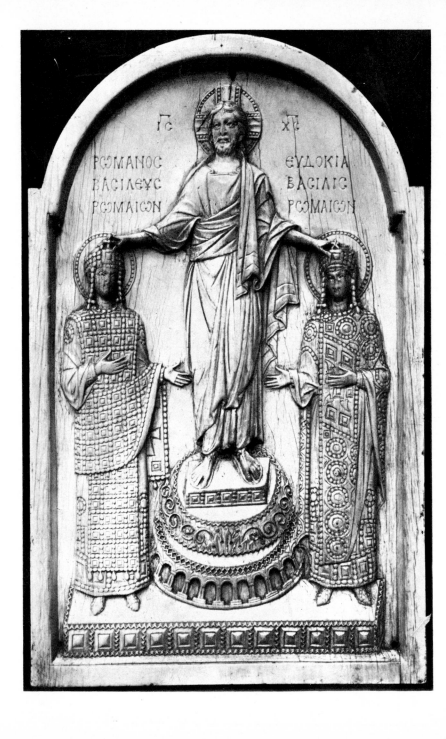

portable altar, and at the top of the central panel Christ is depicted between St. John the Baptist and the Virgin; they intercede with him for the sins of the world. It is the theme known as the Deesis in the Orthodox world. Below and on the wings the prayer is taken up by rows of saints, each of them an individual in himself but all of them uniting in an identical prayer and thereby adding to the significance of their intercession. On the back of the central leaf is a cross, symbol of Christ's victory and symbol too of his presence on earth, so that the ivory becomes a sort of miniature church, an ever-present reminder of the very essence of the Christian faith.

As we look at such things today, when faith of this sort is no longer quite so universal as it was in the Byzantine age, it is the superb quality of this, and many another, ivory that first attracts us. Indeed, whether they worked as ivory carvers, as metal workers, as designers of exquisite enamels, or as silk weavers, the skill and mastery of the mid-Byzantine craftsmen was supreme. But the themes were nearly always basically religious even if they were not wholly Biblical. Thus if an emperor was portrayed, as in the lovely ivory depicting Romanos II and his queen Eudoxia, now in the Cabinet des Médailles in Paris, he is being crowned or blessed by Christ, so that his dependence on the divine power is stressed as well as his role as Christ's vice-regent on earth; if spirited mounted figures are portrayed, they are Christian saints like St. George or St. Demetrius; if there are elegant female figures they more often than not symbolize Christian virtues like Humility and Truth.

This, however, was not the case with secular art. Purely secular objects are today few and far between; the most important of them are the silks and the ivory caskets, and it is only these that could serve, as Yeats wrote, to keep a drousy emperor awake or delight the lords and ladies of Byzantium. His verses serve to indicate what pleasures such things might bring, for Yeats was in no way concerned with the Christian import of Byzantine art.

Nearly all the caskets are bordered with narrow strips of ivory on which rosettes are carved—and though a few of the caskets are made up of plaques adorned with saints, most of them represent classical or mythological themes of a purely secular character. They were probably used as jewel caskets. The majority of the silks were also secular, though here the motifs were Oriental rather than classical. Hunting scenes, animals, birds, or fantastic monsters formed the most usual motifs of the decorations, and they were generally de-

Ivory. The Crowning of
Romanos II. 945–9.
Cabinet des Médailles, Paris

picted in pairs and set in medallions. The majority of the silks that have come down to us have been found in the graves of Western saints or bishops, and one wonders why silks bearing such purely secular themes were chosen, and why it is that only among the silks and the caskets the secular themes have survived. One would have thought that objects with a religious connotation would have been more readily preserved. They would have been cared for and used with reverence in the churches and would perhaps more often have been spared when a town was sacked, whereas secular things would have suffered more constant wear and tear and would at once have been looted. But why were nearly all the textiles that were imported in the West adorned with secular themes even though they were used for the burial of saints and bishops? It is a question to which there is no clear answer.

The two centuries that immediately followed upon Iconoclasm actually saw the fullest and most complete development of the true Byzantine style in art. Though the empire was by no means as vast as it had been in Justinian's day, it was still very considerable and it was remarkably prosperous both politically and economically. Vast resources of wealth and of precious materials like ivory, gold, silver, or silk were available, and the majority of the emperors were very generous patrons. They were joined in this by the nobles and to a greater degree by the Church, though church patronage was in the main devoted to the decoration of the churches themselves rather than to the production of exquisite objects on a small scale. But if some external figure like an emperor or a nobleman was required to assist with a decoration in an expensive material like mosaic, a wall painting was within the capacity of the church community or the monastery, and the Biblical themes were an essential to every interior. In addition church furnishings were no doubt important, though none has survived, and as time went on painted panels or icons became more and more numerous. Such things may have been intrinsically less valuable than the treasures sponsored by the emperors, for the materials used were a great deal less expensive, but from a purely artistic point of view they are not necessarily less significant.

One of the most important forms of church patronage was in the copying of manuscripts, many of which were illustrated. Gospel books, copies of the earlier books of the Old Testament (Octateuchs), the sermons of the church Fathers, and liturgies for use in the church

services were all produced in large numbers, and the majority contained at least a few illustrations. The Gospel books usually tended to follow rather set forms, for the illustrations were in general limited to a portrait of each evangelist at the beginning of his Gospel, while it was seldom that more than a very few scenes were selected for illustration. Such scenes were usually chosen from the principal 'feasts', the Annunciation, the Nativity, the Presentation, the Baptism, the Transfiguration, the Raising of Lazarus, the Entry into Jerusalem, the Crucifixion, the Ascension, Pentecost, and the Dormition of the Virgin. Occasionally a Gospel book was more fully illustrated, and in a few that have survived virtually every scene of Christ's life and Passion is depicted, though the illustrations in such cases are of a sketchy character, primarily interesting from an iconographical point of view. They were perhaps intended as aids for those who could only read with difficulty, so that they could follow every detail of the story; the object of the larger illustrations was to inspire the worshipper, an idea which was carried further in the panel paintings we call icons, which always had a greater spiritual significance in the Orthodox world than religious pictures ever had in the West.

In the lavish days of the tenth and eleventh centuries the icon was not necessarily always a simple panel of wood bearing a painted decoration; it was often made of precious materials, and many of the ivories, works in metal, or enamel that we know, are really to be described as icons. With the eleventh century mosaic panels on a small scale also began to become popular; at first they were virtually wall mosaics of smaller size, the cubes set in plaster. There is a fine one of the Virgin and Child in the church of the Patriarchate at Constantinople which dates from about 1065. Later they were more like miniatures, the cubes, often no larger than a pin's head, being set in wax. The most interesting painted panels we know are those preserved in the monastery of St. Catherine on Mount Sinai, where there is an astonishing collection which has only recently been examined, and still awaits full publication. Others are to be found in museums of the U.S.S.R.; they were taken to Russia along with other treasures made in Byzantium specially for Russian patrons; there they were preserved in the churches till the time of the Revolution, when the majority were transferred to museums.

The majority of the ivories and other small objects bearing sacred figures or scenes were actually not icons, but were used as book

covers or mounts for relics, and they are closely related in character to the other precious objects which were used in the church ritual, such as chalices and patens. Ivories were set in metal mounts and were surrounded by jewelled frames so that they could serve as covers for copies of the Gospel, especially those that stood on the altars of the larger churches. Relics were preserved in very large numbers. They consisted of the bones or parts of the costume of the most revered saints or more especially of small fragments of the true cross. Here the fragment was usually set in a container in the form of a double-armed cross, the upper arm or traverse apparently representing the notice that was placed above the body. This was often enclosed in a sort of flat frame, richly adorned with enamels and jewels. One of the finest of them that survives is now at Limburg on the Lahn in Germany; it was made for the emperor Constantine VII Porphyrogenitus (913–59), and was brought to the West as part of the loot collected after the Fourth Crusade (1204). There is an impressive leafed cross on the back in relief. Usually the figures of Constantine, the first emperor to recognize Christianity, and his mother Helena, whose researches were responsible for discovering the true cross, were shown on these reliquaries, more often than not being depicted in repoussé work on the metal frame. The patens and chalices were either of metal or carved out of some precious or semi-precious stone, set on a gold stem and adorned with enamels or jewels; there are numerous examples in the treasury of St. Mark's at 130 Venice, where they too were taken after the looting of Constantinople by members of the Fourth Crusade. All these objects were both precious and beautiful. Earthly beauty of this sort was generally regarded as a manifestation of spirituality, so that the more lovely and glorious the object the greater was its sacred import. And at this period richness of material was certainly highly prized as a constituent of beauty.

The age that intervened between Iconoclasm and the crusading conquest of 1204 can, so far as art is concerned, be treated more or less as a single period, whether the emperors of the great Macedonian dynasty were in power (867–1059) or only the less successful rulers of the Dukas, the Comnene, and the Angelus lines (1059–1204). The phase is generally referred to as the Second Golden Age of Byzantine art. It was at this time that the art developed along its most characteristic lines, and though at an earlier period Byzantine art can loosely be described as late Roman and at a later date as pre-Italian, at this

Metal back of the
Limburg reliquary.
Germany. *c.* 950

time there is no mistaking it for anything other than Byzantine. It had
developed into a precise and clear-cut style of its own. Its first phase
is sometimes described as the Macedonian Renaissance, its duration
more or less coinciding with that of the Macedonian dynasty (867–
1059). In many respects the art of this age did represent a renaissance
in the literal sense of the word, that is to say not only was it an age

of progress and artistic excellence but also one when the style of a past age of prosperity was to some extent reborn.

In the Macedonian period this rebirth is especially manifest in manuscript illumination, for such manuscripts as the Paris Psalter, which we have already mentioned, and the Joshua Roll in the Vatican clearly reflect the style of late classical art. So classical indeed are some of the illustrations of the Roll and the Psalter that both manuscripts were at one time dated to the sixth or seventh century rather than to the ninth, the date that is now generally accepted. The illustrations of the Joshua Roll may thus in many respects be compared to those of the Ambrosian *Iliad,* a classical manuscript which has been variously dated between the third and the sixth centuries—the later date seems the more likely. The poses, the features, the costumes, and the general appearance of nearly all the figures in the Psalter are highly reminiscent of those prevalent in earlier times even if certain stylistic features support the later date. In many of the manuscripts of this age the classical heritage is also attested by the presence of numerous personifications such as the dark figure of Night with a shawl over her head or Dawn depicted as a boy holding a torch, both of which appear in the scene of Isaiah's prayer in the Paris Psalter. Further, the very conception of a manuscript in the form of a Roll

Chalices with enamel decoration, in the Treasury of St. Mark's Venice. Tenth or eleventh century

was archaic, for well before the ninth century the bound book had become well-nigh universal. Figures which pertain to classical mythology were again depicted in a very classical manner on the ivory caskets or used as illustrations to the classical texts, which continued to be widely read throughout the whole Byzantine period, for the study of classical literature was an essential part of a university education.

Today it is the fashion to lay special stress on the role of the classical heritage in Macedonian times. But without attempting to deny its importance, it must be stated that it is a tendency that can be over-emphasized. For example no form of architecture could be further removed from the classical either in appearance or in spirit than a typical mid-Byzantine church, like those in the monastery of 132 Hosios Lukas in Greece; no sculpture could be less close to a classical model than the fragmentary statue of an emperor of the tenth or 133 eleventh century now preserved in the Museum of Antiquities at Istanbul. Though costumes may often recall those of the classical age, the whole spirit and aesthetic understanding of an ivory like the Harbaville triptych in the Louvre is completely un-classical, and the serried ranks of saints, posed frontally in formal attitudes, are totally opposed to every canon of classical art. In fact all these, and most other mid-Byzantine works, reflect the spirit of the Oriental trends in art that we noted at the outset just as much as, if not more than, they reflect the classical, and in many ways it would be almost as true to

The monastery of Hosios
Lukas, Greece. *c.* 1000.
Josephine Powell, Rome

speak of an Eastern as of a classical renaissance in Macedonian times. The essential is to realize that almost every work of the age has been formed in the spirit of the Christian faith, to constitute a Christian and a Byzantine work of art and it is in this that the essentials of their quality and their interest lie. To look at these things with an eye attuned only to the classical key is wholly to misunderstand the basic nature of mid-Byzantine art.

If this is the case with the grand objects made of precious materials that were to a great extent produced under imperial patronage in Constantinople, it is even more true of the very numerous products

Marble sculpture. An
Emperor. Eleventh
century. In the Museum
of Antiquities, Istanbul.
Hirmer Fotoarchiv München

133

of provincial art, many of them executed in the cheapest of materials. The best known are the numerous wall paintings that adorn the chapels cut out of the rock by the monastic communities in Cappadocia. We know nothing of the minor arts of these regions, for they were no doubt simple and perishable and not even a piece of pottery has come down to us. But the wall paintings have been preserved in large numbers, and represent a very important chapter in the story of mid-Byzantine art. They are not always very elegant or very polished, but they are all wholly sincere and often very effective, and they exercised quite a considerable influence on future developments, bringing to the exquisite art of the capital an element of realism and spirituality which might well have been lost sight of if a more sophisticated style had been given uninhibited rein. Monasticism was always important in the Byzantine world, and monastic art exercised a very powerful influence in more spheres than one.

Finally a word or two must be said about the secular arts, where Oriental influence was often very much to the fore. In this case, however, what we see is not so much the influence of the Syrian style which we discussed above, but rather that of Islamic or of the earlier Sasanian art. Indeed the Sasanian was a major style which exercised a very extensive influence both in its own day and subsequently, and this influence extended to western Europe in one direction and to China in the other. We have already called attention to the markedly Sasanian character of many of the motifs used in the decoration of textiles, notably medallions to enclose other designs and the confronting or addorsing of animal or human figures with the symbol of the 'hom' or Tree of Life between. Certain stylized animal and bird forms, like the winged gryphon, stemmed from the same repertory. These essentially Oriental motifs were not only used on the textiles but also on the stone slabs in sculptured low relief which were especially popular at the time both for use on iconostases and to fill the lower sections of windows. There are good examples at Hosios Lukas. Costumes of Sasanian character, where trousers supplant the usual flowing robes, are also sometimes worn by the figures depicted on the textiles and it is not improbable that they were actually often worn in daily life. Sasanian motifs were similarly, though less frequently, used in the decoration of works in metal or ivory.

Another realm where Eastern influence seems to have been quite important was that of secular architecture, for one of the emperors added what was termed 'the Persian House' to the immense complex

of buildings that formed the Great Palace. It has disappeared along with most of the other diverse buildings that composed the palace, but it would seem that its decoration was similar to that of the rooms on the upper floor of the Palazzo Reale at Palermo, adorned with mosaics for the emperor Roger in the middle of the twelfth century. The motifs are mostly of a truly Sasanian character; we read that similar work was favoured in the Abbasid court at Baghdad.

It is not always easy to determine whether such elements as these came to Byzantine art direct or by way of an Islamic intermediary, for Sasanian influence on Islamic art was very important. But in one sphere we can be sure that links with the Islamic world played a major role; it is that of ceramics. Of all the arts of Byzantium the pottery was certainly the most obviously indebted to the East, both to the Arab world and more particularly to Persia.

We know very little about earlier Byzantine pottery. The types known to Rome, notably simple unglazed wares and *terra sigillata,* seem to have continued in use till the seventh century, and the earliest Byzantine glazed wares that we know can hardly be dated before the eighth; these were vessels, mostly bowls, made of a hard baked white or buff ware, covered with a thin tin glaze of palish colour. But with the ninth century new types came into vogue, the most important and distinctive of which is usually termed 'poly-chrome ware'. In this work the designs were painted in various vitrifiable colours under a thin colourless glaze and the motifs, though sometimes wholly Christian, were also often allied to those that had been in use in Mesopotamia in the ninth century. The technique would appear to have been derived from one that was first developed in northern Persia or Transoxania. Another important technique in the Byzantine world, the *graffiato,* was also allied to one that was universal over the whole Islamic world from eastern Persia to Egypt, and was no doubt adopted from there, though the Byzantines developed their own particular variants of it and made use of their own motifs in addition to those that they copied from Eastern models. Here the bodies were red and were covered over with a white slip, through which the designs were scratched or engraved. In the Islamic world, as in China, the potters had produced vessels that were of the very highest quality, Their Byzantine counterparts perhaps only seldom succeeded in achieving the same aesthetic excellence, but their products were by no means negligible, and they deserve closer consideration than has usually been accorded to them in the hand-

books on Byzantine art. They are of interest also because of the similarity they bear to wares produced in late medieval times in the West.

It might be argued that these experiments in the Oriental style went little deeper than did the affection for things Chinese in eighteenth-century Britain; that we have, in fact, to do with what might be termed a Byzantine '*Persannerie*'. But this is not really so. In many respects Byzantine art of the Second Golden Age would never have been quite the same had not the various Oriental influences been assimilated. Many of the finest works of Byzantine art produced at this time find their happiest home in a museum or collection in association with those from the Near and Middle East, whether Sasanian or Islamic, rather than with those of later classical art. Though the thought-world that was responsible for these arts was something highly individual and wholly independent, it was nevertheless in tune with what was happening in the areas adjoining it to the east, whether basically Christian or wholly Islamic, and was ready to learn from what was going on around as well as to adopt from the past.

The last emperor of the Macedonian line was Constantine VIII. He died in 1028 without a male heir, but left three daughters. One became a nun, which put her out of the succession, while a second, Zoe, married three men in turn, each one of whom predeceased her. The first became emperor as Romanos III, the second as Michael IV, and the third as Constantine IX, while for a brief period Zoe and the third sister Theodora reigned together. In 1056 the last of this series of somewhat ineffective rulers died. This marked the end of the Macedonian dynasty, and with its end the beginning of a long decline in the political and economic fortunes of the Byzantine state. It was to continue with little interruption till 1204. The decline was accentuated by the loss of a large part of Asia Minor as a result of the Seljuk victory at Manzikert in 1071, by the rise of Serbia to independence under Stephen Nemanja soon after the middle of the next century, and by the establishment of the Second Bulgarian Empire in 1186. But though the century and a half that elapsed between the death of the last of the Macedonian line and the crusading conquest of Constantinople was equally disastrous in the material sphere, it was, curiously enough, a period of considerable activity in the realm of art. The mosaics of Hagia Sophia at Kiev were set up by Byzantine craftsmen between 1037 and 1061, paintings at Vladimir were done by Byzantine artists around 1195, and between these two dates Byzantine craftsmen worked in other places in Russia almost continuously. More striking, however, were the various mosaics executed in Sicily for the Norman kings between 1143 and about 1200 either by Byzantine craftsmen or by Sicilians whom they had taught. St. Mark's at Venice was built on the model of the Holy Apostles at Constantinople and was decorated with mosaics, the earliest of which, those of the eleventh century, were again the work of Byzantine craftsmen while many of the later ones were wholly Byzantine in style. Byzantine mosaicists or their pupils set up part of the decoration at Torcello nearby in the eleventh and again in the twelfth century, and similar work was done at the same date at Trieste and rather later at Murano. At the end of the twelfth century a number of wall paintings in a truly metropolitan style were done under the patronage of the Byzantine governors of Cyprus. In fact, though the decline in

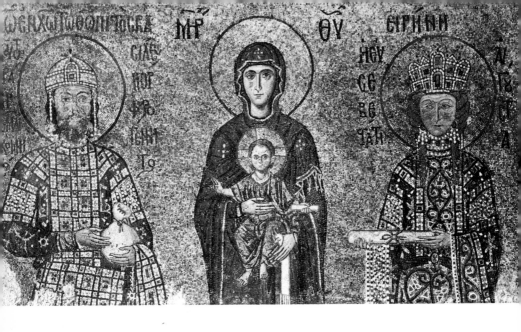

Mosaic. The John Panel, in the church of Hagia Sophia, Constantinople. *c.* 1118. *Hirmer Fotoarchiv München*

the affairs of state was virtually uninterrupted, Byzantine artists were not only active at home, but were also responsible for more work abroad than at any other time in Byzantine history since the days of Justinian.

Apart from this extensive activity in neighbouring lands the art of the Comnene age was remarkable on other counts, for though very little survives, there is enough to show that it was an age in which particularly interesting stylistic developments took place. It would seem that these were responsible for greater diversity and a general change towards a more lively, more humanistic style in which there was a good deal of experimentation. But alongside this more progressive art, work of a very conservative character seems to have continued, so complicating the problems of dating quite considerably.

The more conservative manner is, happily, illustrated by one firmly dated work, a mosaic in Hagia Sophia known as the John panel; it depicts the emperor John II Comnenos (1118–43) and his empress Irene, standing on either side of a full-length figure of the Virgin. The style is linear, the effect rather dry and arid; artistically speaking it is a good deal less successful than the rather similar panel, done some seventy years earlier, which depicts the emperor Constantine IX Monomachos and the empress Zoe on either side of Christ. A number of other works of the first half of the twelfth

century show the same conservative manner, for example a portative mosaic of Christ now in the Museo Nazionale at Florence and a copper-gilt plaque with the Virgin and Child in the Victoria and Albert Museum. The *cloisonné* enamels of the period, which were both numerous and important, are also distinguished by a linear treatment, the partitions being multiplied in number and set closer to one another in parallel lines. The enamels are thus rather easier to date than the ivories or plaques of metal. They illustrate the acme of the court art of the time and embody the more satisfactory elements of such a style, namely polish, elegance, restraint, and richness of material, though at the same time they tend to be rather arid and formal, and there is a marked absence of a desire to experiment otherwise than technically.

Alongside these more conservative works the progressive style was rapidly becoming more and more important. The earliest, and probably the finest, example is the lovely icon known as Our Lady 141 of Vladimir. It was painted in Constantinople shortly before 1130 for a Russian patron, and was taken back to Russia soon after; there it has been preserved ever since, first at Kiev, then at Vladimir and now in the Tretyakov Gallery at Moscow. It is distinguished by a marked feeling for humanism; the more tender and personal side of the theme dominates and this tendency is to be seen not only in the style of the painting but also in the iconography, for the arrangement of the figures belongs to a type termed 'The Virgin of Tenderness', where the Child's face is pressed against that of his mother in affection. The symbolism contrasts markedly with that which dominated until this time in the iconographical type known as the 'Hodegetria', where the Virgin holds the Child on one arm and points to him with the other as symbol of the Way to Salvation. No intimacy, no personal affection, no inkling of human motherhood enters in here, however grand and impressive the paintings may be, and the effect is quite contrary to that of 'The Virgin of Tenderness', the 'Eleoussa' as it is called in Greek. Actually as an iconographical type it was not wholly new, for it appears on an ivory of the ninth century now at Baltimore; but it had found very little favour before the twelfth century; thereafter it became popular along with the growth of the greater feeling for humanism which slowly began to permeate art as a whole.

This tender outlook is clearly reflected not so much in the poses, but in the faces and expressions of the figures in another mosaic in

the south gallery of Hagia Sophia, known as the Deesis panel. It 36
depicts Christ between the Virgin and St. John the Baptist. It is a
mosaic of quite outstanding quality, one of the most beautiful works
ever produced by any Byzantine artist at any period. There has,
however, been some argument as to its date. When it was first
uncovered from beneath the Turkish plaster that overlaid it, a date
around 1130 was proposed on the basis both of epigraphy and of the
similarity of the Virgin's face to that of Our Lady of Vladimir; but
subsequently a date towards the end of the thirteenth century has
been suggested because of its similarity to mosaics and paintings in
Kariye Camii (see p. 159). Today the authorities are divided more or
less equally: to the writer the earlier date seems the more likely.
However, the conception of the figures, more especially those of
Christ and the Virgin, undoubtedly illustrates the new manner.
Christ is conceived as the gentle Saviour of mankind and not the
awesome Judge who dominated mid-Byzantine churches from the
summit of the dome, while the Virgin is tender, humane, and full of
personal understanding.

The more humanistic style that we see in these two works was
apparently also to the fore in a number of painted decorations done
by metropolitan artists in the second half of the twelfth century if one
may judge from the most important one that survives, namely that
at Nerez in Macedonia. It was executed for a member of the Comnene
family in 1164, clearly by artists brought from the capital for the
purpose. The paintings are of extremely high quality, and in addition
to the feeling for greater intimacy and humanism we also see the
development of a delight in lively action and a new interest in
picturesque detail.

Three scenes from among those that survive at Nerez may be
selected as illustrations of the changes that were taking place and two
of them, apart from the details of the compositions, do so by the very
nature of the themes that they depict, namely the Deposition and the 142
Lamentation. The third, the Nativity of the Virgin, is chosen for
mention here because of the way in which the scene itself is depicted.
In mid-Byzantine art the theme of the Passion was concentrated on
the scene of the Crucifixion in isolation. It was usually shown rather
austerely, with the Virgin on one side and St. John on the other,
pointing to the figure on the cross as symbol of the faith. Neither of
these figures really entered into the emotion of the event or the action
of the scene, and their attitudes and gestures were formal and

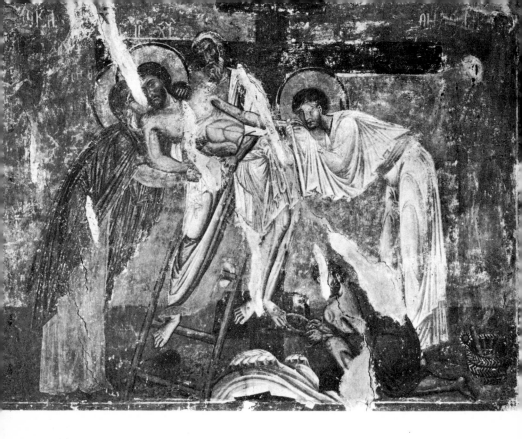

Wall painting, Nerez,
Macedonia. The
Deposition. 1164

stylized. At Nerez the Passion cycle was extended to include the Deposition and the Lamentation, and the emphasis is very different, for in the former the subsidiary figures, the Virgin, St. John, St. Joseph—sometimes Nicodemus is included also—have a real part to play in the drama. St. Joseph helps to lower the body, Nicodemus, if he is present, removes the nails; St. John holds Our Lord's hand, weeping over it in the extreme of emotion; the Virgin receives the limp body, a human mother grieving for her dead son rather than a divine figure attesting his salvation. In the Lamentation the same intimate emotions dominate the scene, and the mother and the followers seem to join together in expressing their grief at the loss of a loved one rather than in attesting the drama of the Crucifixion. These two scenes occupy very prominent positions at Nerez; in earlier decorations they were only very rarely included in the full cycles of the Passion and they would never have found a place at all

in a small church like Nerez, where there was space to illustrate only a limited number of the more essential subjects.

A prominent place was again accorded to the third scene we propose to mention, the Birth of the Virgin. Once again one of the more personal and intimate events of the New Testament story has been selected for distinctive treatment. Most significant here is the way in which the event is conceived, for a new attention is paid here to the individuality and character of the people who take part even if they are of comparatively minor importance in Christian teaching—such as the midwife who washes the child or the one who comes in at the door holding a jug. The former is a wholly practical personality, immersed in the task before her, the latter a very vivid character, who, one would surmise, has been modelled on some girl of the region; one might have met her in a village of Macedonia at any time. It would seem that the painter was trying to avoid anything like a conventional approach when he depicted her, and though his efforts with her left arm have not been wholly successful, she is, nevertheless, a figure that sticks in the memory as a personality.

The Nerez paintings were clearly by a master from the capital; every detail savours of the term 'metropolitan'. They would seem to have exercised a good deal of influence in the region, and some paintings at Kurbinovo, on Lake Prespa a hundred miles or so to the south, which were done in 1191, were clearly inspired by those at Nerez. But in this case it is clear that a local man was at work, for the polish and delicacy of the Nerez paintings are absent, though many of the details have been followed very closely and some of them have been exaggerated into a mannerism. One feature that is especially prominent here is a greater interest in movement for its own sake, to be observed especially in the agitated folds of the costumes of some of the figures, notably that of the angel in the scene of the Annunciation. The angel is by no means a static figure, poised in space, but moves forward, his garments rustling in the breeze created by his own movement. This same feature, which was soon to become a widespread mannerism, appears again in the church of the Anargyroi at Kastoria, a few miles distant on the other side of the present Greek frontier, as well as on several occasions in Cyprus at the end of the twelfth century and in the church of Hagia Sophia at Trebizond about 1260. Professor Weitzmann has also published an icon from Sinai of the second half of the twelfth century which shows the same feature in a work which should in all probability be assigned to

Constantinople. A similar love for rather exaggerated movement is to be seen in the general character of the mosaics at Monreale in Sicily even if it is less prominent in this particular feature of the angel's costume.

Among the works on a smaller scale that show the influence of this new style attention will be drawn here only to two by way of illustration, namely a metal book cover in the Marcian Library at Venice and an ivory in the Victoria and Albert Museum. The book cover bears the Anastasis, the scene usually chosen in the Byzantine world to represent the Resurrection; in fact it depicts Christ's breaking down the doors of hell and raising Adam and Eve from their graves while the prophets and apostles watch on either side. The scene had long been included as one of those specially selected for illustration, so it was very familiar; but on the book cover there is a new feeling for movement and Christ is shown literally pulling Adam up from the tomb, his cloak flying in the wind behind him.

This interest in movement is perhaps less to the fore on the ivory, the new elements there being most apparent in the energy and vivacity with which the various scenes are depicted. The ivory is divided into three horizontal registers; at the top are the Annunciation and the Nativity, in the middle the Transfiguration and the Raising of Lazarus, and at the bottom the Marys at the empty tomb and Christ's appearance to them in the Garden after the Resurrection. Attention may be drawn especially to the pensive figure of Joseph in the Nativity scene, to the boorish figures of the sleeping soldiers beside the tomb, and to the amazed wonder of the Marys when the resurrected Christ appears before them. The comparatively high relief and the expressive attitudes of all the individuals are typical of this twelfth-century phase of art.

The ivory belongs to a group that has been assigned to Italy by Keck and others. This seems to the writer unlikely, for it is wholly Byzantine in iconography and in character. At one time there was a tendency to attribute to Italy any work of the twelfth or thirteenth century that showed any feeling for humanism or which was spirited and alive. It was held that these features could only have been developed in Italy, Byzantine art being looked upon as universally rigid and severe. It is hoped that the foregoing analysis will have dispelled that illusion. In the twelfth century the old ideas were changing, and there seems no reason, in view of this, to attribute the more vivid and lively works to Italy, where sophisticated art was, it

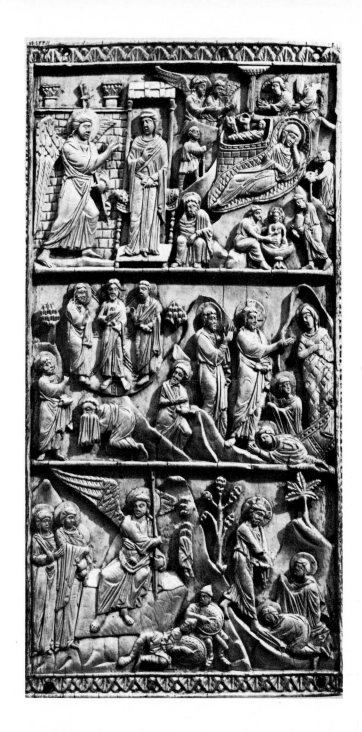

vory panel in three
egisters. Probably
hirteenth century.
*Victoria and Albert
Museum: Crown Copyright*

must be admitted, still in its infancy. The new style was rather something that stemmed from the metropolitan art of Byzantium, and when we find it elsewhere at this time its presence is surely to be attributed to Constantinopolitan influence. In the fifteenth century the Renaissance was to progress in Italy a very great deal further than ever it did, or probably ever could have developed in the Byzantine world. But in the twelfth century art in Byzantium led the van in the one direction while art in the Gothic West led in the other, and Haskin's conception of a Twelfth-Century Renaissance is just as applicable to the Byzantine world as it is to the West, in any case so far as the visual arts are concerned. That there were hints of a similar revival in Byzantine literature also is suggested by the existence of such works as Anna Comnena's *Alexiad,* a lively biography of the emperor, full of everyday details.

Though in the twelfth century Byzantine art was in advance of that of Italy, where the rather old-fashioned style described by Vasari as the 'maniera Graeca' still dominated, it must be admitted that the revival in Byzantium must to a considerable extent be attributed to the opening up of contacts with the West. The First Crusade had reached Constantinople just before 1100, and whether the Byzantines liked it or not, relationships with the West became a good deal more effective as a result. Venice and Genoa possessed influential trading colonies in Constantinople and even though they were beginning to exercise something of a stranglehold on Byzantine shipping, the presence of these colonies undoubtedly exercised a broadening influence on the Byzantine outlook. Efforts were being made, however unwelcome they may have been to some members of the community, to bring about a reconciliation between the Catholic and the Orthodox faiths, and missions were being regularly exchanged between Constantinople and various cities of Italy. All these, and other facts attest the general broadening of outlook that characterized the Byzantine capital during this century. Politically they no doubt bore witness to a decline of Byzantine power. In art their effects were definitely beneficial. Important though the new influences were, however, this does not mean that Byzantine art suddenly became a wholly Western art. Its old spiritual basis still remained; materialism was studiously avoided. Instead the human and the spiritual aspects were more closely united than ever before and a new role was accorded to the highest and most profound of personal sentiments.

In 1204 the Byzantine capital was captured by the forces of the Fourth Crusade, which deflected their energies from the struggle against the Muslims to the far pleasanter and more lucrative task of looting what was the richest city in the world. The mass of superb objects that was destroyed was enormous, but happily a few things were taken home and presented to the treasuries of churches all over Europe; the lion's share went to Venice. It is on these things that much of our knowledge of mid-Byzantine art is based. For this, at least, we must be thankful, for after the Turkish conquest of 1453 practically nothing was preserved. Until 1261 Constantinople remained in the hands of the Latins; their princes ruled from the old imperial palace on the Golden Horn known as the Blachernae, and reports state that it was left in such a disgusting state when they departed that the returning Byzantines were not at first able to use it. Hagia Sophia and many other churches were turned over to the Latin rite, much to the distaste of the majority of the population, who had a dread of Catholicism; and most of the leading Greeks fled the city, the most powerful of them to establish themselves elsewhere as potential successors to the imperial power. Two members of the Comnene family, who went to Trebizond, founded what was to remain an independent empire till it was conquered by the Turks in 1461; the Lascarids, who went to Nicaea, founded a small but successful empire, and it was from there that a ruler eventually returned to Constantinople as emperor of Byzantium; the Angeli, in the Epirus, were for a time the principal rivals of the Lascarids, though they had ceased to count for much by the middle of the century. Alongside these Greek states the newly founded Slav empires in Serbia and Bulgaria formed further bastions of Orthodoxy, more powerful and more prosperous indeed than those ruled over by their one-time masters, the princes of Greek blood.

So far as the story of art is concerned Constantinople thus passes out of the picture for a time. But not so artists trained in Constantinople in the traditions of Orthodoxy, for during the course of the thirteenth century work of extremely high quality in a wholly metropolitan style was produced in the service of Greek and Slav patrons alike, and we find its products today in regions as far apart as central

Serbia on the one hand and Trebizond, at the eastern extremity of the Black Sea, on the other. True, the rich and sumptuous materials that played so important a role throughout the Second Golden Age —ivory, gold, enamel, and precious stones—were lacking, and recourse was had to no more than paint upon plaster or panel; but this did not affect the real artistic quality of the art, and during the thirteenth century were produced some of the most lovely and many of the most interesting works in the Byzantine style that the world was ever to see.

The paintings of this period can, broadly speaking, be divided into two groups, a metropolitan one, where work was very accomplished and the approach sophisticated, and a provincial one, where local elements or a more primitive style were prominent; what was lost here in the way of elegance was compensated for by spiritual sincerity. That it is correct to term work in the former style 'metropolitan' is suggested not only by its polished character, but also by the fact that wall paintings in places very far removed from one another are in many cases very closely related stylistically, and this relationship can only be explained as the result of derivation from a common source, even from a single central atelier. This source can only have been in Constantinople and it may thus be concluded that accomplished painters, trained in the workshops of the capital, fled the city after the Latin conquest in much the same way that members of the noble families left it, and established themselves in the service of Orthodox patrons elsewhere, Slavs as well as Greeks. Doubtless at first the Slavs were more prosperous and could better afford to pay them, apart from the fact that in any case in Serbia the rulers were zealous patrons who sought to employ men of the highest possible ability. These men must have taught others, who maintained the tradition in considerable purity at least till just after the middle of the century.

There are records that wall paintings were done at Nicaea in the service of the Lascarid princes, but nothing survives there. In recent years, however, it has been suggested that a number of illuminated manuscripts dating from between about 1210 and 1260 were executed there, and what may be termed a Nicaean school of manuscript painting has been distinguished. One or two other manuscripts are perhaps to be attributed to Trebizond and some were probably actually produced in Constantinople itself during the Latin interregnum. The most important works of the metropolitan school, how-

ever, were the wall paintings and they are to be found in widely separated regions of the Byzantine world; the earliest examples that survive are at Mileševa in Serbia.

The Mileševa paintings date from 1135. Several different men must have worked there, some of them in a rather provincial style, but the most accomplished of the paintings were essentially metropolitan and their painter was an artist of very great ability. He set out to produce a decoration truly worthy of his patron's dignity, and to that intent the backgrounds of some of the paintings were coloured yellow and divided up by thin criss-cross lines, to look like the cubes of a gold mosaic. But it is the quality of the paintings themselves that is important, not this subterfuge of grandeur. They are vivid and alive, and though they adhere to the old canons of Byzantine iconography, they show many innovations as to detail which mark them out as truly original and experimental; indeed, together with related paintings at Aquilea in northern Italy, they have recently been cited by Mademoiselle Valland as true forerunners of the Italian Renaissance. Attention may be drawn to the scene were the Marys are shown 151 the empty sarcophagus and the discarded grave-clothes by the angel. The sleeping soldiers beside the tomb would seem to have been inspired by living models, while the angel is a figure of marked classicism. The beauty of the paintings is to the fore in the lovely head of the Virgin in the scene of the Annunciation, where she seems to foreshadow the charm and loveliness of Siennese painting. The humanism that we noted in the preceding century in the icon Our Lady of Vladimir has been carried even further here, while in the Deposition the same approach that we first saw at Nerez is to be observed. Personality, individual emotions, and human sentiment are here given full expression, without in any way losing sight of the basically spiritual outlook or the ethereal grandeur of the best mid-Byzantine art.

The paintings in the narthex at Mileševa are in a rather different style, for the old severity, the old frontal poses, the stress on rather monotonous rhythmical compositions, survive. These more conservative paintings are by no means negligible, for they are dignified and impressive, even if they lack the genius of the other work. The point is that they seem to look back rather than forward. They belong to what is usually termed the monastic school, though it is impossible to say whether the painters actually were monks, probable as this is; in any case they must have been locally trained.

Some thirty years later the same diversity of styles is to be found further to the south, at Sopoćani. The church is comparatively large, and there are six subsidiary chapels as well as a large outer narthex, all frescoed. Two men of particularly outstanding ability appear to have worked together in the main body of the church. The figures they executed are grand and monumental, and if the delicate charm of the Mileševa painter is missing, it must be admitted that the impressiveness of the figures at Sopoćani is perhaps better suited to the art of wall painting in a large building. The painters there also paid rather closer attention to straightforward illustration, for the scenes are all depicted with real feeling for the story. In the Nativity, for example, such details as the Annunciation of the good tidings to the shepherds and the Washing of the Child are indicated very vividly and in a very human way, and in the scene where the youthful Christ disputes with the priests in the Temple, the old men are represented with great sympathy. But it is perhaps the compositions themselves that are most striking. The wall spaces on which the Nativity and the Presentation are shown are divided up by large central windows, but the figures have been arranged in such a manner that the story is not interrupted and the windows themselves form a very satisfactory addition to the scheme. 40

All the main scenes from Christ's life are included in this decoration. There is a very impressive rendering of the Dormition of the Virgin on the west wall and the individual saints are there to intercede, so that the general scheme for the decoration of a church that was initiated by Basil I is followed. But changes have been made in the comparative sizes of the figures, and there is greater variation in the importance laid upon them, while the attention paid to human details attests the genius and originality of the painters. Yet the stress on the spiritual is in no way diminished; one might say that here God has come down to earth, and that the paintings try to show that God was there to benefit the life of man.

The early paintings in Yugoslavia were first brought to the attention of Western scholars by the French Byzantinist Gabriel Millet, who made a series of journeys in the area in the first decade of this century, but the material he assembled was not adequately published till well after the Second World War, when he himself was already dead, and though valuable accounts of the various monuments were published in local journals, the articles were mostly in Serbo-Croat and the plates that accompanied them were very inade-

Wall painting at Mileševa, Serbia. The Angel at the empty Tomb. *c.* 1235

150

quate so that the quality of these fine paintings passed unrecognized in the West by all but a few specialists till the nineteen fifties, when several exhibitions of excellent facsimiles were organized by the Yugoslav authorities.

From the stylistic point of view the paintings at Sopoćani show a very close relationship to some in the church of Hagia Sophia at Trebizond, which would seem to have been executed for the emperor Manuel II Comnenos of Trebizond round about 1260. Once again there is a marked feeling for vivid details—a child pulls a girl's pig-tails in the Feeding of the Five Thousand, while men forming the multitude in the same scene appear to have been modelled on Lazes, a race to which many of the inhabitants of the region belonged. Once more the individuals express their emotions freely and effectively, like the daughter of the woman of Canaan who is being cured by Our Lord of a realistically depicted epileptic fit. But the style is still 37 monumental and the whole decoration is imbued with great dignity. Neither here nor at Sopoćani is the work in any way to be described as provincial. Rather it is extremely competent, very highly finished, and of real artistic quality.

On the basis of its excellence and of the obvious relationships between Trebizond, Sopoćani, and Mileševa, we are surely entitled to conclude that the thirteenth century was an age of great produc-tiveness and that the metropolitan style must have been very widely spread at this time. The fact that so few examples have survived is to be attributed to the vicissitudes of fate rather than to the fact that no others existed.

Work that is of slightly lower quality is, however, rather more fully represented by surviving monuments, though most of them belong to the second rather than the first half of the century. In some of these paintings there are hints of the glories of Sopoćani, as for example at Gradać and to a lesser extent at Arilje, both in Serbia; but in most of the paintings other elements predominate, notably, a strong feeling for emotion and realism. There is one exception, however, namely, a rendering of the Crucifixion on the west wall of the main church at Studenica. It dates from 1209 and foreshadows similar renderings of the same scene done by Giunta Pisano around the middle of the century; they are all characterized by the fact that Christ is depicted as dead, with closed eyes. The style here is perhaps more Romanesque than Byzantine, and the work stands somewhat alone.

A marked tendency towards the dramatic characterizes a large group of paintings dating from the end of the thirteenth and the earlier years of the fourteenth centuries executed under the patronage of king Milutin. Here the figures are rather less monumental, the compositions less well balanced, and the faces less delicate and beautiful. Indeed in the work of Milutin's school there was at times a tendency almost towards caricature, while the poses were often angular and inelegant. The relationship of these paintings to those of the old monastic schools is clear, but it is hard to say whether this was due to a conscious admiration for earlier monastic work or to a lesser degree of competence on the part of the painters. Whatever the cause, we are confronted with the fact that a new and distinct school was in the process of formation here and work in the new style was being produced almost simultaneously in Macedonia under the patronage of king Milutin and on Mount Athos, more especially in the church of the Protaton at Karyes, to satisfy the demands of Greek abbots. Happily these paintings are in comparatively good condition, but two other decorations on Athos, at Chilandari (1302) and Vatopedi (1312), were unfortunately wholly over-painted in hideous colours in the nineteenth century. The work at its best is expressive, forceful, and full of drama and movement; but there is a certain lack of refinement, while the colours do not show the imaginative quality and loveliness of the earlier paintings.

It would seem that the main centre in which this school developed was situated at Salonica, which had for several centuries assumed the position of the second city in the Byzantine world and which had been freed from crusading overlordship much more rapidly than Constantinople. But the painters seem to have moved around quite freely and to have worked for Slav and Greek patrons alike. The French scholar Gabriel Millet termed this school the 'Macedonian' and this name seems as satisfactory as any other, though in the course of the fourteenth and fifteenth centuries work in the style was done not only in Macedonia and on Mount Athos, but also in many other parts of Serbia and Greece. All of it is of considerable interest to specialists because of the complexity of many of the church decorations and the interesting iconographical system that was developed, drawing both from the art of Constantinople and from that of the monasteries of Asia Minor. The intermixture of influences was often effective and always intriguing, but from a purely artistic point of view these later paintings are not really satisfactory. The interiors of the larger

pp. 154 and 155
Wall paintings, Boyana, Bulgaria. Portraits of the Despot Kaloyan and his consort Dessislava. 1259

churches seem somewhat overwhelming, and even in the smaller ones every inch of wall space was painted, every detail included, and little was left to the imagination. The paintings were always inspired by the religious ideal in that those who executed them were intimately familiar with every detail of the Bible story and set out to express its meaning, but somehow their work does not attain the profundity of spiritual feeling achieved by the painters of the metropolitan school, and their work cannot as a whole really compare even with the more general run of fresco painting in Italy.

A particularly interesting feature of this age is that the individual, both patron and artist, begins to come to the fore as a personality and a name. Thus the men who worked for king Milutin in the church of the Virgin Peribleptos (also known as St. Clement's) at Ochrid signed their names; one, called Michael, on the sword of his picture of St. Mercury, and the other, Eutychios on the belt of St. Procopios. Another man, called by the pseudonym Astrapas, perhaps also worked there, though we know him better through his paintings at Prizren. The most famous of the Greek painters, Manuel Panselinus, may well have been the man who decorated the church of the Protaton at Karyes on Mount Athos. Hitherto it had only been the patron whose name was recorded, and that by no means always. At the same time donor portraits began to be more usual, another instance of the interest that was beginning to grow up in individuals as such. King Vladislav, by whom Mileševa was founded, was thus depicted twice, and Stephen Uroš and other figures appear at Sopoćani. Finlay states that he saw a portrait of the emperor Manuel in Hagia Sophia at Trebizond, though it is no longer there. The most delightful of all the portraits of this age, however, are perhaps those of the Sevasto- crator Kaloyan and his consort, Dessislava, in the little church of 154, Boyana near Sofia in Bulgaria, done in 1259. They are particularly personal and intimate, and in this respect it is interesting to contrast them with the rather more conventional ones of the Tsar Constantine Asen and his Byzantine queen in the same church. The Boyana painter seems to have been especially good at depicting individuals, for his rendering of the youthful Christ, in the scene where he discusses with the doctors in the Temple, is particularly alive and expressive. Though certain elements in the Boyana paintings attest links with Constantinople, the style is very individual and the fact that the inscriptions are in old Bulgarian suggests that the work was done by a local master.

The tendency towards greater humanism that we noted in the twelfth century was thus carried forward in the thirteenth. We see it finding expression not only in the greater attention paid to individuals, patrons and artists alike, but also in the more personal, more intimate character of the paintings themselves. This is perhaps most noticeable in the works of the metropolitan group, but in those of the 'Macedonian' school the same thing is apparent in the new concern with the dramatic. As a consequence of this the products of this age are probably in an idiom that it is easier for the Western observer to understand and appreciate than was the case with some of the earlier examples of Byzantine art. But concessions must still be made by the Western observer none the less, both because the old manner has not entirely changed, and also because so many of the paintings are in a battered and incomplete state, so that it is not easy to appreciate them at their true value. But when they are reasonably well preserved, as is the case at Sopoćani, their high quality is at once obvious. They deserve to be accorded much closer attention by Western art historians than they have generally received in the past, for they have a very significant role to play in the story of European art. That they have been neglected is, however, perhaps not surprising, firstly because many of them have only recently been cleaned and published in anything like an adequate form; secondly because most of them are to be found in areas which even today are not very easy of access, and which can only be reached after long and comparatively arduous journeys; and thirdly, it is only within the last decade that reproductions which are really satisfactory have become available; even now most of the fuller accounts are in Greek, Bulgarian, or Serbo-Croat. More summary accounts, accompanied by adequate plates, are nevertheless becoming available in Western languages, and there is now no real reason why the old dictum that no art of quality was produced till Giotto came on the scene should not finally be discarded.

CHAPTER 11 The Picturesque Style

In 1261 Manuel VIII Palaeologos returned to Constantinople as the head of a new dynasty of emperors, the Palaeologan. It was to survive for nearly two hundred years, till the final conquest of the city by the Turks in 1453. Orthodoxy was restored to its old home, and almost at once—around 1280 if those who ascribe the Deesis mosaic in Hagia Sophia to a late date are to be believed (see p. 140)—art of the old Orthodox type began to be produced. The Latin interregnum seems to have been responsible for no decline of skills, for the most important of the early Palaeologan monuments are in mosaic, an art which, so far as we know, was not practised by the masters who went into exile or by the pupils they had schooled at Nicaea and Trebizond or in the Balkans. The considerable energies that were devoted to art so soon after the re-establishment of Orthodoxy, on the other hand, were no doubt at least to some extent to be accounted for by the very fact that Constantinople had been for a time under Latin domination. The majority of the population was violently opposed to the Latins and to any link-up with the Catholic West; and despite the efforts of a few who favoured unity, if only for political reasons, most of the populace wished for complete independence. The enthusiasm with which art was regarded was perhaps an expression of these sentiments.

Whatever the reason, art developed apace along its own lines, very little attention being paid to anything that was happening in the West. Gothic art thus had little, if any, effect except perhaps in the more westerly parts of Serbia, and when Italian art began to explore new ground in the early fourteenth century the Byzantines paid equally little attention to what was being done there. There are of course obvious similarities, for Cimabue, Cavallini, Giotto, and Duccio drew extensively from what had been done in the Byzantine world in previous centuries and it may be that some of the men in the West, more particularly Duccio, even visited Constantinople or at least paid attention to Byzantine panel paintings that reached the West at the time. One such, a small icon of the Archangel Michael now at Pisa, is of a type which may well have been familiar to Duccio. Broadly speaking, however, each area went its own way, though in both supremely lovely and important works were produced.

The quality of the work executed by the Italian painters around the

year 1300 has long been appreciated; that of the Byzantines is very much less well known. Though the empire was reduced to little more than the hinterland of Constantinople, with a small outpost at Mistra in the Peloponnese, and though the fabulous wealth of Byzantium in the middle period had dwindled away, the general atmosphere was still one of considerable prosperity. The remnants of three full-scale mosaic decorations that were set up in Constantinople during the first quarter of the fourteenth century still survive; it is probable that others were executed at this time also and numerous wall paintings were certainly done. If ivory was no longer available, steatite was carved in much the same way; good work was done in metal as a magnificent chalice made for Manuel Cantacuzenos (1349–80) now in the monastery of Vatopedi on Mount Athos attests, and to judge from the portraits of such men as Theodore Metochites, the donor of the Kariye mosaics, or the High Admiral Apocaucos in a manuscript of Hippocrates in the Bibliothèque Nationale (Gr. 2144), fine patterned silks were still woven. Moreover a virtually new art, that of miniature mosaics, was added to the list of the old ones. These are exquisite little objects made of tiny glass cubes, each no more than the size of a pin's head, mounted in wax on a wooden panel. A few examples would appear to date from the twelfth century, but the greater majority of those that survive were made in the fourteenth, and the art is really to be counted as a characteristic of the earlier Palaeologan period.

In fact, if art is to be taken as a guide to the nature of an age, the early Palaeologan era was by no means as impoverished and as unfortunate as has sometimes been supposed. There was, however, one notable difference between this and preceding periods; the principal patronage was no longer more or less limited to the imperial family, but was drawn from a wider circle of court officials and grand families. This was the case with the three mosaic decorations that survive at Constantinople, and there is a rather similar one in the church of the Apostles at Salonica which must have been sponsored locally. The same was true of the majority of the painted decorations.

The most famous of the mosaics is that in a little church close to the land-walls of Constantinople, the church of the Saviour, sometimes known as the church of the Saviour in Chora, or more often by its Turkish name of Kariye Camii, the Chora mosque, for it became a mosque soon after the Turkish conquest. The domes, vaults, arches, and walls were once entirely covered with mosaics; in the two

narthices—a sort of transverse nave—they are comparatively well preserved, but most of those in the body of the church were destroyed by a fall of the dome in Turkish times. They were all set up thanks to the munificence of Theodore Metochites, whose portrait appears over the main door presenting a model of the church to Christ. The interior is a veritable jewel, and constitutes one of the loveliest monuments of all Byzantine art. A single aisled structure at one side, the paracclesion, is adorned with paintings in a style closely similar to that of the mosaics.[1]

Both the mosaics and the paintings are firmly dated to between 1310 and 1320, so that they are almost contemporary with the decoration executed by Giotto in the Arena chapel at Padua (c. 1303). It is interesting to compare the two, because iconographically they have a very close relationship; Giotto must have drawn from the same age-old Byzantine sources as the Kariye masters. But stylistically there are considerable differences. Where Giotto sought for a new realism the mosaicists at Kariye were bound by tradition; where Giotto sought to convey a three-dimensional effect they were content with two; where he tried to make his figures as sculpturesque and as material as possible, they sought to associate them with the other world, for however human, however vivid, the details might be, the Byzantine conception was still basically spiritual rather than mundane; where Giotto was experimenting with vanishing perspective the men at Kariye remained faithful to the old system of inverted perspective, where the spectator seems to take up the position of someone inside the painting looking out rather than someone looking at it from in front (see p. 10).

These differences are probably most clearly marked in some of the more straightforward scenes that illustrate the events of Our Lord's or the Virgin's life. One of the most earthbound of them, if one may use the phrase, illustrates the numbering of the people at Bethlehem. 162 The scene is depicted with a realism rare in Byzantine art. The clerk writes down the names on his scroll, while the Governor presides in his official costume; a rather bored guard indicates with his sword that the Virgin should move forward; she is obviously shy and nervous, while Joseph is worried lest she should not acquit herself to best advantage. Yet in spite of this clear observation and feeling

[1] Both paintings and mosaics have recently been very fully published, following upon their cleaning by experts working for the Dumbarton Oaks Research Institute of Washington. See P. A. Underwood, *The Kariye Djami*, London, 1967.

for narrative, the tall, elegant figures have an ethereal quality while the architecture in the background is unreal, fantastic, of another world rather than of this.

Though the style of all this fourteenth-century art in the Byzantine world is wholly of its period and quite distinct from that of earlier ages, it is nevertheless a conservative art; for experimentation to any very marked degree was not permitted, nor was it considered in any way desirable either by the artists or by their patrons. Giotto sought for new ideas and new methods by which to put them into practice, and this is clearly illustrated by his rendering of the scene of the Last Supper in the Arena chapel. He places the apostles at a rectangular table, four of them with their backs to the spectator, whereas in the Byzantine world the old D-shaped table, with the figures round the curve, facing the spectator, was retained without change. We first see it in the Ravenna mosaics and in one of the miniatures of the Rossano codex, and the arrangement was still followed by the fresco painters of Mount Athos in the sixteenth century. Giotto's experiment can hardly be considered a success—Duccio did it much better in one of the panels of his *Maestá* at Sienna—but it was a daring and adventurous effort and serves as an apt illustration of the difference of attitude between the East and the West. The conservative Eastern outlook has often been termed hidebound and staid by Western critics; to the Byzantine mind Giotto's approach must have seemed, to say the least, worldly, and many would no doubt have gone so far as to consider it well-nigh impious.

The Arena chapel differs from Kariye in another important respect, namely the relationship of the setting to the decoration. Giotto's pictures are uniform in size, all of them enclosed in rectangular borders almost like picture frames, and they are set like hung pictures on the flat walls of a simple rectangular structure like a box. The effect is severe, but the paintings show to very good advantage. Kariye is an ornate piece of late Byzantine architecture, its walls divided by niches and arcades, its roof consisting of an elaborate complex of domes, vaults, and arches. The broken, curving surfaces create a wholly different effect, making the mosaics, or even the paintings in the parecclesion, part of an elaborate architectural decoration. The compositions are bordered not by frames but by the actual form of the vault or wall on which they are placed. As a decorative complex it is certainly a good deal more effective, more developed, than the Arena chapel; but it is as impossible to think of

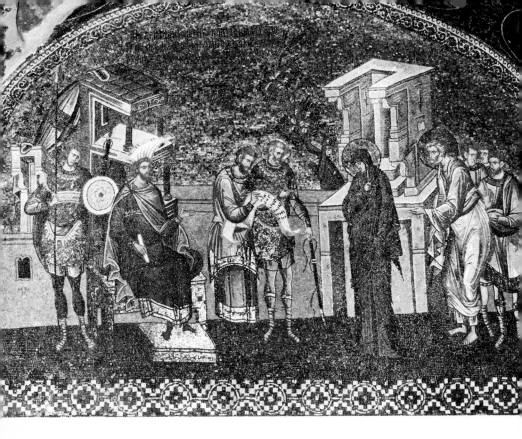

Mosaic, Kariye Camii,
Constantinople. The
Numbering of the People.
1310–20. *Josephine Powell,
Rome*

Giotto's paintings removed from their rectangular frames as it is to
imagine the Kariye ones on flat walls within a simple rectangular 29
interior: how much they gain from their placing is illustrated if we
compare this delightful interior with the rather arid effect produced
by the mosaic decoration of Monreale in Sicily, where it is once again
confined to flat walls.

It would be true to say that the Kariye mosaics owe something of
their appeal to their brilliant colour and to the scintillating effects that
they produce, set as they are for the most part on curved surfaces, but
that this is a superficial view is proved by the fact that the paintings
in the adjacent paracclesion are no less beautiful. Indeed it might even
be said that the effect that the paintings produce is still more pro-
found, and certainly there are few compositions in Byzantine art that
are more beautiful than the great Anastasis in the semi-dome of the 29
eastern apse. Here a comparison with Giotto's paintings can perhaps
be made more justly, for the eye is not distracted by the jewel-like

162

effect of the mosaic cubes and one can concentrate on the composition and the colour treatment. The Anastasis is a very great painting, profound, expressive, and very beautiful. The colours are used in a most subtle way, not only to achieve the modelling, but also to enhance the spiritual atmosphere. They are not always the colours of nature, and strange hues are used to build surprising contrasts. We have here a work of art conceived in colour, not a drawing to which colour has been added, and this is a feature which it shares with later Byzantine paintings in general, especially those at Mistra in Greece. Even the stained glass windows of Chartres can hardly claim to have used colour in a more creative or a more imaginative way.

Vestiges of two other mosaic decorations of this age may also be noted in Constantinople, and there are important fragments in the church of the Holy Apostles at Salonica. There were no doubt others, for towards the end of the century there are records that a single painter, Theophanes, who afterwards went to Russia, worked in no less than forty different churches. None of his work, and practically nothing else by any other hand, survives in Constantinople. But if many of these paintings were of the same quality as the work at Kariye, the fourteenth century in Byzantium should be regarded as one of the great ages of painting, different though its products were from those of contemporary Italy. Pious patrons were apparently numerous, in spite of the fact that the population was declining and that there was considerable economic depression. Or was it because of these very things? To the Byzantines material vicissitudes seemed to come as the result of divine displeasure, and they called forth acts of piety. Political disasters had produced Iconoclasm, for it was believed that manifestations of faith had taken a wrong turning. In the fourteenth century disasters similarly occasioned an artistic revival of very considerable significance even though we can estimate its character today from only a very few surviving monuments.

Outside Constantinople the finest work that has come down to us from this age is to be found in a number of quite small churches at Mistra. The city was under the direct control of the capital, and the emperor's eldest son was usually installed as its ruling prince. Under his patronage, or more often under that of one of the local nobles, various churches were decorated between about 1300 and 1430; the most important that survive are the Brontocheion, dating from soon after 1300, the Peribleptos, painted around 1350, and the Pantanassa, restored and repainted in 1428. The style of the work was closely

allied to what was being done in Constantinople; the more dramatic Macedonian style which we noted in the last chapter was much less influential at Mistra than in the rest of Greece. All the paintings are on a comparatively small scale, but great attention was paid to detail and the results are perhaps more picturesque than in the capital, the architectural background in the paintings being particularly elaborate and the colours especially gay. The finest are probably those in the Pantanassa, and a description of one of them, the Raising of Lazarus, 32 which was written on the spot and published in *The Birth of Western Painting* may be quoted at length, because it conveys very clearly the vivid impression made by the composition and the colouring of this remarkable painting.

The general background of the scene presents the colour and tone, and has the same translucency, as bottled honey, slightly tinged with olive. The escarpment on the left, above the group containing Christ, is a definite green. The valley in the middle is deeply shadowed in olive. Such of the sky as has survived the cracking of the plaster is a rich navy-blue, a colour quite distinct from the toneless indigo which forms the background to most of the Athonite frescoes. Thus far the colouring is strikingly reminiscent of Greco's *Agony in the Garden* in the National Gallery in London. The buildings at the back, however, seek the most exaggerated contrast with the landscape, in a tint of crushed strawberry which, in the doorways and shadows, gives the impression of having been burnt. Bearing in mind the surpassing brilliance of all the colours mentioned, it is not difficult to imagine that, if the artist is to bring his figures into the foreground against such a scene, and thus rescue his composition from the level of mere pattern, he must have recourse to measures unknown in Western art until the present day.

The group on the left is depicted mainly in Prussian and sky blues, the only exception being the brilliantly lit apostle immediately behind Christ, who is clothed in a kind of pink-tinted brown, which discloses the top of a Prussian blue tunic. Of the group at the back below the buildings, the foremost figure is robed in a dark wine colour, without highlights, the second in glowing amber, the third again in sky-blue—that being the colour most completely divorced from the background. These separate compositions are intended to act as a foil to the actual upraising of Lazarus on the right.

A most beautiful moving humanism pervades these six persons, which culminates in the weeping figure on the left, and is accentuated by a little white flower with chocolate leaves that grows beneath the feet of the lid-bearers. The anatomy is no longer hieratic, no longer the anatomy of physically abnormal ascetics. The weeping figure is perfectly proportioned; the mummy expresses a tragic resignation; while the man unwinding is fired with a frantic vigour. His legs tread the ground with the classic assurance of Signorelli's frescoes at Orvieto. All the heads, legs, arms and hands of the

picture are achieved by the use of a yellow vermilion, almost the colour of a dark crocus, lit with fine white lines, and shadowed, through grass-green, which is painted over in a masterly way with transparent sky-blue in order to emphasise the lights. The garment is edged with amber, lighted like a topaz and again shaded in wine-red. Both the garters and neckerchief are of the same sky-blue with the same claret shadows.

Lazarus himself is wrapped in a shroud of pearly opalescent yellow, to which the pinkish chocolate interior of the tomb acts as foil. The unwinding figure is dressed in an upper garment of dark wine-red, lit with white, green, lit with sky-blue and white. The lid is marbled in crushed strawberry followed by sky-blue shorts, which, from the distance appear to be white. The right-hand figure at the top wears a cloak of deep sky-blue, shadowed in claret and having a claret lining, beneath which hangs a robe of yellowish beneath which flows a drapery of the same pearly yellow as the shroud, and buff; the right-hand bearer wears a purple and white kilt with sky-blue draperies; the left is clothed in the same pearly yellow. If the reader will now recall the honey colour and the crushed strawberry of the background, and the dark-blue and brown group on the left, he will perhaps retain some impression of the brilliance of the whole scene.

After describing other scenes among the Pantanassa paintings in the same manner, Robert Byron and I went on to add: 'A further example of anti-naturalistic colour is exhibited in the head of a Saint in the same church, a magnificent exposition of the Byzantine method of giving form to a dark mass by the application of light. This is painted entirely in leaf-green, ochreous white and dark chocolate purple.' What is most significant about all this work is the treatment of light, which seems to emanate from the figures rather than to come from any normal source. It was through this inner light that the spiritual effect of later Byzantine painting was achieved.

Once more one may compare, or perhaps rather contrast, Giotto's painting of the Raising of Lazarus at Padua with that in the Pantanassa. The basic iconography is well-nigh identical: the mummy stands to the right before a hillside; in the background workmen carry away the lid of the sarcophagus; Christ stands to the left, his right hand raised in blessing. In Giotto's painting the figures in the background are clearly less important than those in the foreground; those immediately concerned express their emotions clearly; their costumes are modelled in an essentially sculpturesque manner. All stand out clearly against a dark background, unencumbered by detail; the composition has great unity. At the Pantanassa there is a good deal of detail in the background, the figures fall into three almost

distinct groups and there is little hint of emotion. The event is transferred from the world of everyday to the world of miracles and what we would term fantasy. Human emotions of a profound character were very much Giotto's concern; in the Byzantine painting Christ, with the simplest of gestures, brings to life a body that is already decaying, as is indicated by the fact that the workman nearest to it has to hold his garment to his nose. Here this realistic trait is most effectively used to express the miraculous nature of the event.

To enter into comparisons of quality when two great works are concerned would be invidious. What it is important to realize is that the aims and objectives of the two artists were not the same: Giotto sought to intensify the realism, the Byzantine painter to stress the miraculous aspect, not only through the nature of his figures but also in the colouring. Perhaps in no other instance in the whole of Byzantine art is colour used with such effect both to stress the form and to convey the spirit of the event as here, in this scene of the Raising of Lazarus in the Pantanassa at Mistra. That it was not an isolated manifestation is suggested by a fragmentary painting in a tomb niche in the exo-narthex at Kariye Camii which shows similar imaginative qualities in its colouring and conception.

CHAPTER 12 The Byzantine Heritage in Russia

When Constantinople fell to the Turks in 1453 the mantle of the
leader of the Orthodox faith passed in fact, if not in theory, to Russia.
Moscow, as the monk Filofey of the Eleazer monastery at Pskov said
about fifty years later, was to become the third Rome. And he added:
'A fourth there shall never be.' How true his prophecy was to prove!
Contacts between the budding state of Russia and the Byzantine
world had been extensive and well-nigh continuous since the con-
version of Kiev in the tenth century, even if the Mongol inroads in
the thirteenth had hampered, or even for a time prevented, them.
There were extremely important trading contacts between the two
states. Russian bishops and metropolitans were frequently appointed
from Constantinople, for even when the city had come to count for
very little in political affairs the Orthodox patriarch at Constantinople
continued to retain his influence in church matters, while in the
sphere of art the Byzantine outlook was fundamental. The mosaics of
Hagia Sophia at Kiev were thus the work of Byzantine craftsmen,
while quite a number of the wall paintings in the earlier churches were
either done by Greek artists who had gone to work in Russia or by
Russians whom they had trained as pupils, so that the style of the
paintings followed that of the Byzantine ones very closely. But as
Byzantine political power waned Russian power grew in every
sphere; and when the hold of the Mongols was finally broken at the
Battle of Kulikovo in the fourteenth century, all was set for the rapid
development of an active and progressive Russian state, even if its
complete unity was not at once achieved.

In so far as art was concerned, elements that were essentially
Russian rapidly began to affect the course of developments; they had
indeed actually begun to appear at an earlier date, for the portrait
figures painted on the walls of the gallery of Hagia Sophia at Kiev
around 1045 have a lightness of touch which distinguishes them
from typical Byzantine works of the same date like the mosaic of
Constantine Monomachos and Zoe in Hagia Sophia at Constanti-
nople, which was a good deal more formal and severe. The Russian
wall painting depicts the four daughters of Yaroslav; they were
mostly to marry Western rulers, and it may be that the style of the
painting was also to some extent influenced by the West. But whether

this was the case or not, it was a good deal less Byzantine than were the mosaics that stood close to it. It is rather harder to distinguish anything particularly Russian about the mosaics set up half a century later in the church of St. Demetrius at Kiev (c. 1108). They are indeed more human and show a greater lightness of touch than those in Hagia Sophia, but so do a number of Byzantine works of the first half of the twelfth century, like the icon, Our Lady of Vladimir (see p. 139f.), and even at the end of the century some of the most important wall paintings in Russia were being done by Greek masters like those in St. Demetrius at Vladimir (c. 1195).

Nevertheless, just as the Byzantine work at Nerez in Macedonia served as the model for a good deal of work done locally during the next thirty years or so, so the Vladimir paintings inspired a new phase of activity in the principality; and even at the time of the Mongol invasions it remained a very active centre of painting, where an art which was truly Russian was able to develop. However it was Novgorod further to the north that became the true home of Russian art, Byzantine in essence, but cut off from direct influence by the Mongol wedge driven after 1220 into the southern part of the country. Wall paintings done in both places around the end of the twelfth century really represent the first flowering of a truly Russian art, while it was in Novgorod that the most significant developments took place and it was there that panel or icon painting, which was soon to flourish even more brilliantly than in Byzantium, began to take on a new importance. The old folk art of Russia affected it quite considerably and brought to the Byzantine idiom a number of new and interesting ideas. And when contacts with Constantinople were renewed in the latter part of the fourteenth century, the two styles competed almost as equals.

The truly Novgorodian icons belonging to the thirteenth and earlier fourteenth centuries are quite easy to distinguish; the approach is more naïve, the colours more limited, and the effect achieved is rather like that of a poster. A large proportion of them were devoted to depicting saints who were especially popular at Novgorod, such as St. Nicholas. But it is a good deal less easy to distinguish from their Byzantine predecessors the more sophisticated icons painted there or elsewhere in Russia. Perhaps the most marked distinction is the greater stress that is laid on purely rhythmical movement in the Russian work. Great delight was taken in pattern for its own sake both in the costumes and in the compositions as a whole, while the

figures tended to be even thinner and more elongated. The hair was done in severe twisted plaits or combed back in clearly defined streaks, while the form of the foreheads and cheek-bones was accentuated in a series of parallel lines or curves. Less attention was paid to the modelling of the figures, more to the patterns on the textiles from which the costumes were made, while human emotions tended to play a more marked role than in the art of Constantinople. When the painter Theophanes the Greek, whose work in Constantinople has already been mentioned, arrived in Russia he developed a very personal style in the treatment of high-lights, and this was especially marked in wall paintings he did in 1378 in the church of the 170 Transfiguration at Novgorod. Here the high-lights are violently accentuated in a series of parallel white streaks. The style that Theophanes developed in Russia was copied by others, and what may aptly be termed a school of Theophanes was established; today authorities dispute which works were actually done by him and which by his more accomplished followers. But the style was comparatively short-lived, and after about 1400, to a great extent under the influence of the purely Russian painter Andrew Rublev, a new manner came into being, distinguished by very tall, almost ethereal figures, with long sloping shoulders and high, bulbous foreheads.

Another feature, which was much developed in Russian wall painting at the end of the fourteenth century, was a stress on the visionary character. A preoccupation with the transcendental already distinguished Byzantine art; in Russia it developed along different lines, as we can see if we compare a truly Byzantine work like the mosaic of the Virgin in the apse of Hagia Sophia at Constantinople with a Russian mural like the scene of the Transfiguration at Volotovo (c. 1385). In the former, the Virgin dominates the church, looming out against a gold background. At Volotovo Christ is 172 silhouetted against a glory of changing colour, and all the light of the picture seems to emanate from him; he is truly the Light of the World. No more striking example of the use of what we defined earlier as the 'inner light' of a painting could be found (see p. 8). The apostles are prostrated in the foreground in amazement in positions which, though they are realistically quite impossible, nevertheless help to enhance the visionary atmosphere. One thinks at once of the art of William Blake when one looks at this painting, for he too sought to escape the rigid bonds of reality in visions of pure imagination. The Russian love of rhythmical composition is also there, in

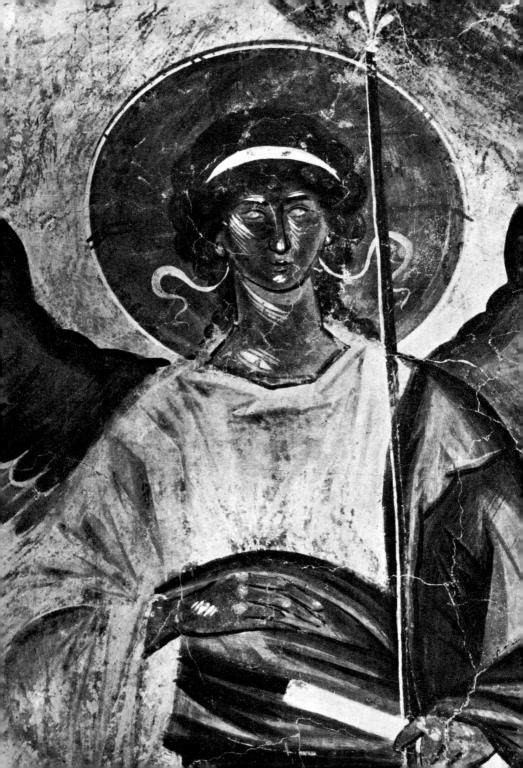

the pattern of the mandorla or in the curious angular rocks or the patterns made by the white high-lights: yet, in spite of this, and even more in view of the unworldly treatment of light, the painting is imbued with great humanism, and as we look at it a fact which is applicable to most later Byzantine work becomes clear, namely that the spirit of humanism is not necessarily conditional upon naturalism.

Though painted panels, often of very great size, had grown to importance in the Novgorod region as early as the twelfth century, it was not really till the fifteenth century that portative icons generally became more important than the wall paintings, and it was certainly not till much later that painters began to specialize in one branch or the other. Both Theophanes and Rublev worked in the two techniques alike, and there are preserved in the Tretyakov Gallery at Moscow supremely lovely panels by both of them. The very accentuated treatment of the high-lights which marked Theophanes's frescoes is less in evidence here though it is apparent on a close examination, and one can also see the influence that his work exercised in this respect on that of Rublev. But such words as 'delicacy', 'gentleness', and 'loveliness' are the ones that come most naturally to mind to describe Rublev's work, and these features are expressed in a way that is more Russian than Greek, and they were already prominent in Theophanes's work; perhaps, like El Greco at a later date, Theophanes only really found his true self in the country of his adoption, and the very fact of living in new surroundings helped him to develop his individuality, for individual he was, to a degree hardly realized by any other master of the Byzantine school.

It has sometimes been claimed by writers on Russian art that it is on the whole more personal than the Byzantine. This conclusion is to some extent true, but like all generalizations it needs qualification in any case so far as later Byzantine art is concerned. Important though the stress on the spiritual was in Byzantium, the Greeks were at heart a very practical people. Miracles were universally accepted, so that for them depiction of the miraculous was really illustration of the actual; there was no questioning God's presence in heaven or Christ's presence for a time on earth, so that both could also be illustrated without recourse to visions. The Russians were more imaginative and set greater store on an attempt to escape from this world; they were carried away by the beauty of the liturgy or by visions of the future life to a far greater degree than the Greeks, and they seem to have been particularly adept at expressing some of the

Wall painting in the church of the Transfiguration, Novgorod. *c.* 1378

171

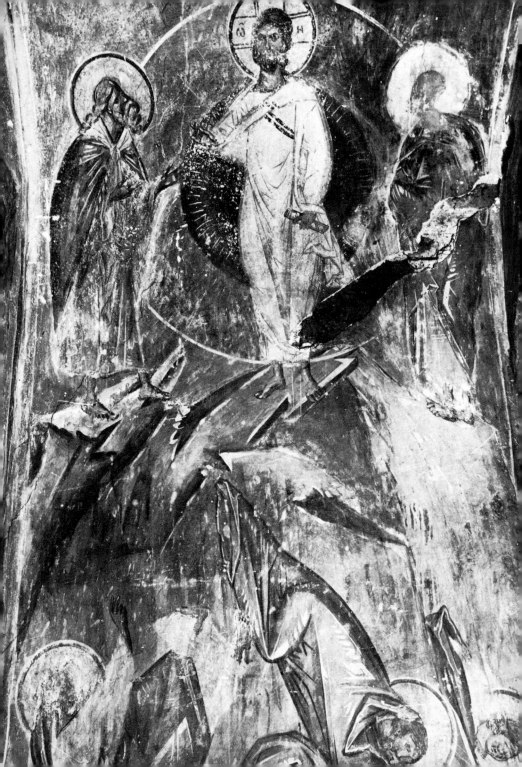

more abstract ideas of the faith in visual form. A wall painting in the church of the Nativity of the Virgin in the Therapont monastery, 175 painted about the year 1500, or an icon of Our Lady's Assembly in the Tretyakov Gallery, may serve to illustrate this point. The paintings are devoted to the theme, 'In thee rejoiceth'. The Virgin, holding the Christ-child on her knee, is seated on a round throne; behind is a glory made up of a series of concentric circles in different colours, and its form is echoed by a great choir of angels, who seem to be singing and praising the Lord of Creation, and through him the mother. In the top background of the fresco is a gaily coloured church, symbol of man's contact with the divine, and below are choirs of apostles, saints, holy women, and the Fathers of the Church. The theme is 'Praise', and it is hard to conceive of a more effective rendering of so abstract a subject in visual form.

By the time that this painting was executed the fashion for depicting individuals as very tall, with sloping shoulders, had come fully into its own. From the middle upwards the body was more or less triangular in shape. Is it going too far to suggest that the idea of the Trinity lay dormant in this conception? It would be something wholly in keeping with the Russian conception of art, and would follow on from Rublev's famous icon of the 'Old Testament Trinity', the composition of which is wholly based on a series of triangles. Less attention is also paid to the form of the body beneath the drapery than in the Byzantine world, and here there can be little doubt that this was due to greater concentration on the immaterial aspect. On the other hand architectural compositions in the backgrounds tend to be more truly representational, while inverted perspective, which was so very popular in Kariye Camii, was a good deal less in evidence. Perhaps both of these features are to be attributed to the rather closer contacts that Russia had with the West.

This humanistic, idealist, and delicate style reached its peak with Andrew Rublev (c. 1370–c. 1430). He seems to have begun his career as a painter in association with Theophanes the Greek, working on wall paintings in the cathedral of the Annunciation at Moscow. But though he no doubt acquired a technical facility and a feeling for the grand manner from Theophanes, Rublev's work, as it developed, became much more intimate and tender. He was a monk, and it is recorded that, like Fra Angelico in Italy, he began his work with prayer. Somehow, though Fra Angelico was essentially Italian and Rublev essentially Russian in outlook, there is a similarity between

Wall painting in the church of the Transfiguration, Volotovo. The Transfiguration. c. 1385

173

their art, for both men were so clearly dominated by their conception of the faith. The most famous of Rublev's wall paintings that survive are those in the cathedral of the Dormition at Vladimir, where he worked in 1408 with a painter known as Daniel the Black; portions of a great Last Judgement are all that survive. The two painters seem to have been associated elsewhere on other occasions, though most of what they did has now perished. A few of the individual figures at Vladimir, notably two angels and a group of apostles, are clearly by Rublev, and the pensive expressions of the former recall the figures on the most famous of his icons, the Old Testament Trinity, now in the Tretyakov Gallery.

The icon was painted for the monastery of St. Sergius and the Trinity at Zagorsk. Properly speaking its theme illustrates an event recorded in the book of Genesis, where Abraham encounters three angels beside the Oak of Mamre and takes them home to entertain them, thinking that they are travellers. But the illustrative character of the subject tended to be forgotten as time went on, and instead the three figures became symbols of the Trinity. In the Byzantine era no attempt to paint the Trinity in a direct way ever seems to have been made, though it was depicted by later painters in Russia, as on a Novgorodian icon now in the Tretyakov Gallery, where the Father sits frontally on a throne, with the figure of Christ Emanuel before him, and he in turn holds a medallion with the Holy Spirit as a dove upon it. But the Old Testament Trinity was always a popular theme, though on no other occasion was it rendered with such reverence and with such spiritual feeling or, one may add, with such beauty as in Rublev's painting. It is in many ways the quintessence of Russian art, delicate yet powerful, simple yet profound, combining earthly and spiritual beauty in a way that is only possible when the painter is governed by the sincerest piety. It is undoubtedly one of the world's very greatest religious paintings, and has as universal an appeal as any masterpiece of art.

A number of important wall decorations were put in hand by later Russian painters, the most important of whom was Dionysius (c. 1440–1509). His most famous work was done in the Therapont monastery. But on the whole the painting of icons must be regarded as the national art at this time, rather than wall painting. Distinctive schools had begun to develop from the thirteenth century onwards in most of the more important towns; the most outstanding were at Vladimir, Pskov, and, especially, Novgorod. Moscow only became

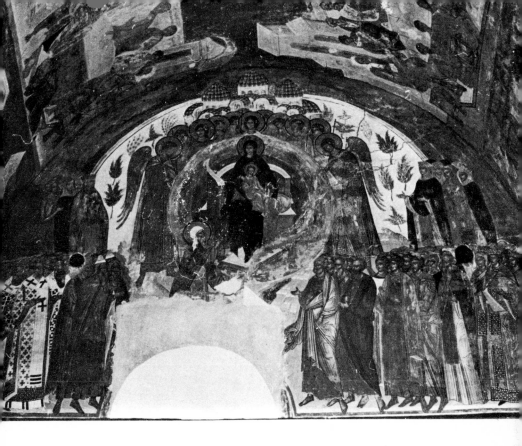

important after about 1400. At a first acquaintance it is by no means
easy to distinguish the work done at one place from that done at
another—but it is probably no more difficult for the expert than to
determine to which of the many north Italian cities where painting
flourished an Italian primitive of the fifteenth century should be
assigned. In any case what may be termed connoisseurship has been
highly developed in the U.S.S.R. in recent years, and classification into
schools has been carried to considerable lengths. But when once the
age of real glory had passed, around 1600, the painting of icons
became so much a question of mass production that it is far harder
to distinguish schools, still less the work of individual masters, with
the exception of the painters of the so-called Stroganov school and
those who worked for the Tsars in the Palace of Arms at Moscow.
Later icons seldom attain to the highest artistic excellence. But the
tradition was firmly established and well founded, the reproduction

of hallowed themes was a duty imposed on the painter by the Church, and to copy was an honourable profession, not one to be deprecated as in the West; for the faithful all icons were imbued with true religious significance, and it is from this point of view that an Orthodox Christian would regard them. To the Westerner, who looks at them primarily as works of art, there can be no question as to the outstanding quality of the finest. But even the second rate icons, because of the sincerity of their painters, should probably be regarded more seriously than second rate pictures in the West.

The preceding pages have been in the main devoted to the central area, to the lands which formed the inner core of the Byzantine empire, where the outlook on art was dominated by that of the capital, and where the churches were under the direct control of the patriarch of that city. This central area varied in extent very considerably throughout the thousand years or so of our story and, as we have seen, it was at the end reduced to little more than the great city and its immediate hinterland. This decline was initially due to a number of causes: the loss of the uplands of Asia Minor to the Seljuk Turks as a result of the defeat of the Byzantine forces at Manzikert in 1071; the establishment of independent Orthodox Christian states by the Slavs in the Balkans in the twelfth century; and the growth in the power and importance of the West. But at the end of the fourteenth century a new enemy arose which was eventually to strike the final blow, in the form of the Ottoman or Osmanli Turks; after first establishing themselves on the coastal areas of northern Asia Minor they crossed into Europe, attacking the Byzantines and the independent Slav states alike. The Serbs were defeated at Kossovo in 1389, and the whole of the Balkans, with the exception of what is today Rumania, was in their hands by soon after 1460; early in the next century they were at the gates of Vienna.

Till that time the central empire, whether large or reduced in size, was surrounded by a number of Christian communities which were either independent politically, like that of Armenia, or though flourishing, were through most of their history subject to Muslim rule, as was the case with the Copts in Egypt. In some instances the churches of these communities recognized the Orthodox patriarch at Constantinople, if only for a time, as happened with the Slavs in the Balkans; on other occasions they enjoyed complete religious freedom under their own patriarchs. Some of them had, at an early date, accepted interpretations of the Christian faith which were regarded as heretical by the official Churches in Rome and Constantinople, notably the Nestorians in the east and the Monophysites in Egypt. Yet all these peoples belonged to the great family of Eastern Christendom and all of them boasted arts which were in one way or another, and to greater or lesser degree, allied to the art of Byzantium.

The oldest of these communities and in many ways the most distinctive, was the Armenian. There Christianity had been accepted as the official faith by 301, and from that time onwards the Armenian Church boasted its own patriarch and the Armenian people developed a distinctive church art of their own, the most important branch of which was architecture, though at a later date miniature painting came to be developed to a degree hardly surpassed even in Constantinople itself. Wall paintings, though a few examples are known, were never very numerous or, apparently, very important.

Thanks to an abundance of good building stone all over their territory buildings of carefully worked stone were constructed at a very early date and from the seventh century the Armenian builders had elaborated a complicated system of stone vaults and domes as the universal form of roof. The pendentive, the most effective means of transposing the square plan below into the circle required to support the dome, was probably more effectively developed by their architects even than in the Byzantine area and some authorities maintain that it was as the result of experiments made in Armenia that the system was used with such success in Hagia Sophia at Constantinople. This is problematical, but it is certain that a considerable number of variations on the ground plan, many of them of a highly sophisticated character, had been devised as early as the sixth century. It would seem that the architects delighted in very complex ground plans, which contrasted markedly with the simple system with three aisles and three apses usual in the Byzantine world. But as in the Byzantine area there was nearly always a dome at the centre, and the domes were all of a characteristic conical shape, distinct from the hemispherical Byzantine ones, even if the system of transition from the square below was the same. The domes were placed at the top of a tall drum, a practice which was not adopted in the Byzantine area till a comparatively late date. There was undoubtedly a good deal of give and take between the Byzantines and the Armenians, but in architecture at any rate the Armenian developments must be counted as constituting a distinct style from as early as the seventh, even perhaps the sixth, century onwards.

Armenian miniature paintings were rather more closely allied to those of Byzantium. In 586 a very interesting copy of the Gospels had been made by a monk called Rabula at Zagba in upper Mesopotamia. Its illuminations were in the style which we distinguished as Syrian at the beginning of our survey, and Byzantine art owed quite

a considerable debt, if not to the Rabula manuscript itself, in any case to Syrian manuscripts that were allied to it. Some four centuries later its style also served as a basis for another important manuscript, this time with text in Armenian; it is known as the Etchmiadzin Gospels and is now in the Armenian National Library at Erivan in Soviet Armenia. This is the earliest Armenian manuscript that survives, and Armenian painting was thereafter very much indebted to its miniatures. A very great deal of work in the way of illumination was done from the eleventh century onwards, first in Greater Armenia and later in Cilician Armenia, where a large Armenian community flourished for the first two centuries after the second millennium. Though these manuscripts were written in Armenian script, the miniatures owed a considerable debt to Byzantium as well as to Syria for not only did they follow the same iconographical heritage, but also they underwent a good deal of direct contemporary influence. Like their Byzantine counterparts the Armenian miniatures were primarily devoted to recounting the Bible story especially that of the New Testament. They tell it vividly, though the elegance of the best Byzantine work is lacking. But the Armenian painters also took a great delight in lively details—chapter heads, paragraph openings, and decorative borders—and it is here that the greatest artistic achievements of the art are to be found. At the hands of the most accomplished masters, like the painter Toros Roslin, this work has a freshness and an imaginative quality which are truly remarkable.

Somehow the spirit of this decorative work is more akin to what was being done in the West than is the case with regard to the Byzantine manuscripts, and the lively subject-matter and the fantastic birds and beasts savour of those so popular in the Gothic manuscripts. In later times there may well have been an interrelationship, for the crusaders encountered the Armenians of Cilicia quite regularly. But it is harder to explain the close similarities that are to be observed between late Romanesque and early Gothic architecture in the West and Armenian architecture two hundred years earlier. Pointed arches, engaged columns, ribbed vaulting, and other features that were to be developed by the Gothic builders in the later twelfth and thirteenth centuries were being used freely in Armenia in the tenth. The interior of Ani cathedral, a longitudinal stone building with pointed vaults and a central dome, built about 1001, is astonishingly Gothic in every detail, and numerous other equally close parallels could be cited.

An architecture that was closely related to the Armenian was developed from an early date in the neighbouring land of Georgia and there has been some dispute among the authorities as to which country was responsible for first devising a number of interesting innovations, but the other arts in Georgia have very little similarity to those of Armenia. Wall paintings, even mosaics, were used quite extensively, and both these and the miniatures show marked Byzantine influence and no hints of Armenian connections. But most striking is the profusion of works in metal and enamel made in Georgia, whereas in Armenia such things were extremely rare. Georgian works in metal, especially book covers and frames and mounts for icons, were produced in large numbers from the ninth century onwards and enamels were equally numerous after the eleventh century. The works in metal are related to the Byzantine, though even a hasty glance indicates that they are the products of a different culture, but the enamels are so closely akin to those made in Constantinople that it is sometimes very hard to determine their true place of origin.

Had it not been for developments made in the Byzantine world, Georgian art, except for architecture, could never have taken on its present form. In Armenia, on the other hand, the national factors were so important that an independent style would almost certainly have evolved even had Byzantium never existed. In Armenia art is the tangible expression of a very old cultural history, and the full importance of the role that that country played in developments elsewhere all through the Middle Ages is something that requires to be more fully investigated.

Though they were not at first independent of Rome and Constantinople, as Armenia was, the Christian communities of Syria and Egypt were established at an equally early date. Antioch and Alexandria were both very prosperous cities and the teaching of the new faith boasted numerous adherents in both of them long before it was officially recognized by Constantine in 313. For the first two or three centuries the Christians of these cities were at one with those of Rome and Constantinople in their beliefs, and their patriarchs played a very important role in formulating the early affairs of the Church. But in the two great synods held at Ephesus in 431 and Chalcedon in 451 in order to determine the exact nature of Christ their patriarchs took a divergent line. At the former Nestorius, patriarch of Antioch, promulgated the theory that Christ's nature was entirely human,

though the word of God dwelt in it; at that of Chalcedon, Athanasius of Alexandria insisted on the contrary view, holding that Christ's nature was divine and that the human aspect was wholly absorbed within it. Both doctrines were in turn declared heretical, and they have remained heresies to this day though both found considerable numbers of adherents, the Nestorian belief being widely accepted in Syria and Mesopotamia, while the Monophysite, as the heresy sponsored by Athanasius was termed, was adopted almost universally in Egypt—though there were, of course, those in both areas who preferred the Orthodox approach and who remained in union with Rome and Constantinople. For the majority, however, it meant separation, and when the Islamic armies appeared on the scene in the seventh century both Nestorians and Monophysites accepted their overlordship with very little opposition. In consequence the Christians of these groups were accorded special privileges by the Muslims, and they have constituted important minority populations in the two areas ever since.

So far as art is concerned the Nestorian contribution does not seem to have been very considerable, though it is true that as yet we do not know very much about it. A few of their churches, built of mud-brick and dating from the eighth and ninth centuries, have been excavated in central Mesopotamia, and others of rather later date, built of stone, are still in use in the north today. The decorations of the earlier ones seem to have been sparse and wholly aniconic, the only motif that they appear to have favoured being the leafed cross of a type like that we encountered on two of the pages of the famous *Homilies* of Gregory Nazianzus or on the Limburg reliquary. This form of cross was used by the Nestorians of central Mesopotamia to adorn small gesso plaques which seem to have been used almost as icons. But the motif spread along with the faith right across Asia, where the religion boasted numerous adherents down to the thirteenth century. The Nestorian monument at Tsi gan Fu in China, dated to 981, is to be counted as their most spectacular legacy in that direction and the leafed cross plays a prominent role in its ornament. The Nestorian churches of northern Mesopotamia are decorated with a more elaborate array of stone carvings, and here the human figure is quite extensively used, but the work is all in low relief and most of it is of a very popular character.

The role played in art by the Monophysite Christians of Egypt, the Copts as they were called, was very much more significant. In early

times they were responsible for some fine churches, decorated with sculptured capitals and cornices of a very Byzantine type, and Egypt would seem to have been the centre of an active industry in ivory carving; in that done at Alexandria a very classical style seems to have persisted longer than anywhere else. But in general Coptic art had taken on a very individual style by the sixth century, especially in the fields of bone carving, stucco work, and wall painting, and Egypt was throughout an important centre of textile weaving. The frescoes at such places as Baouit and Saqqara are typical. A forceful, expressive if somewhat inelegant style predominates in the paintings; the stuccos are more exuberant and at times are almost Indian in character. The development of these arts was somewhat curtailed by the Islamic conquest of Egypt in 641; after that date it was primarily in the sphere of the minor arts that the best work was done. The production of pottery and textiles was almost entirely in the hands of the Copts, work being executed for Christian and Islamic patrons alike. For themselves they produced a quite distinctive form of unglazed pottery, adorned with drawings of Christian subjects; for their Islamic patrons they wove superb silks and made lovely glazed vessels.

Distinctive though the Coptic products are, it is impossible to discern even in the finest of them any expression of the Monophysite beliefs in the way that we can discern an expression of Orthodox thought in Byzantine art. Only in one series of works, wall paintings from Faras in Nubia, do we see any reflection of the outlook and life of those who produced them. Here the great portraits of Christ and the Virgin are clearly concerned with the expression of divine power, and at the same time the details of costume and jewellery reflect contacts, however distant, with other areas of the Near Eastern world.

Of Byzantium's immediate westerly neighbours the first to achieve independence was Bulgaria, a country which was ruled by its own princes from 679 till 1018, during the age known as the First Bulgarian empire, and again from 1186 till 1393, the age of the Second Bulgarian empire; most of the country fell to the Turks half a century before the capture of Constantinople itself. Though during both periods the art and culture of Bulgaria were allied to Byzantium, Bulgarian work being at times well-nigh indistinguishable from Byzantine, it shows in other respects a considerable degree of independence. Throughout much of her history Bulgaria was

probably Byzantium's most serious enemy, and when the First Bulgarian empire was conquered by Basil II severer repression was meted out to the Bulgars than to any other enemy. At first Bulgaria was still mainly a pagan country and it was really thanks to the missionary activities of two priests, Constantine, or Cyril as he later came to be called, and Methodius, that the Bulgarians were converted. At first they looked to Rome; but this move was at once countered by the Byzantines, for it came at a moment when a very active dispute was raging between the Pope and the Byzantine patriarch Photius over the interpretation of the *filioque* clause in the creed and each of them had excommunicated the other. The Bulgarian Church was very quickly subjected to the Byzantine and it remained within the sphere of the patriarch of Constantinople till 1204, when the Bulgarian king Kaloyan was crowned by a papal legate and archbishop Basil was established as independent primate of Bulgaria.

The development of Christian church architecture began at the time of Bulgaria's conversion, and the earliest buildings, notably those at Preslav, are both interesting and original. Their decoration on the other hand seems to have been essentially Byzantine in the use made of low relief sculpture and polychrome inlay, which is closely akin to that unearthed during recent excavations on the site of the church of St. Polyeuktos at Constantinople. Pottery which is related to some from the Byzantine world was also found there, as well as kilns for its manufacture, and a more extensive use seems to have been made of this material for adorning the interiors of the buildings than was usual in the Byzantine world. The pottery is of the type known as 'polychrome ware'; it seems to have come into use both in Bulgaria and in the Byzantine world in the ninth century. In Bulgaria tiles were most usual; in the Byzantine area the same technical process was used to adorn small revetment plaques and domestic vessels.

Wall paintings of high quality were also produced in Bulgaria from quite early times. Their history, however, belongs at first essentially to that of wall painting in the Byzantine world, though as time went on national elements tended to make themselves more clearly felt, so that by the thirteenth century one can distinguish a Bulgarian style within the wider Byzantine framework. Attention has already been drawn to the most delightful of these Bulgarian paintings in the little church at Boyana near Sofia, executed in 1259 (see p. 154). From that time onwards links with Byzantium became less important and distinctive styles grew up in various different regions, in architecture

as well as in painting. The nature of one of these local styles is particularly apparent in the churches at Nusebr (Mesembria) on the coast of the Black Sea. Their gay exteriors, adorned with ornamental brickwork and polychrome pottery vessels set into the masonry, are different from anything we know in the Byzantine area proper, though they can of course be included under the generic term of Byzantine.

Though Serbia also became independent in the twelfth century, her art remained in closer accord with the best of the Byzantine for a longer time. The wall paintings of the thirteenth century at Mileševa and Sopoćani were, as we have suggested, essentially metropolitan in character, while there is little to distinguish work of the so-called Macedonian school in the fourteenth century from what was being produced in Salonica or on Mount Athos at the same time. But in Serbia the architecture soon began to develop on quite independent lines, and the great stone churches of the more important monasteries in the south of the country are quite individual. At Dečani and Studenica there is a good deal of Western influence, while Gračanica represents what might be described as the logical quintessence of the late Byzantine style, with stress laid on height and on immensely tall and narrow domes. In fact we see here an art which savours of the grandeur of the metropolitan, but which is also essentially local; it has an elegance and a majesty worthy of the Byzantine empire at the height of its power; it reflects links with the West which cannot be ignored, yet at the same time it is a truly national art and bears witness to the breadth of outlook and the high culture of its patrons, the rulers of the Nemanja line.

The last link in this peripheral chain of the east Christian world is made up of the land that is now Rumania. The more southerly parts of the country had adopted Orthodox Christianity in the thirteenth century, and the fine princely church at Curtea de Arges survives to attest the basically Byzantine character of the art of the region, though the paintings that adorn it also bear witness to links with Serbia. But it was not till the fifteenth century that Rumania really came into its own as a creative centre of art, under the patronage of the princes and the nobles of Moldavia and the northern parts of the country. The princes were at times vassals of the Turks, yet they retained a degree of independence unparalleled in the rest of the Balkans and were able to sponsor lavish painted decorations and to build churches on a really grand scale. The monasteries of this region reflect the generosity of this patronage and represent the continuation of Byzantine

art in the grand manner right down to the eighteenth century. Only in Holy Russia were comparable buildings erected and equally fine paintings executed, for in the Greek and Slav lands of the Balkans Turkish overlordship had reduced the artistic standards almost to those of a folk art. What most distinguishes these Rumanian churches are their painted exteriors; nowhere else except on a few occasions in the region of Trebizond were painted exteriors in vogue, and certainly nowhere else were they on such a large and lavishly decorated scale. The painted churches of Moldavia, like those of Arborei or Voronetz, represent the last, but by no means the least, glorious of the contributions that the Byzantine idiom made to the world's museum of art.

CHAPTER 14 The Icon

The term 'icon' literally means picture or likeness, and as such it was applied generally to any form of depiction of a sacred being, whether on panel or wall, that was in two dimensions. The Iconoclasts began their destructions by removing a large-scale mosaic of Christ which was situated above the principal gate of the imperial palace, known as the Chalke or bronze gate, and they were relentlessly opposed to all such representations whether portable or static. But in post-Iconoclast times the term 'icon' began to be used in a more limited way, primarily to describe portable depictions of sacred beings, though it was also used more widely to refer to all portable pictures, whether they depicted individuals or scenes; and as time went on the variety of scenes that were represented on the panels increased considerably, to include first some of the principal events of the Old Testament and the Gospels, and later scenes from the life of the Virgin or the lives of the saints. Later still themes of an almost abstract nature such as that called 'In thee [the Virgin] rejoiceth', also came to be included in the normal subject-matter depicted.

The production of portable panels would seem to have begun very early in the Christian era, for according to a widely spread belief the earliest of them were painted by St. Luke and depicted the Virgin with the child Christ on her knee, in the position which was later termed 'Hodegetria' (Indicator of the Way). The Virgin holds Christ on her left arm and points towards him with her right hand. Several panels exist both in Italy and in Greece which are claimed to have been painted by St. Luke, but it is unlikely that any of them are much earlier than the seventh century, even if they are as old as that. But it is hard to judge, for in some cases the paint has almost entirely perished and in others the panels are covered with later metal adornments and are considered so sacred that it has proved impossible to examine them.

With the exception of one or two panels in Rome which are perhaps as early as the seventh century and which should be called icons rather than paintings in the Western sense of the term, the most important collection is preserved in the monastery of St. Catherine on Mount Sinai, apparently the only place in the Byzantine world that was not subsequently looted and which escaped the attacks of the

Iconoclasts in the eighth and ninth centuries. One of the earliest of them is devoted to an Old Testament subject, the Three Hebrews in the Fiery Furnace; it was a scene that was often included among the wall paintings in the Roman catacombs, and the rendering on the Sinai panel is very similar to that in the catacomb of Priscilla. The earliest panels were mostly painted in the encaustic technique, where wax was used as the medium. The technique and to some extent the style also seem to have been derived from the mummy portraits that were popular in Ptolemaic Egypt, though stylistically the best of them reflect the manner current in the great metropolitan cities. A particularly fine panel in the Sinai monastery, bearing St. Peter, must surely be an import from Constantinople, so elegant and accomplished is the work.

Though the majority of these icons depict individuals, quite a number of the early ones bear scenes from the New Testament. One of the finest of the latter is devoted to the Ascension; another, in a more popular style, bears scenes in three registers, the Nativity at the top, the Ascension in the middle, and Pentecost (or the Giving of Tongues) below. In this icon the figures are rather dumpy and the work crude in comparison to the St. Peter panel; it is clearly a local product, the work being in the Oriental manner that we distinguished in the third chapter. But whatever the style or the artistic quality, these panels are all wholly sincere, and are to be appreciated as witnesses to the faith even when their artistic qualities are not very great. But some are very fine, for throughout the ages the Sinai monastery received gifts from all over the Christian world, and the icons that are preserved there represent a virtual microcosm of what once existed over the whole Byzantine area.

The problem of dating these early panels exactly is by no means easy, for there is little dated or parallel material on which to base conclusions, but it is likely that quite a number of them should be assigned to the eighth and ninth centuries, the very age at which the production of such things was forbidden in Constantinople. The Iconoclast ban was never enforced in Rome, so that it is possible that gifts were received from there, but the rather crude style of most of the Sinai panels of this date suggests that they were more probably of local workmanship. Some of them, like a series depicting the Crucifixion, serve to show that both the iconographical systems we distinguished at the outset exercised an influence. On one of the panels, for example, Christ is clothed in the long robe or collobium

which was usual in Eastern iconography, while on the others he wears the loin cloth which was a feature of the system of depiction normally practised in Constantinople. In all cases the style is equally primitive.

With the end of Iconoclasm icons began to assume a new importance. This was perhaps partly due to the fact that it was against them that the most violent outbursts of the Iconoclasts had been directed and partly because icons, of all forms of art, were held to be especially effective as intermediaries between the worshipper and the divine power; and further, it was in the portable icon that miraculous powers were most generally believed to lie. Particularly sacred icons were thus resorted to in times of stress, and the Byzantines believed that an icon of the Virgin which was especially revered had saved the city when it was in danger on more than one occasion; it was paraded round the walls, accompanied by chanting and prayers. Prayers could also be offered, and candles burnt, before the icon of a particular saint, imploring him to act as intercessor, for the icon was a vehicle that would help to convey the worshipper's prayer towards the source of divine power. It was not an idol, and it was not itself worshipped but it was sacred in that it was more closely allied to the divine than was anything else in the material world.

In view of the intense belief in the omnipresence of a spiritual power behind every aspect of life, the role of the icon was very considerable, and this affected its artistic character. It was thus not intended to be attractive or to have any direct appeal to the senses, but rather to have a quality of constancy or permanence. No side face representation, no fleeting glance, was permissible, and the full-face pose was invariably resorted to, so that the whole attention of the worshipper would be centred upon it in the same way that the divine or saintly glance was centred on the observer.

With the end of Iconoclasm in 843 the quantity of the icons preserved in the Sinai monastery increases, for gifts from the central area once more began to arrive. A few very fine panels reflect the polished, accomplished art of Constantinople, while others, no doubt painted locally, show the influence of the metropolitan works, even if they are not themselves always of quite the same artistic excellence. Examples that are to be dated to between the ninth and the eleventh century are, however, still few and far between and it is really not till late in the twelfth century that it becomes possible to distinguish local styles and particular groups with any degree of assurance. Of the Sinai icons of this date one, a Virgin and Child, with depictions of the

prophets on the surrounding margin, is surely to be regarded as an import from Constantinople. Others are clearly local works, and others again are to be assigned to a separate group which Professor Weitzmann has termed the 'Crusader school'. He suggests that the main centre of production for this group was at Acre. These panels are in a curiously mixed style. Elements of naturalism which are foreign to the Byzantine outlook are present; the faces show greater emotion than was usual in Byzantine works, and details such as the shape of the eyes follow Western rather than Byzantine conventions. But the scenes depicted are those that were usually dealt with by icon painters. Certain of the painters knew something of French art; others followed a more Italianate style, and it is tempting to assign the panels to painters from these lands who had assimilated the local idiom. So far as iconography is concerned, their Eastern contacts were with the art of the region, that is to say, they followed the Syrian trend, rather than that of Constantinople. Professor Buchthal in his book on the Crusader manuscripts has distinguished a similar style in manuscript illuminations; the well-known Psalter of Melisenda in the British Museum is a typical example of it.

The very fact that crusading painters were called upon to produce such works is significant; it shows how profound was the influence that Byzantine art exercised on all those who came into contact with it, and in view of this it is not surprising that a great many Byzantine elements were assimilated in the West at this time. Didron, as early as 1840, was the first to call serious attention to them, particularly with regard to iconography, and some twenty years later another Frenchman, Monsieur de Verneilh, wrote a book dealing with the presence of Byzantine architectural styles in France. Since the time that these pioneers worked the question has tended to be sidestepped, and only an occasional writer from time to time devoted a few pages to individual problems until Dr. Bemus published his Wrightsman lectures in 1971. In Britain the role of Byzantium in general and the effects produced on the arts, in particular by the crusaders, are problems which could be very profitably studied more fully.

Exactly what the role was that the crusaders attributed to these icons is not very easy to determine. It is doubtful if they looked on them with quite the same mystic reverence as did the faithful among the Orthodox. Rather, perhaps, they thought that they had a role to play in personal devotions or as teaching pictures, which would help

to make the Christian story more readily comprehensible. One of the panels in St. Catherine's monastery published by Professor Weitzmann is of special interest in this connection; it depicts the Nativity, and one of the three kings who bring their gifts to the stable is depicted as a Mongol, with slit eyes and long turned down moustache. There was at the middle of the thirteenth century a hope, indeed a distinct possibility, that the Mongols who were then advancing into western Asia might be converted to Christianity. One of their khans, Abagu, had married a Byzantine princess; another established relations with France; and Western travellers were already beginning to make contacts with their leaders. Could this icon have been painted in the hope that it might help to bring the Mongols into the Christian fold by convincing them that one of the 'kings of the Orient' was actually a Mongol? It seems a distinct possibility.

Quite a considerable number of the Sinai icons are of a type that one would naturally expect to find in a monastery; they depict the hierarchies of saints and martyrs, either as erect figures ranged in the order of the days on which their feasts were celebrated or in the process of being martyred. Those of the former group are often of high quality from the technical point of view, but the mass of figures in almost identical positions produces a monotonous effect, so that they are not of very general interest. But they are important from the point of view of church history and indicate that visual representations could be of practical use in a monastic community.

Another type of panel which seems to have been popular in the Sinai monastery was made up of painted beams, which must have formed parts of the iconostases in some of the smaller chapels. They carry paintings on quite a small scale which depict the major feasts of the Church in a row, one after the other. They thus represent the predecessors of the range of small festival icons which became usual in the iconostases of Greece, Serbia, and Russia at a later date. It is these icons, with their lively scenes, that constitute today the chief delight of collectors in the West. Perhaps the most important group of such panels is one formerly preserved in the church of the Virgin Peribleptos (St. Clement) at Ochrid in Macedonia, the work of painters of king Milutin's school done soon after 1300.

With the thirteenth century the Sinai monastery ceases to be the only, or indeed even the main, source of material. Panels of this date and even a few from the twelfth, have in recent years come to light

as the result of cleaning operations undertaken in Greece, Yugoslavia, and Russia; in the latter country the work of conservation had indeed been begun before the Revolution, at the instance of a few enlightened collectors, and very good work has been done in the restoration workshops intermittently ever since. In Yugoslavia serious cleaning only began after the Second World War while in Greece scientific investigations have been even more recent, though a good deal of rather amateurish cleaning was undertaken for collectors even before the First World War. There was a spate of activity just before the Byzantine exhibition at Athens in 1964 which resulted in the discovery of several previously unknown paintings. We thus today have quite a wide field of material from which to draw. It serves to show that many of the icons of these centuries were painted at Constantinople, for it seems that both in Greece and more especially in Russia it was customary to commission in the Byzantine capital panels which were subsequently taken back home. But schools of icon painting were no doubt beginning to grow up in most of the larger towns of the Orthodox world. The workshops at Salonica were of considerable importance, good work was done at Ochrid and probably elsewhere in Macedonia and Serbia, while in Russia Kiev in early times and later Vladimir, Suzdal, Novgorod, and finally Moscow all boasted distinctive and very productive workshops. Works produced in one centre were quite often moved elsewhere; thus some of the icons that till recent years had stood on the iconostases of churches in Moscow have now been shown to be Novgorodian products and others may have come from elsewhere. Painters also moved about very freely. Usually they remained within their own countries, travelling only from one town to another as commissions came forward, but occasionally Greeks moved to Russia and settled there, as happened in the case of the painter Theophanes (see p. 171). Perhaps he found that restrictions imposed by the Church were less rigorous there than in Constantinople, for his style certainly developed along very unconventional lines when once he settled in his new homeland.

As a result of the vicissitudes of preservation, the icons that survive from the later periods are naturally more numerous than those of earlier date, but it is also true that more icons were produced at this time; the Palaeologan age was especially productive. As more precious materials like ivory, gold, and silver became scarce or prohibitive in cost, painted panels assumed a new importance, while

after about 1400 the demand for them seems to have increased as a result of the Turkish conquests. In the first place their aid was called for more and more frequently in the role of intercessors to alleviate the rigours of conquest and Muslim domination, and in the second it was at this time that icons seem to have begun to play a role in homes as well as in the churches. Similarly the cult of the icon grew in importance in Russia throughout the fourteenth and fifteenth centuries. But unfortunately increased demand led also to a decline in artistic quality and by the seventeenth century the majority of the icons that were painted represented little more than hack work. But there are exceptions. Good work was sometimes still done in Russia and in those of the Greek islands that were subject to Venice, especially Crete, a new attitude was beginning to grow up, in that the icons were coming to be appreciated not only on religious grounds but also because they were the works of individual painters. Quite a considerable number of panels produced in the sixteenth and seventeenth centuries were signed, and many of the Cretan painters went for a time to work in Venice, where they learnt something of the Western outlook. True, their basic style was but little affected, for the Western elements that they adopted were in the main of a very superficial character, such as Baroque architectural compositions in the background or carved frames to surround the icons, but even so the icons began to have more the character of pictures than cult objects, and patrons began to seek the work of this or that painter rather than an icon executed anonymously in the service of the faith.

During the seventeenth, eighteenth, and early nineteenth centuries the old outlook of reverence for icons continued, as indeed it continues among the faithful to this day, but with the dawn of a more sceptical age the attitude began to change. Already before the Revolution collectors in Russia had begun to search out the older and finer panels in much the same way that connoisseurs elsewhere sought out Siennese primitives, and several important private collections had been assembled; they were subsequently taken over by the State and the icons that were in them are now to be found in public galleries like the Tretyakov at Moscow or the Russian Museum at Leningrad. But in recent years in Russia the public collections have been considerably supplemented by icons taken from the churches and freed from accumulations of dirt, smoke, or over-paintings in the State Restoration Workshops. In Yugoslavia on the other hand there were very few private collectors, and it was not really till the best icons

were taken over by the State after the Second World War that it became possible to appreciate the early icons as works of art; before that they were so dirty and obscured that they could hardly be considered for serious study. In Greece a few private collections were assembled in the early years of this century, but it was the signed icons of the sixteenth and seventeenth centuries that were most sought after, and the earlier panels mostly remained in the churches, uncleaned and unrecognized. In Bulgaria icons never played quite such an important role as in the rest of the Orthodox world. There are few local products that date from before the fourteenth century but later ones are numerous and there, as in Yugoslavia, the work of cleaning and conservation was put in hand after the war, and now the icons are looked upon as a very vital part of the country's artistic heritage.

An appreciation of icons as works of art in the West is, on the whole, a recent manifestation. True, quite a number were brought home as souvenirs by travellers throughout the nineteenth century, but few of these are to be counted as much more than curios. But as a result of the Revolution in Russia and the forced removal of the Christian populations of Turkey after the Graeco-Turkish wars of the early twenties, material began to become more readily available and it was from this date that the few serious collections that exist began to be assembled. And it so happened that the availability of material coincided with a change in tastes which made its acquisition seem desirable. As we have tried to show, the study of Byzantine art had progressed and judgement of the quality of work in the Byzantine style had become more acute; at the same time it was becoming easier for the average person to appreciate the severely stylized, almost abstract character of the art thanks to the acclimatization of his vision for such things, resulting from the departure from naturalism and the increasing love of abstraction in everyday contemporary art. Painters like Rouault turned to icons for inspiration, while the critics began to discern in them something more than the dull repetitions which had formerly been regarded as their chief characteristic. Today the wheel has turned full circle, icons have become the fashion, and whether good, bad, or indifferent, they command very high prices in the sale rooms. This will no doubt prove to be a passing fashion, but the fine icons, which were so long disregarded, are now assured an honourable place in our museums and galleries of art. It will, however, always be only in Yugoslavia, Greece, the Sinai monastery, and the U.S.S.R. that the really outstanding examples will be available.

Of all the factors that differentiate the study of Byzantine art from that of painting in the West the most striking is perhaps the anonymity of the artists. It is not till the fourteenth century that we know the name of a single painter or worker in mosaic, and even then we know very few, while the names of those who fashioned the ivories or works in metal remain wholly obscure. Only in Greece, in the sixteenth and seventeenth centuries, were icon painters esteemed as individuals, and even then it is not very easy to distinguish the work of one man from that of another, for their paintings conformed to a universal ideal in a manner quite unknown in the West even in medieval times. Only in Russia, after about 1400, can any serious attempt be made to attribute particular paintings to an individual artist on stylistic grounds in the same way that attributions are made with regard to the works of the early Siennese or Florentine masters in the West. The criteria adopted by Western art historians, one of whose main concerns is the attribution, are thus not in general applicable to the study of Byzantine painting. The problems there are indeed much closer to those that confront medievalists in the West, whose concern is more with what are usually termed workshops than with individuals, and whose methods are as much those of the archaeologist as they are those of the art historian. True, in the West the medievalist has to deal mainly with objects, that is to say with works in metal or ivory, with stained glass or tapestries, or with stone carvings, none of which can show the same touches of individual work as paintings, whereas in the Byzantine world mosaics in early times and wall paintings in later ones constitute the branches of art that most nearly concern us. But the anonymity of the Byzantine mosaicists and painters calls for the same kind of approach and the employment of similar methods. The workshop or school is thus the essential, not the individual; art reflects the spirit of a region or of an age, of the milieu that produced it, rather than the ideas of the individual who was responsible, whether he was a genius or a mere journeyman. It is the expression of a collective rather than a personal outlook.

The rules that governed the production of a work of art in the Byzantine world were very exact and had to be followed very

Manuscript illumination. Silk weavers at work. In the Vatican Library (Gr. 747). *Courtauld Institute of Art*

λομβμου. καιβιοσουκειμοσορόμης
ιαοχρισσιο. Καὶ ιπαέθηκαντοις

ελ
ια
αν
λο
κος
ιπο
λει
ξε
τοιλ

Σα
σι
ης
σγ
στο
ους
ς

ἔργον ποικιλτοῦ. ὁμτρόπομου
Καὶ ἐποίησον τὸ πέσαλον τὸ χρυσοῦ

precisely. Thanks to the investigations of Dr. Lopez we probably know most about those that applied to the textile workers, and especially those concerned with the most valuable woven material, silk. The finest silks were woven on the imperial looms which were located in a part of the Great Palace of the emperors called the ¹⁹⁵ Zeuxippos. Employment was on an hereditary basis and workmen were not permitted to leave or change their employment for fear that they might disclose technical secrets. Women were employed as well as men. The finest silks, and especially those with a purple ground, were reserved for the imperial household; they could not be sold and were only very rarely given as presents to particularly distinguished recipients. But if the products of the imperial looms were reserved, other textiles of almost equal quality were much in demand among the nobles, court officials, and richer citizens, though there were strict rules as to the sort of silks that each class of citizen might wear. They were mostly made on private looms, their products being regulated and controlled by the Prefect. The workers who made these more ordinary textiles were organized into guilds, the spinners and the dyers being the most important, while there were other guilds that dealt respectively with the men concerned with the distribution of silks, the merchants of raw silk, the merchants who sold the finished materials, and those who dealt with imported textiles. Each of these was very strictly controlled, and could only operate in its own particular sphere. It is probable that this closed system was in force right down to the time of the crusading conquest and perhaps even later; it was certainly in firm control in Macedonian times.

It would seem that in any case in the middle period much of the finest work in the other arts was also executed in the imperial workshops, though we know less about the actual system of organization. Some of the emperors took a keen personal interest in what was done, and it is likely that Constantine IX Porphyrogenitus was himself an amateur metal worker, for his name is associated with the production of a superb reliquary for the true cross which is now at Limburg on the Lahn in Germany. But no doubt, as with the silks, there were privately run workshops also. Among the ivories of the tenth and eleventh centuries that have come down to us some were obviously made in the court workshops, like that depicting the crowning of the emperor Romanos and his queen Eudoxia now in the Cabinet des Médailles at Paris, but others are less refined in style, and smaller in size; these were probably the products of the private

institutions. The best tusks were no doubt reserved for the royal carvers. In metal work again the imperial workshops no doubt dealt mainly with precious metals, gold or silver-gilt, yet a great deal of work was done in bronze and copper; here again the use of the richer materials was no doubt similarly restricted.

It must be assumed that all these men, including the mosaic workers and painters, worked on commissions or were employed directly by the patrons. It would be quite wrong to assume that any works of art were produced independently and offered for sale, as happens today. But no doubt anyone who could afford it would be able to commission a work, and from the twelfth century onwards we know of icons being executed in this way for patrons who came from Russia especially to acquire them. Whether patrons from the West came to the capital more than very rarely is uncertain, but Byzantine silks were in keen demand there and it is improbable that all of them were sent as presents. We do know that Luitprand of Cremona was able to acquire silks to take home when he visited Constantinople in the ninth century; at the end of his second visit they were confiscated by the customs, but it would seem that this was done more to cause him annoyance than to satisfy normal export regulations.

We are, alas, totally ignorant of how, or how much, the craftsmen or artists were paid, for such documents as survive are silent on the question. In the most informative and comprehensive of them, *De diversis artibus,* compiled by the monk Theophilus probably in the eleventh century, it seems to be tacitly assumed that the craftsman was attached to some sort of organization, a workshop or a monastery, and that the problem of subsistence did not concern him. Theophilus was a Latin monk, and in this respect he was writing for the West; but it may be questioned whether the same situation pertained in the East, for there the monasteries do not appear to have been centres of art production, with the possible exception of manuscript illumination. From what we can learn with regard to the silk trade it would seem that both imperial and private workshops existed in other spheres also. But the descriptions that Theophilus gives of the various techniques would seem to take into account methods that had long been in use in the Byzantine world.

Theophilus's book is divided into three sections. In the first he gives full instructions with regard to painting, on wall, on panel, and in manuscripts, describing methods of preparing and mixing the colours, the treatment of the ground, and the types of medium that

could be employed. The methods he outlines are closely akin to those used in the Byzantine world and must in part have been derived from Byzantine sources. The second section, in which he deals with the manufacture of glass, both for vessels and for windows, is more properly applicable to the West alone, for with the exception of the preparation of the sheets of thick opaque glass which were fashioned into tesserae for the mosaics, glass does not seem to have been much used by the Byzantines; only one vessel of importance, now in the treasury of St. Mark's, survives and very few fragments are known, whereas quite a few complete bowls and dishes of pottery and hundreds of fragments of ceramics have been found in such excavations of Byzantine sites as have been conducted. Recent discoveries at Constantinople do however suggest that stained glass was sometimes used in Byzantine churches, but it must have been a rarity, and it is not even certain that it was actually made in the East.

The third section of Theophilus's book is devoted to the implements required and the techniques employed in metal working. Here some of the text, though by no means all of it, is applicable to the Byzantine world as well as to the West. It closes with a few remarks about ivory carving and the polishing of gems which might also be applicable to the East, though the references he makes to glass cutting surely have to do solely with the West.

So far as the technical problems of mosaics and paintings are concerned, a good deal can be learnt from a careful analytical study of the works themselves, especially in cases where they have to some extent fallen away from the walls or panels. The earlier mosaics were usually set on three layers of plaster, a basic one of coarse plaster in which a binding material like straw was mixed, a second layer of finer plaster, and a final layer which formed the setting-bed itself. The design was roughly sketched on the second layer in black or red ochre outline, as can be seen in the mosaics of the fourth century in the Baptistery of San Lorenzo at Milan, where the cubes and the plaster of the upper layer have fallen. In late work, as has been disclosed by the very careful study of the mosaics of Kariye Camii made by Dr. Paul Underwood and his team of experts, it would seem that the sketch to guide the man who set the tesserae was actually executed in several colours. In the case of the background the gold cubes were set in plaster painted red, and this red no doubt helped to give depth and richness to the gold, for it not only tinged the colour, but was also visible in the tiny divisions between the cubes. Exactly when the practice of

colouring the sketch—or sinopia, as it would have been termed in Italy—began, it is impossible to say, but further detailed examinations of the type carried out at Kariye should go far to increase our knowledge.

Theophilus and the Italian Cennino Cennini in the first half of the fourteenth century have a lot to say about the materials of the painter's craft, and the later writer follows very closely the suggestion laid down by the earlier one. What they say also tallies very closely with the account given in a most important manuscript from the Byzantine world. It is called *The Painter's Guide,* and was compiled by the monk Dionysios of Fourna in the sixteenth century, though it would seem to record processes which had been in use very much earlier. A copy was acquired by Didron on Mount Athos in 1839 and published six years later. Rather similar handbooks called *podlinniki* and founded on Byzantine practice, also existed in Russia from about the sixteenth century onwards. Dionysios's book differs from those of Theophilus and Cennino Cennini, however, in that it not only describes the methods and technique, but also states how the various themes of the Bible story should be rendered and how the individual saints should be depicted. The descriptions are in most cases closely applicable to such paintings as survive from much earlier days, certainly from the tenth century onwards, so that it is reasonable to conclude that similar written guides existed long before the sixteenth century—unless of course instructions were handed down by word of mouth from master to pupil; in this case the pupil would have to have learnt it off more or less by heart. That pupils were able to do this without great difficulty is suggested by Didron's description of the painter he watched at work in the monastery of Esphigmenou on Mount Athos. His account is of the greatest interest.

The painter was a monk called Joseph, and he had several assistants to help him. Joseph sketched in the outlines, and the principal assistant filled in the contours with colour, another prepared the plaster, and a third gilded the haloes, while two younger men mixed and prepared the colours. Joseph possessed a copy of the *Guide,* which he had used when he was himself a learner, but when Didron watched him he was working entirely from memory and in the space of an hour he had sketched on a large scale the whole scene of Christ dispatching the apostles on their mission of teaching and preaching, which forms the last scene of the Passion cycle in Byzantine iconography. The painter even dictated from memory the inscriptions that

accompany the scene. He worked with the greatest ease and fluency, and while he worked he talked to Monsieur Didron. This recalls a statement made by the Russian chronicler Epiphany the Wise describing the way in which the painter Theophanes the Greek worked.

When he portrayed or painted he was never seen by anyone to look at models, as certain of our icon painters do, who in perplexity constantly stare (at them), looking hither and thither, and do not so much paint with colour as just look at models. In Theophanes's case his hands seem to do the painting while he himself is perpetually walking about, chatting to visitors, and pondering wise and lofty thoughts in his mind, seeing goodness with his thoughtful, sensitive eyes.[1]

In both cases the master had his design so to speak at his finger tips, and could therefore work very quickly. In Serbia it is recorded that a painter could cover six to seven square yards of wall space in a single day. The way in which the painters worked can have changed very little throughout the ages, so that the account given in *The Painter's Guide* is of very great significance.

The chronicler Epiphany mentions models, and these must have taken the form of sketch books containing drawings or descriptions of individual figures. They also apparently contained details of orna-mental motifs which were used as borders, for the repertory here seems to have followed fairly set forms. A hint of what these model books must have looked like is given by a Western manuscript of the twelfth century with drawings of a wholly Byzantine style which is known as the Wolfenbüttel pattern book. The drawings it contains are in line, but the details of the costumes and so forth are beautifully drawn, and it would not have been difficult for a painter to make use of them; indeed, some of the paintings in Hagia Sophia at Trebizond might well have been modelled on these or similar works. Attention may also be drawn to a manuscript in the British Museum (Add. 43868), which also contains what appear to be artists' sketches, though they are not very well done and only date from the eighteenth century. In Hagia Sophia at Trebizond the painters also executed small-scale sketches on the masonry of the wall itself, before the plaster was applied. These were done in a very haphazard way, perhaps to illustrate some points that had arisen in a discussion with one of the other masters or to explain something to a pupil. But such

[1] From V. N. Lazarev, *Old Russian Murals and Mosaics,* London, 1966, p. 181.

sketches can only have been in use in the process of 'preparing the finger tips'.

An idea proposed by Kondakov that full-scale tracings were used by the wall painters cannot be accepted. True, in later times, when the business of icon painting had become a mechanical routine, tracings were used in Russia, the outline being pricked through on to the gesso ground of the panel. That the tracings were sometimes applied in reverse accounts for the fact that oft-repeated subjects like the Virgin and Child sometimes appeared the wrong way round. But the wall painters did undoubtedly make use of incised guide lines which were scratched into the plaster while it was still damp. When they came to finish the work the painters did not necessarily adhere to these lines exactly, but used them only in a general kind of way. They are mentioned by Cennino Cennini and in *The Painter's Guide*, and they can be discerned in many paintings when they are looked at closely, notably in those of Hagia Sophia at Trebizond. Guide lines in red or dark green were also employed and these too were often done on the damp plaster, so that they are in true fresco and survive intact whereas the painting itself, done on the dry plaster, has often flaked off. Investigations made by Dr. Underwood at Kariye Camii show that the mosaicists there covered very large areas with plaster laid at one throw; they must have had some means of keeping it reasonably damp over a long period. The painters however do not seem often to have sought to do this, preferring to apply their colours to the dry surface, building them up from a dark undercoat and adding the modelling in lighter shades as they worked till finally the high-lights were applied. These did not necessarily correspond to the areas which would have caught the light naturally, but were often in shaded places such as below the eye; they were there to produce the effect of 'inner light' so dear to the Byzantines rather than to achieve sculpturesque modelling.

So far as colouring is concerned it would seem that the first part of the painting to be executed was the background. From the thirteenth century onwards this was in blue over black for the sky and green over black for the ground; today the blue has often faded, so that the skies appear black, and give a somewhat gloomy appearance to paintings which would otherwise be bright and gay. The green of the ground is usually better preserved. Costumes and architectural motifs were done next and the details of the figures last of all. These were executed with special care and the colours were built up in

several layers, whereas for the costumes one layer, above which high-lights or shadow lines were added, would suffice.

The colours themselves were significant and they often had a symbolic connotation. Purple was reserved for the costumes of the more significant figures like Christ and the Virgin because in pre-Christian times it had been associated with imperial power, purple textiles being reserved for the use of the emperor. White was, and still is, the colour of purity. In the scene of the Separation of the Sheep from the Goats in the upper tier of the mosaic decoration of S. Apollinare Nuovo at Ravenna the good sheep and their guardian angel are coloured pinkish gold and the bad goats and the figure that accompanies them bluish grey. Here we see the survival of a very old conception that goodness is symbolized by the colours of day and evil by the colours of night.

Though there are no rules laid down in *The Painter's Guide* relating to the choice of colours as there are for the poses and the facial types, it would seem that certain conventions were fairly generally followed. Thus Christ was usually depicted in white for the Trans-figuration, in blue in the scenes that took place before the Crucifixion, and in purple in those enacted after the Resurrection, while the Virgin's robe was dark green, dark blue, or purple. Sometimes, especially in miniature painting after about the eleventh century, the high-lights on the figures of Christ and the Virgin were picked out in gold. The object was no doubt to intensify the atmosphere of glory, for gold was the colour of glory and goodness. This practice passed from later Byzantine painting to Italy, where it was much favoured by Duccio, notably in many of the scenes on the back of his *Maestà* at Sienna.

A concern for colour seems to have developed at an early stage in the story of Byzantine art, for in his description of the marbles used to adorn the interior of Hagia Sophia Paul the Silentiary stresses the glories of their colours. They included 'spring-green marbles from Karystos and many hued ones from Phrygia where red and silver shine like flowers'. The porphyry he describes as being powdered with stars, while other stones produced the effect of 'crocus flowers glistening with gold or of milk poured on to black flesh, while others were like blue corn-flowers growing in drifts of snow'. These words applied by Paul to marbles also serve to describe the effect produced by the bright colours and striking high-lights of later Byzantine paintings. Can the feeling for such effects have been

universal in the Byzantine world throughout the long period of its history? It would seem that this was very probably so.

At a later date St. John of Damascus (*c.* 750), when discussing the importance of visual perception, stresses the fact that colour is a factor of sight. ' Sight is primarily the perception of colour,' he writes. For him it was the colour that served to discriminate the form of the body and the essence of the compositions made of a number of figures. In this he heralded the conceptions of the Second Golden Age, when artists composed in colour; their paintings were never merely coloured drawings, as they were, for example, in medieval manuscript illustrations.

Today it is primarily the brilliant colouring of the mosaics and the subtle hues of the paintings that most charm the Western observer of Byzantine art. For the Byzantines it meant something more. Light was the very source of goodness, and bright colours, contrasting with dark, constituted the materialization of light. It was no doubt for this reason that the Byzantine painters never attempted to blend their colours on the wall or panel as the oil painters of the West did, but applied the pure colours one above the other. Guided by a subtle and introspective line of thought, in which the rendering of the spiritual essence in visual form was the basic aim, the Byzantine painters eschewed the half-tones and blendings so favoured in the West and pursued rather the glory of light itself.

This brief study of colour brings us to the very heart of our theme— the difference between Byzantine art and that of the West. Founded on a common heritage, that of the legacy of Greece and Rome, the arts of the two areas inevitably embraced much common ground, and their interrelationship was intensified throughout the Middle Ages as a result of the influence that the highly sophisticated art of Byzantium exercised on the more troubled West. But unlike the art of the West, that of Byzantium had drawn a good deal from the East, so that it gave expression to many ideas and conceptions which were foreign to the Western outlook. These were mostly ideas of a mystic, inward looking character, but they affected the outward forms of art quite considerably, so that the art of the east Christian world tended to develop along lines very different from those followed in the West. And when once the phase of barbarism came to an end in the West, around the year 800, an outlook came to be adopted there which was something new and distinct and which influenced the future develop-

ment of Western art in a very different way.

In the East, however, progress was interrupted by the Turkish conquests soon after 1400, whereas in the West new ideas were introduced with ever increasing rapidity, and as a result of the Renaissance the old conceptions were forgotten, and the vital role that Byzantium had once played passed into oblivion; by the eighteenth century it had even come to be denigrated, and the same attitude persisted throughout much of the nineteenth century. But with the twentieth century a new outlook developed once more, which led to a reconsideration of accepted values. In fact the time had come for a reappraisal. But the ideas of the age of reason had become so deeply imbedded that, in order to appreciate the true character of the age of faith, the criteria of judgement required very considerable alteration; so far as art was concerned, one's eyes had, as it were, to be refocused. The preceding pages have been written with the aim of giving some slight indication of some of the directions that our efforts to effect this change of outlook may take.

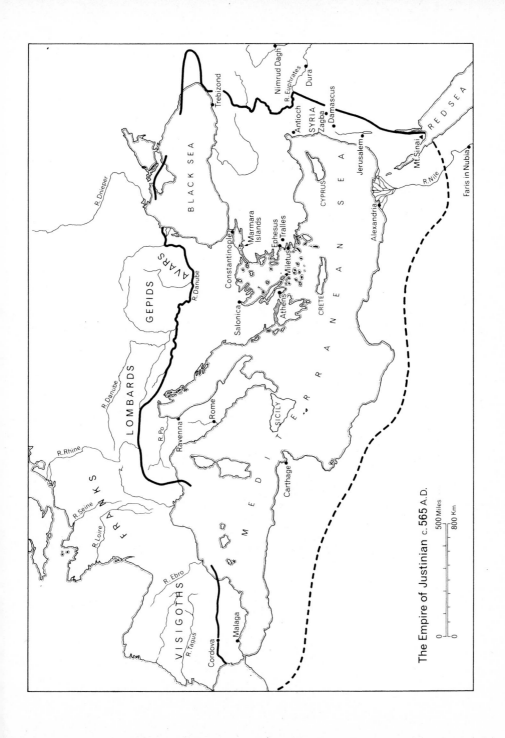

The Empire of Justinian c. 565 A.D.

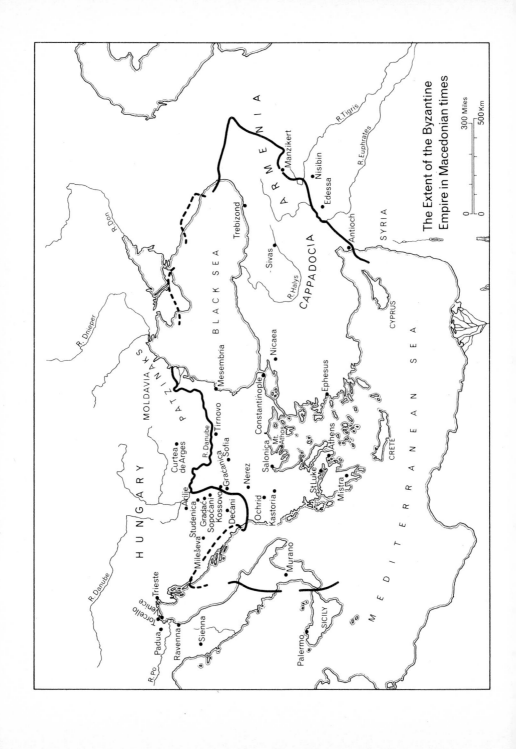

The Extent of the Byzantine
Empire in Macedonian times

300 Miles

500 Km

R.Tigris

R.Euphrates

A R M E N I A

Manzikert

Nisibin

Edessa

Antioch

S Y R I A

C A P P A D O C I A

CYPRUS

Trebizond

Sivas

R.Halys

B L A C K S E A

R.Don

R.Dnieper

Mesembria

Nicaea

Ephesus

Constantinople

Mt.Athos

Salonica

Athens

St.Luke

CRETE

Mistra

M O L D A V I A

P A T Z I N A K S

Tirnovo

Curtea
de Arges

R.Danube

Sofia

Gracanica

Nerez

Ochrid

Kastoria

Arjlie

Studenica

Gradać

Sopoćani

Kossovo

Dečani

Mileševa

H U N G A R Y

R.Danube

Trieste

Torcello

Venice

Padua

Ravenna

Sienna

R.Po

Murano

SICILY

Palermo

M E D I T E R R A N E A N S E A

Bibliography

I General Works
Beckwith, J., *Early Christian and Byzantine Art*, London, 1970.
 The Art of Constantinople, London, 1961.
Rice, D. Talbot, *Byzantine Art*, London (Penguin), 1968.
 The Art of Byzantium, London, 1958.

II Books Cited in the Text or of Special Interest for Individual Chapters
CHAPTER 1

Breasted, J. H., *Oriental Forerunners of Byzantine Painting*, Chicago, 1923.
Panofsky, E., *Meaning in the Visual Arts*, New York, 1955.
Paul the Silentiary: see Krumbacher, K., *Geschichte der byzantinischen Littera-*
 tur, Munich, 1897. His remarks on Hagia Sophia are extensively
 quoted in Lethaby and Swainson, *The Church of Sancta Sophia, Con-*
 stantinople, London, 1894.
Ravenna: for the Ravenna mosaics see various works by G. Bovini.

CHAPTER 2

Baynes, N., *Byzantine Studies and other Essays*, London, 1955.
Burckhardt, J. C., *The Age of Constantine the Great*, London, 1852.
Bury, J. B., *History of the Later Roman Empire*, London, 1889.
 A History of the Eastern Roman Empire, London, 1912.
Byron, R., *The Byzantine Achievement*, London, 1929.
Byzantine Research Fund, Publications of:
 Schultz, R. W. and Barnsley, S. H., *The Monastery of St Luke of Stiris in*
 Phocis, London, 1901.
 Harvey, W., and others, *The Church of the Nativity at Bethlehem*, London,
 1910.
 George W. S., and others, *The Church of St. Eirene at Constantinople*,
 Oxford, 1912.
 Jewell, H. H. and Hasluck, F. W., *The Church of our Lady of the Hundred*
 Gates in Paros, London, 1920.
Conway, Sir Martin, *Early Tuscan Art from the 12th to the 15th Century*,
 London, 1902.
Curzon, R., *The Monasteries of the Levant*, London, 1848.
Dalton, O. M., *Byzantine Art and Archaeology*, London, 1911.
Didron, M., *Manuel d'iconographie chrétienne*, Paris, 1845.
Diehl, C., *Histoire de l'Empire byzantin*, Paris, 1930, and other works.
 Manuel d'art byzantin, Paris, 1910.
Fallmerayer, J. P., *Geschichte des Kaiserthums von Trapezunt*, Munich, 1827.
Finlay, G., *History of Greece from its Conquest by the Crusaders to its Conquest by*
 the Turks, London, 1851.

Greece under the Romans, London, 1852.

The Byzantine Empire, London, 1852.

The Greek Revolution, London, 1854.

Fossati, G., *Aya Sophia, Constantinople, as recently restored by order of H.M. the Sultan Abdul Mejid,* London, 1852.

Fry, R., *Transformations,* London, 1926.

Gardiner, P., *Principles of Christian Art,* London, 1928.

Gibbon, E., *The History of the Decline and Fall of the Roman Empire,* London, 1776–81.

Hegel, G. W. F., see Michelet.

Hertzberg, G. F., *Geschichte Griechenlands seit den Absterben des antiken Lebens bis zum Gegenwart,* Gotha, 1876–9.

Hopf, K., *Geschichte Griechenlands von Beginn des Mittelalters bis zur unsere Zeit,* Leipzig, 1967.

Kondakov, N. P., *Histoire de l'art byzantin consideré principalement dans les miniatures,* Paris, 1891.

Krumbacher, K., *Geschichte der byzantinischen Litteratur,* Munich, 1897.

Lecky, W. H., *History of European Morals,* London, 1869.

Lethaby, W. R., *'Byzantine Art',* in the *Encyclopedia Britannica,* eleventh ed., 1910.

Lethaby, W. R. and Swainson, H., *The Church of Sancta Sophia, Constantinople,* London, 1894.

Lindsay, Lord, *The History of Christian Art,* 1st ed., London, 1848, 2nd ed., Edinburgh, 1885.

Lubke, W., *History of Art,* translated by F. E. Burnett, London, 1868.

Michelet, C. L. and Hegel, G. W. F., *The Philosophies of Art,* Edinburgh, 1886.

Middleton, H., 'Mosaics', in the *Encyclopedia Britannica,* ninth ed., 1876.

Miller, W., *Trebizond: The Last Greek Empire,* London, 1926.

Millet, G., *Les Monuments de Mistra,* Paris, 1910.

Recherches sur iconographie de l'evangile, Paris, 1916.

Montesquieu, C. de S., *Causes de la grandeur des Romains et leur décadence,* Paris, 1734.

Morris, W., *Collected Works,* London, 1910–15.

Muratov, P., *La Peinture byzantine,* Paris, 1928.

Ostrogorsky, G., *History of the Byzantine State,* German ed., 1940, English ed., Oxford, 1956.

Peirce, H. and Tyler, R., *Byzantine Art,* London, 1926.

Rambaud, A., *L'Empire grec au dixième siècle,* Paris, 1870.

Robb, D. M. and Garrison, J. T., *Art in the Western World,* New York and London, 1935.

Ruskin, J., *The Seven Lamps of Architecture,* London, 1880.

The Stones of Venice, London, 1867.

Salzenberg, W., *Die altchristlichen Baudenkmäler von Konstantinopel,* Berlin, 1954 (album).

Schlumberger, G., *L'Epopée byzantine à la fin du dixième siècle,* Paris, 1896–1905.

Un Empereur byzantin au dixième siècle, Paris, 1890.

Sewter, E. R. A., *The Chronicles of Michael Psellus,* London (Penguin), 1966.

Texier, C. and Pullan, R. P., *Byzantine Architecture,* London, 1864.

The Principal Ruins of Asia Minor, London, 1865.

Uspenskij, T. I., *History of the Byzantine Empire* (in Russian), Vol. I, St. Petersburg, 1913; Vol. II, Leningrad, 1927; Vol. III, Moscow, 1948.

Vasiliev, A. A., *History of the Byzantine Empire,* Madison, 1952.

Vienna Genesis: noted in Petri Lambecii, *Hamburgensis, Sacrae Caesarae majestatis Commentariorum de Augustissima Bibliotheca Caesarea Vindobonensi,* 1659, with engravings by J. Sadler. Reissued Vienna, 1776–82, with engravings by A. Schlecter.

Wulff, O., *Altchristliche und Byzantinische Kunst,* Berlin, 1914.

Xivrey, Berger de, on the works of the Emperor Manuel Palaeologos, read in 1840 and 1841, see *Mémoires de l'Institut Royal de France,* XIV, 1845, p. 108, and XIX.

CHAPTER 3

Ainalov, D. V., *The Hellenistic Origins of Byzantine Art,* New Brunswick, New Jersey, 1961.

Avery, M., 'The Alexandrine Style at Sta Maria Antiqua', in *The Art Bulletin,* VII, 1925, p. 131.

Breasted, J. H., *Oriental Forerunners of Byzantine Painting,* Chicago, 1923.

Dalton, O. M., *Early Christian Art,* Oxford, 1925.

Grabar, A., *Les Ampoules de terre sainte,* Paris, 1958.

Kraeling, C. H., *The Excavations at Dura Europos,* VIII, Pt. 1, New Haven, 1956.

Matzulewitsch, L., *Die Byzantinische Antike,* Berlin-Leipzig, 1929.

Millet, G., *L'Iconographie de l'evangile,* Paris, 1916.

Radojčić, S., *Mileševa,* Belgrade, 1963.

Rostovtzev, M., *Dura and the Problem of Parthian Art,* Yale Classical Studies, New Haven, 1935.

Segal, J. B., 'The Sabian Mysteries', in E. Bacon, *Vanished Civilizations,* London, 1963.

Strzygowski, J., *Orient oder Rom,* Leipzig, 1901.

Origin of Christian Church Art, Oxford, 1923.

CHAPTER 4

Delbrueck, R., *Die Consulardiptychen,* Berlin-Leipzig, 1926.

Harrison, M. and Firatli, N., 'Excavations at Sarachane in Istanbul', in *Dumbarton Oaks Papers* 19 (1965), 20 (1966), 21 (1967), and 22 (1968), Harvard.

Volbach, F., *Elfenbeinskulpturen der Spätantike und des frühen Mittelalters,* Mainz, 1952.

CHAPTER 5

Bovini, G., *Mosaics of Ravenna,* Florence, 1956.
Gerstinger, H., *Die Wiener Genesis,* Vienna, 1931.
Grabar, A., *Les Peintures de l'evangiliaire de Sinope,* Paris, 1948.
Lethaby, W. R. and Swainson, H., *The Church of Sancta Sophia, Constantinople,* London, 1894.
Munoz, A., *Codex Purpureus Rossanensis,* Rome, 1907.
Procopius, *The Buildings,* Loeb edition, Vol. VII, Harvard, 1961.

CHAPTER 6

Cruikshank-Dodd, E., *Byzantine Silver Stamps,* New York, 1961.
Levi, D., *Antioch Mosaic Pavements,* Princeton, 1947.
Matzulewitsch, L., see Chapter 3.
Walker Trust, *The Great Palace of the Byzantine Emperors at Constantinople,* Vol. I, London, 1947, Vol. II, Edinburgh, 1958.

CHAPTER 7

Baynes, N. H., 'The Thought-World of East Rome', in *Byzantine Studies and other Essays,* London, 1955.
Grabar, A., *L'Iconoclasme byzantin,* Paris, 1957.
Underwood, P. A., 'The Evidence of Restorations in the Sanctuary Mosaics of the Church of the Dormition at Nicaea', *Dumbarton Oaks Papers,* 13, 1959.

CHAPTER 8

Cosmas Indicopleustes, edited by G. Stornajolo, *Miniature delle Omilee di Giacomo monaco e dell'Evangelioro Greco Urbinate,* Rome, 1910.
Demus, O., *Byzantine Mosaic Decoration,* London, 1947.
Jerphanion, G. de, *Les Églises rupestres de la Cappadoce,* Paris, 1925 and later.
Mango, C. and Hawkins, E. J. W., 'The Apse Mosaics of St Sophia at Istanbul', in *Dumbarton Oaks Papers,* 19, 1966.
Mathew, G., *Byzantine Aesthetics,* London, 1963.
Rice, D. Talbot, 'The Pottery of Byzantium and the Islamic World', in *Studies in Islamic Art and Archaeology in Honour of K. A. C. Creswell,* Cairo, 1965.
Schmidt, T., *Die Koimesis-Kirche von Nikaia,* Berlin, 1927.
Thierry, N. and M., *Nouvelles Églises rupestres de la Cappadoce,* Paris, 1962.

CHAPTER 9

Comnena, Anna, *The Alexiad,* translated by E. A. Dawes, London, 1967.
Haskins, C. H., *The Renaissance of the Twelfth Century,* Harvard, 1927.

Keck, A. S., 'A Group of Italo-Byzantine Ivories', in *The Art Bulletin*, XII, 1939, p. 147.

Rice, D. Talbot, *Byzantine Painting: The Last Phase*, London, 1968.

CHAPTER 10

Djurić, V. J., *Sopoćani*, Belgrade, 1963.

Hamann-Maclean, R., *Die Monumentalmalerei in Serbien und Makadonien*, Giessen, 1963.

Millet, G., *Les Monuments de l'Athos*, Paris, 1927.

 La Peinture du moyen-age en Yougoslavie, Albums presentés par M. Frolow et Tania Vellmens, Paris, 1954 and later.

Rice, D. Talbot, *The Church of Hagia Sophia at Trebizond*, Edinburgh, 1969.

Valland, R., *Aquilée et les origines byzantines de la Renaissance*, Paris, 1963.

CHAPTER 11

Byron, R. and Rice, D. Talbot, *The Birth of Western Painting*, London, 1930.

Millet, G., *Monuments de Mistra*, Paris, 1910.

Underwood, P. A., *The Kariye Djami*, London, 1967.

CHAPTER 12

Lazarev, V. N., *Old Russian Murals and Mosaics*, London, 1960.

Rice, Tamara Talbot, *A Concise History of Russian Art*, London, 1963.

CHAPTER 13

Amiranashvili, C., *Medieval Georgian Enamels*, New York, 1968.

Grabar, A. and Miatev, K., *Bulgaria-Mediaeval Wall Paintings*, UNESCO, 1962.

Nersessian, S. der, *Armenia and the Byzantine Empire*, Harvard, 1945.

Rice, D. Talbot, *Art of the Byzantine Era*, London, 1963.

CHAPTER 14

Buchthal, H., *Miniature Painting in the Latin Kingdom of Jerusalem*, Oxford, 1957.

Demus, O., *Byzantine Art and the West*, London and New York, 1971.

Didron, M., see Chapter 2.

Rice, D. Talbot, 'Icons', in *Antiques International*, ed. P. Wilson, London, 1966.

Verneilh, Felix de, *L'Architecture Byzantine en France*, Paris, 1851.

Weitzmann, K., Chatzidakis, M., Miatev, K., and Radojćić, S., *Icons from South East Europe and Sinai*, London, 1968.

Dionysios of Fourna, *The Painter's Guide,* edited by M. Didron, in *Manuel d'iconographie chrétienne,* Paris, 1845.

Lopez, R. S., 'Silk Industry in the Byzantine Empire', in *Speculum,* XX, 1945, p. 1.

Philipps, L., *Le Monde byzantin dans l'histoire de la verrerie* (V — XVIième Siècle), Bologna, 1970.

Theophilus (called also Rugerus) Presbyter, *De diversis artibus,* English translation by R. Hendrie, London, 1847.

Weitzmann, K., 'Zur Byzantinischen Quelle des Wolfenbüttler Muster-buches', in *Festschrift Hans R. Hanbloser,* Basle, 1959.

Winfield, D., 'Middle and Later Byzantine Wall Painting Methods', in *Dumbarton Oaks Papers,* 22, 1968.

Index